Digital Humanities in Practice

Digital Humanities in Practice

Edited by

Claire Warwick, Melissa Terras
and Julianne Nyhan

facet publishing

in association with

UCL CENTRE
FOR DIGITAL
HUMANITIES

Published by Facet Publishing,
7 Ridgmount Street, London WC1E 7AE
www.facetpublishing.co.uk
Published in association with UCL Digital Humanities Centre.

Facet Publishing is wholly owned by CILIP: the Chartered Institute
of Library and Information Professionals.

British Library Cataloguing in Publication Data
A catalogue record for this book is available from the British
Library.

ISBN 978-1-85604-766-1

First published 2012

Text printed on FSC accredited material.

Typeset from editors' files by Flagholme Publishing Services in
10/14 pt Palatino Linotype and Frutiger
Printed and bound by CPI Group (UK) Ltd, Croydon, CR0 4YY

Contents

Contributors

Mona Hess (m.hess@ucl.ac.uk) is working as a Research Assistant for UCL Museums and Collections and is based at the UCL Photogrammetry, 3D Imaging and Metrology Research Centre (UCL Civil, Environmental and Geomatic Engineering) as a part-time PhD student. After finishing her architecture studies in Munich, Germany, and a one-year internship in an architectural office, specializing in heritage buildings in Montreal, Canada, Mona Hess pursued a Master's degree in Heritage Conservation in Bamberg, Germany, where she specialized in CAD, 3D imaging techniques and databases, particularly in the fields of conservation science and architectural conservation. Her graduate internship in 2006/07 at the Getty Conservation Institute in Los Angeles, USA, gave her work experience in international projects (Middle Eastern Geodatabase for Antiquities – Jordan). Specializing in 3D colour imaging, digital heritage and replicas of museum objects, she has taken on projects within UCL (E-Curator's '3D colour scans for remote object identification and assessment' and a workshop 'Life cycle of a digital object'), for museums in London (British Museum, Science Museum) and also internationally (Università degli studi Lecce/Italy, CULTNAT Egypt). Currently, she is actively involved with the 3D Encounters Project at the UCL Petrie Museum.

Sally MacDonald (s.macdonald@ucl.ac.uk) is Director of UCL Museums, Collections and Public Engagement. She has worked in museums for over 20 years, leading museums of archaeology, decorative arts and social history and winning several personal and institutional awards for innovation and achievement. She has a particular interest in community engagement and audience development, as well as in ethical issues relating to collections. Her remit at UCL includes responsibility for public engagement across the

university. At UCL she has led two research projects, looking at the potential applications of 3D scanning in museums and has published, more generally, on public attitudes to museum displays and on museum strategy and practice.

She is a Fellow of the Royal Society of Arts and of the Museums Association and she is a board member of several national professional organisations, including the Museums Association and the Women's Leadership Network. She has served on committees established by the Department for Culture Media and Sport to look at the treatment of human remains in museums, has worked internationally with the British Council and UNESCO and has helped set up a UCL campus in Qatar, focusing on museums, archaeology and conservation.

Simon Mahony (s.mahony@ucl.ac.uk) is a classicist by training, with a background in Latin literature, and now works as a Teaching Fellow at the UCL Centre for Digital Humanities, University College London. Simon is Programme Director for the MA/MSc in Digital Humanities and teaches a range of technical and non-technical modules. His current interests are in the application of new technologies to the study of the ancient world, using new, web-based mechanisms and digital resources to build and sustain learning communities, and collaborative and innovative working. He is also active in the field of distance learning and is a member of the University of London's Centre for Distance Education. Simon is an Associate Fellow at the Institute of Classical Studies (School of Advance Study, University of London), one of the founding editors of Digital Classicist and is an editor at the Stoa Consortium weblog.

Julianne Nyhan (j.nyhan@ucl.ac.uk) is Lecturer in Digital Information Studies in the Department of Information Studies, UCL and European Liaison Manager of UCL's Centre for Digital Humanities. Her research interests include the design and use of metadata languages in the humanities and the history of computing in the humanities. From 2009–2011, she was a member of the Technical Council of the Text Encoding Initiative and, since 2008, has been book reviews editor of *Interdisciplinary Science Reviews*. She is also a member of the AHRC Peer Review College and tweets as @juliannenyhan.

Stuart Robson (s.robson@ucl.ac.uk) is known for his research in the field of traceable online dynamic 3D co-ordination and monitoring of engineering, medical and fine art structures using photogrammetry, vision metrology and

colour laser scanning. Stuart Robson founded, and now leads, the cross-faculty UCL 3D scanning initiative, stimulating pan-London and international research projects and providing a strategic vision of the significance of 3D imaging technologies to heritage, medical, engineering and creative sectors. He has a track record in engineering measurement, working with NASA, Airbus, UK Atomic Energy Authority (JET) and NPL, and in medical physics, where he collaborates to optimise optical tomography and EEG sensing for clinical studies. His digital heritage projects are centred on 3D colour artefact and environment scanning with UCL Museums and Collections, Institute of Archaeology, The Slade and The Bartlett, founded on corporate agreements with Arius3D, Faro and Leica Geosystems, along with funding from AHRC, JISC and EPSRC.

Claire Ross (claire.ross@ucl.ac.uk) is a PhD student and researcher at the UCL Centre for Digital Humanities. Her research focuses on information seeking, user-centred design and user studies of digital technologies in a cultural heritage context; she focuses on the value and impact of digital technology in museums, by exploring user information-seeking and interaction behaviour. Her research looks at the nature of participation and engagement possibilities provided by digital spaces and social media and whether online interactions with cultural content provide engaging experiences for users, supporting inquiry and meaning-making. Research projects include QRator with UCL CASA and UCL Museums and Collections, and Social Interpretation at the Imperial War Museums. Formerly, she was an E-Learning Development Project Manager, working on a collaborative project with the University of Exeter and Geevor Tin Mine Museum. She is Chair of the Digital Learning Network for Museums, Libraries and Archives.

Irish Sirmons (irish.sirmons.10@ucl.ac.uk) graduated from the United States Naval Academy in 2003 with a BS in English. She earned her MSc in Information Sciences at University College London in 2011. Whilst writing her dissertation, Irish interned with the UCL Digital Humanities OER Project Team and is currently helping to build an information resource centre in Little Baddow, Essex, which will include a community skills database and an OER training course.

Melissa Terras (m.terras@ucl.ac.uk) is Co-Director of the UCL Centre for Digital Humanities and Reader in Electronic Communication in UCL's

Department of Information Studies. With a background in classical art history, English literature and computing science, her doctorate (University of Oxford) examined how to use advanced information engineering technologies to interpret and read Roman texts. Her publications include *Image to Interpretation: intelligent systems to aid historians in the reading of the Vindolanda texts* (2006, Oxford University Press) and *Digital Images for the Information Professional* (2008, Ashgate). She is the general editor of *Digital Humanities Quarterly* journal, the secretary of the Association of Literary and Linguistic Computing and on the board of the Alliance of Digital Humanities Organisations. Her research focuses on the use of computational techniques to enable research in the arts and humanities that would otherwise be impossible. You can generally find her on Twitter, @melissaterras.

Ulrich Tiedau (u.tiedau@ucl.ac.uk) is a historian and digital humanist. He has worked on, and across, the boundaries of the humanities and communication technologies for most of his professional life and published widely on Belgian, Dutch and German history, as well as on distance education and digital scholarship. He is an Associate Director of the UCL Centre for Digital Humanities and held a series of R&D grants within JISC's and the Higher Education Academy's UKOER programme. He has recently been appointed as UCL Knowledge Transfer Champion for Open Access and Open Educational Resources at UCL for 2012.

Claire Warwick (c.warwick@ucl.ac.uk) is Professor of Digital Humanities at UCL, Head of UCL Department of Information Studies, Co-Director of UCL Centre for Digital Humanities and Vice-Dean: Research for the Faculty of Arts and Humanities. Her research is on the use of digital resources in the humanities and cultural heritage, social media and reading behaviour in physical and digital spaces. She has led and co-investigated numerous digital humanities research projects, including LAIRAH, UCIS, QRator, VERA, LinkSphere and INKE. She has served on the advisory boards of several digital humanities projects, chaired the *International Programme Committee for the Digital Humanities* 2009 conference, is a member of the AHRC Peer Review College and serves on the international editorial board of *Informatica Umanistica* and the *ASLIB Proceedings*. She tweets as @clhw1.

Anne Welsh (a.welsh@ucl.ac.uk) is Lecturer in Library and Information Studies at University College London and Digital Identity Manager at UCL Centre for Digital Humanities. She spent 15 years as a librarian, mainly

working in special libraries, before becoming a full-time academic. Her teaching is centred on historical bibliography and knowledge organization, and, from 2012, she will be teaching on the 'Approaches to Knowledge' core module of UCL's new BASc degree, as well as on the MA Library and Information Studies course, the MA Archives and Records Management course and the MA Digital Humanities course. Facet Publishing published her co-authored book, *Practical Cataloguing: AACR, RDA and MARC 21*, which contextualizes the new international standard – Resource Description and Access (RDA) – within general cataloguing principles in the digital era. She has chaired CILIP's Executive Briefings on RDA since they began in 2009 and is a well-known conference speaker at national and international level, including the Online Conference, Internet Librarian International and the International Federation of Library Association's Rare Books and Manuscripts Section. A former editor of Catalogue & Index, Anne is now the Assistant Editor of *Alexandria: the journal of national and international library and information issues*. She blogs regularly, http://annewelsh.wordpress.com and tweets, @AnneWelsh, as well as for @UCLDH.

Graeme Were (g.were@uq.edu.au) is Convenor of the Museum Studies Postgraduate Programme at the University of Queensland and the Director of Postgraduate Studies in the School of English, Media Studies and Art History. His recent work includes the monograph *Lines that Connect: Rethinking Pattern and Mind in the Pacific* (University of Hawaii Press, 2010) and the co-edited volume *Extreme Collecting* (Berghahn Books, 2012). His research interests include: anthropological approaches to material culture and museums, digital heritage and source community engagement, and materials and design in Pacific society.

Introduction

Claire Warwick, Melissa Terras and Julianne Nyhan

 What is digital humanities? At present, this question seems to be repeatedly asked, but seldom answered to anyone's satisfaction. It may even appear that the act of asking is, in itself, what some scholars think digital humanities are about. Nevertheless, this book does not attempt to define digital humanities or provide a theoretical discussion of our field. Instead, we have chosen to take a more practical, empirical approach to the question of what digital humanities may be, since we believe that in studying what is being done in our field, we may better understand it. The particular emphasis of this book is, therefore, the integration of digital humanities research, with practice within and beyond academia; the involvement of the general public in digital resource creation and design; and the application of digital technologies to cultural heritage. However, for those who are interested in the theory of digital humanities, there are several excellent discussions of such ideas, for example, those collected by Gold (2012) and Berry (2012).

In the following pages, we shall look at several different types of digital humanities activity associated with one digital humanities centre at University College London (UCL): the UCL Centre for Digital Humanities (UCLDH: www.ucl.ac.uk/dh). UCL is the only world-leading university – regularly ranked in the top 20 in the world and the top five in the UK (www.ucl.ac.uk/about-ucl/about-ucl-home) – to have a dedicated research centre for digital humanities and a Masters and PhD programme in digital humanities. UCLDH integrates people from a wide range of disciplines and aims to develop new research and teaching in this vibrant multidisciplinary field and to engage in a truly transdisciplinary process of knowledge exchange and creation. We are able to capitalize on UCL's world-leading

strength in information studies, computing science and the arts and humanities. UCLDH brings together work being done in many different departments and centres, including the university's library services, museums and collections. The centre's location in central London, close to the British Museum and British Library, also makes it an ideal base for collaboration with organizations outside UCL, such as museums, galleries, libraries and archives.

The centre offers a research-led MA/MSc in digital humanities (www.ucl.ac.uk/dh/courses/mamsc), allowing students who have a background in the humanities to acquire necessary skills in digital technologies, and students with a technical background to become informed about scholarly methods in the humanities. We also have a thriving group of PhD students (https://www.ucl.ac.uk/dh/courses/PhD) working on various interdisciplinary topics. UCLDH therefore provides a useful case study of many of the emerging themes in digital humanities and the way in which this growing subject area integrates research, teaching, collaboration with cultural heritage institutions, and the involvement of users and the general public in the creation, design and use of digital resources.

Our approach in this book is, therefore, specific to our experience at UCLDH. The topics we discuss are ones that are of particular interest and relevance to us: they are not the only ones possible, nor are they necessarily the most typical forms of digital humanities to be found internationally. Several of them are areas in which UCLDH is world-leading, for example, the use of social media, studies of users in digital humanities and work on image processing. What we have chosen to discuss is, thus, a sample of cutting-edge research, which may not be found in all universities or digital humanities centres. However, we aim to provide practical examples of ways in which digital humanities can be carried out, discuss some of the areas that we believe to be most important in the current research landscape and to assess their potential for future development. We have chosen an approach based on case studies, because work being carried out across UCL is very diverse. This book will, therefore, provide a selective overview of the type and range of research and teaching projects which are possible within an institutional setting, given adequate infrastructural support. In doing so, it will demonstrate the vibrancy and interdisciplinary nature of digital humanities, as a field of growing importance.

At UCLDH, we think of digital humanities as the application of computational or digital methods to humanities research or, to put it another way, the application of humanities methods to research into digital objects or

phenomena. We also believe it is essential that new knowledge should be generated in both parts of the equation – both in technical research and humanities scholarship. The following chapters demonstrate actual examples of this kind of partnership in practice. Each chapter introduces a thematic area – for example, image processing or social media – it explains why this area is important, considers current research and practice and discusses any relevant debates and controversies. We also provide comprehensive bibliographies, which we hope will point our readers towards other important texts in each subject area. Each topic is illustrated with case studies of digital humanities projects: these are either based at UCL or are produced by colleagues, collaborators, former students or researchers now in various parts of the world. These case studies can also be found on our 'Digital humanities in practice' blog (http://blogs.ucl.ac.uk/dh-in-practice/). The QR codes at the beginning of each chapter will take you to the relevant section of the blog, where you can access additional content. This will allow readers to link from them and interact with the digital material itself, for example, by transcribing a manuscript written by Jeremy Bentham or being able to manipulate 3D scanned images of artefacts in the Petrie Museum.

Digital humanities does not only happen within academia, and, at UCLDH, we collaborate widely with the cultural heritage sector beyond universities. There is often little difference between digital resources created by cultural heritage or academic institutions; they may be used in both sectors, as well as by the general public. Several of our case studies reflect this kind of collaboration: e-Curator, QRator, the Thera Frescoes, the eSAD project and Transcribe Bentham are all projects where we are working collaboratively with cultural heritage organizations, including libraries, museums and archives.

There is little point in creating digital resources in either sector if they are not used, however. We know that people use digital resources if they fit their needs, yet many digital humanities resources are still designed without reference to user requirements. This often means that expensive digital resources remain unused or unappreciated by their intended audience. In Chapter 1, Claire Warwick demonstrates why it is important to seek to understand the behaviours of humanities researchers and the users of cultural heritage resources, in the context of digital tools and resources, so that they may be designed to be more usable and sustainable in the future. She discusses different methods of carrying out such studies and shows why they should be introduced at the beginning of the project and not simply in

its later stages. She presents recommendations, based on UCLDH research, for good practice in the design of digital resources, so that they are as appropriate as possible for their users.

As well as studying users, and trying to design more suitable resources for their needs, digital resources can also integrate user-generated content, using social media and crowdsourcing techniques, as Claire Ross shows in Chapter 2. Social media has attracted millions of users, many of whom have integrated these sites into their daily work practices. Although this is sometimes seen as an ephemeral leisure activity – being on Facebook as a distraction from real work – social media is increasingly attracting the attention of academic researchers, who are intrigued by its affordances and reach. Social networks, blogs, podcasts and crowdsourcing are now central to our work in digital humanities. Because of their ease of use, they offer an opportunity for powerful information sharing, collaboration, participation and community engagement. Yet, we know too little about who is accessing and using social media and crowdsourcing applications and for what purpose, in an academic or cultural heritage context. This chapter discusses the use of social media in digital humanities research, highlights the projects at the heart of UCLDH and stresses the opportunities and challenges of utilizing such techniques, both in an academic context and to enhance community engagement.

UCLDH also has a particular strength in the use of image-based computing techniques for research in digital humanities. Although early research in our field was often dominated by text processing and language corpora, access to ever larger computational capacity and processing power now means that work concerning images is moving towards the core of digital humanities research. This area of expertise is relatively unusual in digital humanities internationally. However, it is one in which UCL excels, because of our excellent collaborations with UCL's departments of computer science, geomatic engineering, medical physics and engineering and the Centre for eResearch at Oxford, as well as access to UCL's impressive research-computing infrastructure. Three chapters in this volume, therefore, look at different aspects of work on images: digitization, image processing and the use of 3D scanning techniques in museums and cultural heritage. They discuss ways in which digital resources make it possible for users to carry out innovative research and interact in new ways with their heritage.

In Chapter 3, Melissa Terras discusses digitization – the conversion of an analogue signal or code into a digital signal or code. This is the bedrock of both digital library holdings and digital humanities research. It is now

commonplace for most memory institutions to create and deliver digital representations of cultural and historical documents, artefacts and images to improve access to, and foster greater understanding of, the material they hold. This chapter focuses on the developing role of digitization to provide resources for research within the digital humanities, highlighting issues of cost, purpose, longevity and use and providing a round-up of sources for guidelines and standards. The recent interest from, and investment by, commercial information providers is juxtaposed with institutional concerns about the creation of digital resources for the humanities.

Chapter 4 discusses the ways in which images, once digitized, can be manipulated, studied and processed. Melissa Terras shows how image-processing techniques may be used to reconstruct ancient Theran wall paintings or to help us to read ancient documents, such as the Vindolanda Tablets from Hadrian's Wall. She discusses different processing techniques and research methods and the new discoveries that these have made possible. In addition to this, Terras explores why image processing is not a commonly used procedure in digital humanities and advises on how an individual may undertake research in this area.

In Chapter 5, Stuart Robson, Sally MacDonald, Graeme Were and Mona Hess show how engineers and museum professionals can collaborate to create new knowledge, using computational techniques. They introduce the key principles, advantages and limitations of 3D scanning and look at its existing and potential applications in museums. These include the ability to record objects 'in the round' more scientifically (in order to support conservation programmes or enable close comparison of similar objects) and the potential to introduce new interpretations and to reach new audiences globally. They also discuss some of the potential issues – ethical, aesthetic and practical – that 3D interpretations raise for the museum world.

Despite the fascinating work being carried out in image-based computing at UCL, it is, of course, important to remember that digital text still offers us many exciting opportunities for new work in digital humanities, as Julianne Nyhan shows in Chapter 6. She reflects on how a digital text, created using digital humanities methodologies and techniques, tends to differ from other kinds of digital texts. She asks what the Text Encoding Initiative (TEI) is and how it can be used, and she gives an overview of the advantages and disadvantages of TEI. Current practice is evidenced by the inclusion of two case studies: the 'Webbs on the Web' project and the 'DALF' project. The chapter closes by pointing to key resources for the teaching and learning of TEI.

Given the enormous transformational potential of digital text, is there still a need for the printed book? What is the role of the librarian and bibliographer in the digital age? These are questions that Anne Welsh discusses in Chapter 7. She examines the impact of online resources on the study of the history of the book and on historical bibliography as an academic subject. As well as highlighting key digital resources, their uses and impact, this chapter considers the work that historians, librarians, conservators and other heritage professionals undertake in creating digital resources, from online catalogues and exhibitions, through to digitized texts and born-digital materials. She considers the impact of large-scale digitization initiatives, such as Google Books, and shows how the skills of the textual bibliographer remain important when working with digital resources.

We hope that this book may be used to support teaching and learning in the digital humanities and, as a result, felt it was important to include a chapter that is concerned with such matters. In Chapter 8, Simon Mahony, Ulrich Tiedau and Irish Sirmons discuss open access educational resources: a new initiative to make teaching materials available in digital form. They take, as their example, two projects at UCL: one in a traditional humanities subject – Dutch – and one in digital humanities itself. They show that the digital medium not only makes possible sharing and crowdsourcing of material for humanities research and in cultural heritage domains, but that learning objects can now be shared and repurposed by teachers, as well as enriching the experience of learners. Material from our new MA/MSc in digital humanities at UCL will form part of this new initiative.

The balance between the various activities undertaken in digital humanities: teaching and learning, research, resource creation and technical support, is an important issue that Claire Warwick discusses in Chapter 9, where she reflects on the institutional contexts in which digital humanities takes place. The model that we chose for UCLDH is highly innovative, since it is the hub of a large network, connecting digital humanities activity throughout UCL and beyond. However, this chapter also considers what we can learn from studying the models on which digital humanities centres and programmes have been run in the past and what these may mean for the future of the discipline. In this context, it is also important to discuss the institutional environment in which digital humanities takes place, in terms of prestige, management support, career progression of researchers and the importance of communicating what we do in digital humanities to others. Given the huge growth in digital humanities globally, it is important that we

discuss such issues now, so that recommendations for good practice may be made to support the future of the discipline.

This book presents a discussion of several different ways in which digital humanities may be practised. It also demonstrates the potential of the digital medium to allow us to make connections between one small centre in a single university in the UK and numerous other researchers, practitioners, and teachers and learners, whether in libraries, museums, archives or in other academic institutions in the UK and internationally. Digital humanities is a field undergoing huge growth and, thus, inevitably, huge change. The danger inherent in trying to define what such a field might be is that either such a definition becomes rapidly outdated or it becomes unnecessarily restrictive and limits the potential of the discipline to mutate and include new areas of interest and collaboration. Our aim, in this book, is to discuss some examples of digital humanities, as it currently exists, and suggest some of the ways that its potential may be realized, both now and in the future, wherever it is practised.

References

Berry, David M. (2012) *Understanding Digital Humanities*, Palgrave Macmillan.

Gold, Matthew K. (ed.) (2012) *Debates in the Digital Humanities*, University of Minnesota Press.

CHAPTER 1

Studying users in digital humanities

Claire Warwick

Introduction

 Until relatively recently, it was unusual to study users in digital humanities. It was often assumed that the resources created in digital humanities would be used by humanities scholars, who were not technically gifted or, perhaps, even luddites. Thus, there was little point asking them what they needed, because they would not know, or their opinion about how a resource functioned, because they would not care. It was also assumed that technical experts were the people who knew what digital resources should look like, what they should do and how they should work. If developers decided that a tool or resource was a good one, then their opinion was the one that counted, since they understood the details of programming, databases, XML and website building. The plan, then, was to provide good resources for users, tell them what to do and wait for them to adopt digital humanities methods.

Frustratingly, potential users seemed stubbornly to resist such logic. The uptake of digital resources in the humanities remained somewhat slower than in the sciences. As I have argued elsewhere, the numbers of articles in journals, such as Computers and the Humanities (CHUM) and Literary and Linguistic Computing (LLC) in the 1990s and early 2000s, complaining about why traditional humanities scholars did not use digital humanities techniques or suggesting techniques they might use, grew heavily to outnumber those reporting on the actual adoption of such techniques in the mainstream (Warwick, 2004). Lack of knowledge was sometimes advanced as a possible reason for lack of engagement. During this period, very large amounts of money were spent on initiatives to publicize digital resources for humanities research and teaching. In the UK, this included the Computers

and Teaching Initiative (CTI) (Martin, 1996), the Teaching and Learning with Technology Programme (TLTP) (Tiley, 1996) and the Teaching and Learning Technology Support Network (TLTSN) (Doughty, 2001); the Arts and Humanities Data Service (AHDS: www.ahds.ac.uk) also had an advice and outreach role, as well as its core function of data preservation. None of these are now in existence; funders did not feel they had proved sufficiently successful to continue supporting them. Many university libraries and computing services also offered training courses in the use of digital resources for humanities scholars. Yet, the rate of change remained stubbornly slow. Funding bodies also supported digital resources for humanities scholars, with little thought to, or predictions about, levels of possible use because they did not know how such predictions might be made. Such resources often cost hundreds of thousands of pounds, so there was a risk of a severe waste of money and of academic time and energy if a funded resource was then not adopted.

In the late 1990s, a few of us began to wonder if there might be another cause for the lack of adoption of digital humanities resources. Could it be that users did not adopt resources because they were not useful or did not fit what they would like to do as scholars? Could there be other reasons to do with design, content, presentation or documentation? Initially, I suggested that digital resources available in the late 1990s did not fit the predominant research method of humanities scholars, which is complex reading (Warwick, 2004). Later, empirical studies on the way humanities scholars interact, or fail to interact, with digital resources allowed us to test this hypothesis. This chapter presents an overview of the findings of such work, arranged thematically.

What we know about humanities users

Despite some erroneous perceptions in both digital humanities and the computer industry, we know a significant amount about how humanities scholars use information, whether digital or not. Since Stone's pioneering article in the early 1980s (Stone, 1982), numerous studies of information needs, and some of information behaviour, have been published, both of the humanities as a field and of individual disciplines (Warwick, Terras, et al., 2008). As we have argued in more detail elsewhere (Warwick, Terras, et al., 2008), these suggest that humanities scholars are not luddites; they simply behave differently from scientists, and many social scientists, when interacting with physical and digital information. Humanities scholars tend

to avoid performing systematic keyword searches, although most information systems and digital resources assume this. Instead, they will follow footnotes in texts they are reading (what Ellis calls chaining (1993)) or browse for information. They may even do what Bates calls 'berry picking' – in other words, select interesting pieces of information that are particularly germane to the argument they want to make, rather than citing everything written on the subject (Bates, 1989, 1). (We might speculate that this may also become more common in science in the future, when the sheer number of articles published every year exceeds the researcher's ability to read them all.) They also need a greater range of information, in terms of publication date and type: instead of reading journal articles from the last five years, they may need to consult printed books or manuscripts that are hundreds of years old, as well as images, film, music, maps, museum artefacts and various different types of historical source material (Barrett, 2005). They do not expect to solve a research question comprehensively, but to reinterpret the sources and revise the findings of others: after Crick and Watson, no one tried to redefine the structure of DNA, but articles about *Hamlet* will probably always be written. They often reread or re-examine sources in a complex, immersive way, rather than searching digital documents for factual information.

It is evident, therefore, that humanities scholars have different information needs, both on- and offline, than scientists. They are a problematic population to design for, and the field lacks the financial clout of Science, Technical Engineering and Medicine (STEM) subjects, so funding to create resources for their needs is less plentiful and may seem less profitable for commercial publishers. It is, therefore, not surprising that, until recently, most resources have been designed for the majority of users who are not from the humanities. Yet, we might argue that the way they use digital resources is, in fact, closer to the way that the average, non-academic user interacts with digital or printed information. Most of us read for pleasure, may consult a wide range of information resources and don't conduct systematic keyword searches of recently published scientific literature; thus, a study of humanities user needs may also produce important results relevant to non-professional digital resource use.

How to study users

There are numerous methods for studying users, most of which have been developed in the fields of Human-Computer Interaction and Information Studies. There are also many excellent texts describing, in detail, how these

may be carried out, for example, Shneiderman and Plaisant (2009), Blandford and Attfield (2010) and Ruecker, Radzikowska and Sinclair (2011). Our approach at UCLDH has been to use a variety of methods, most of them designed to be as naturalistic and unintrusive as possible. Our overall approach is to study use in context; that is, to study what people do in their real life or work activities. This means that we prefer to visit someone in their office (or, in one case, an archaeological dig) and ask them to carry out a real research activity using a digital resource, rather than asking them to perform a set task in an interaction lab. We have used task-based lab testing for some research projects, but, in general, prefer to adopt as naturalistic an approach as possible to avoid the user's behaviour being prejudiced by unfamiliar conditions.

Our approach to studying users is to involve them, if possible, from the beginning of the project. Too often user testing, both in academic projects and industry, is left until late in the project; users are only asked for their opinion when the resource is built and a prototype is being tested. This may work, if the users like what has been built for them. However, if they do not, and feedback suggests radical change is necessary, there may not be sufficient funding, time or goodwill from developers to make such modifications. In such cases, the resource either remains unmodified or different researchers may be called in to conduct other tests, in the hope that they will find what the developers want them to discover, not report what users actually need. This is a very dangerous strategy, for reasons that I shall discuss below.

Thinking about use before a resource is built means studying the users, not the resource; this may be achieved using various methods. We have used interviews to determine what scholars like and dislike about digital resources and how they use information, and we have observed them using existing digital resources. We have asked them to keep diaries of their use of information and digital technologies over periods varying from between a day and a week (Warwick, Terras et al., 2009). This allows us to identify patterns of, and problems with, information usage, about which we can subsequently interview users. We have used surveys and questionnaires about the use of existing resources. We have interviewed the creators of existing, successful resources to see whether it is possible to identify any common features, in terms of design, creation or documentation (this is an unusual approach, and we believe we are the only team to have employed it in digital humanities; but it is an approach that we found very instructive during the Log Analysis of Internet Resources in the Arts and Humanities

(LAIRAH) Project) (Warwick, Galina, et al., 2008). All of these methods allow us to build up a picture of what users like and dislike, what they want to do and what they currently cannot achieve. This is then fed back to design teams to inform initial design and prototype ideas.

When initial ideas are being developed, it is also possible to use models, such as Ruecker's affordance strength model (Ruecker, Radzikowska and Sinclair (2011): Chapter 3), which allows us to test the potential functionality of a prototype design against some possible uses. At a slightly later stage in development, we can use wire frames and design sketches to run user focus groups. We have also conducted workshops, where users are asked to investigate different digital resources, record their views on paper and then take part in a subsequent focus group discussion. During the LAIRAH project, for example, we presented users with a mixed sample of resources that were either known to be used or neglected, without identifying them, asked them to speculate on which ones where used and comment on their reasons for saying so. This was then followed by a focus-group discussion. This proved a useful way to limit the bias inherent in focus groups, when one or two vocal members of the group may dominate and, thus, skew results. Subsequent examination of the written responses showed that users were willing to be more positive about some resources in writing, than they were in group discussions.

This variation between what people may say to others and what they will record in private is the reason why it is important to use a variety of different methods in user studies. It is well known that interviewees may say what they think someone may wish to know; thus, they may be more forthcoming if asked to fill in a survey or write down responses to a hands-on workshop session (Smith and Hyman, 1950). This is also why we have used quantitative data from web log analysis, since reported use may differ from what logs record, which may also be attributable to the interviewer effect. In the days before logging software, such as Google Analytics, was routinely used, very few projects or, even, institutions, such as libraries, had any reliable indication of which resources were used. Log data allowed us to determine that up to one-third of digital resources in the humanities remained unused (a very similar level to that of printed material in libraries) (Warwick, Terras et al., 2008) and to indicate the kind of material most commonly searched for. Log analysis can also indicate whether certain parts of a resource are used more often than others and whether this is related to content or design problems (the more clicks away from the index page, the less likely it is that users may find material, for example) (Huntington et al., 2002).

Of course, conducting user studies adds to the cost of developing digital resources. The time required to undertake such activities, especially if they last throughout the project, is considerable. Some projects have, instead, chosen to make use of personae or use cases. Some designers create indicative personae of typical users, giving them names, ages and occupations, and thus suggesting the uses that such a person might make of a resource (Jane is a secondary school teacher in her 30s. She wants to use a museum website to construct some new assignments about Roman food for her year 11 class on classical civilization, for example) (Grudin and Pruitt, 2002). Personae can be a useful tool, if they are constructed as a result of the kind of user studies mentioned above. However, if they are used as a substitute, there is a danger of a kind of self-fulfilling prophecy of use, where functionality is designed for the kind of users the designers want or can imagine. Yet, they cannot be sure that this is the kind of user that the resource will actually attract or that these predicted difficulties are the kind of difficulties that imagined users might face.

Use cases consist of reports of how a user, or small group of users, is using a given resource or one that is very similar. These are often used to make the case to develop something new or to argue that certain types of interface or functionality may be useful. Once again, these may be used as part of a multimethod user study, as evidence of real usage (Keating and Teehan, 2010). However, if used in isolation, the picture of use may be very partial, unless a very large number of use cases are collected. The behaviour of expert users or early adopters may also be very different from that of a majority of users, yet it is often the interested experts who furnish the use cases. As a result, the need for complex, specialist functionality, or the general enthusiasm in the user population for the resource, may be overstated. Use cases and personae should, therefore, be used with care in a multimethod user study, and should never be a substitute for other, more time-intensive methods.

Luddites or critics?

Despite the popular image of the luddite humanities scholar who does not know what they need or how to use it, we have found that users have very complex models of their information needs and environment; they are thoughtful and critical about the affordances of physical and digital resources. This may help to explain why e-journals have been such a success, and e-monographs are still not widely used. Users are aware that a journal

article and a book are used in very different ways, even if they do not articulate this until asked. Thus, most of us still prefer to read a book in print, because it is more convenient, but are happy to read a short article on screen or print out a longer one. We also found that humanities users had complex ways of evaluating physical information resources and could tell, simply from the design, publisher or even size of a book, whether it was likely to be useful. It is still difficult for users to find digital analogies for such skills, however, and it remains an important challenge for creators of large digital resources to design tools that will allow users to orientate themselves digitally as well as they can in a physical library. This is the reason for tools such as Amazon's 'user recommendation systems' (users who bought this, also bought ...), but it is far more difficult to deploy such metaphors in an academic setting. Even the question of extent of collections is problematic; physical library users can see how big the shelf is that they are looking at and how many of them there are in a library. It is still very difficult for users to estimate how large a digital resource is and, thus, how comprehensive the results set from their search may be and how much further they need to explore. This is important for humanities users, who value recall over precision and expect to find about 90% of the results from a given search familiar. Nevertheless, we should not assume that humanities users always prefer physical to digital information resources. Users we have studied have found the convenience of digital information delivery as important as those in any other discipline and expressed considerable enthusiasm for the use of digital resources and methods. Difficulties caused by a badly designed interface to a digital collection were no more significant than a library or archive that was cold, cramped, dark or uncomfortable or an unhelpful member of staff. However, they were more likely to put up with difficult physical conditions than persist with a disappointing digital resource. It would seem ridiculous to a humanities scholar to refuse to return to a physical library if a book they hoped to find was not stocked, yet I have often heard digital resources dismissed outright if the contents were not as expected. It is difficult to tell whether this is something inherent in the nature of physical and digital information resources or whether, like the question of transferring information skills from physical to digital libraries, it is a problem of relative unfamiliarity on the part of users and signals the need for further refinement of the digital resource design. We may only find the answer to this question by repeating studies over time and trying to determine whether, and how fast, attitudes change. It is not, however, necessarily a function of being a digital native or immigrant; indeed, a recent

study suggests that there is no empirical basis for such assumptions. Rowland's research suggests that the information literacy of even, what he calls, the 'Google generation' is relatively unimpressive (Rowlands et al., 2008, 1). We found that even students who have been trained in information-seeking skills will give up as soon as they have a minimal level of information to complete a task and that they use their relative expertise to determine how little searching is necessary in a given situation, rather than conducting more complex searches to find a more complete result set. If the results of a search seem too complex to evaluate, they may even alter their query to achieve a simpler, less demanding answer. We cannot, therefore, assume that once a younger generation of scholars arrives, their ability to interact with complex digital information will necessarily improve.

Finding and using digital information seems to have something to do with how important it is to users. Students may not gain expertise gradually, however. The difference noted in the skill levels of young legal professionals, who may only be a few years older than our student sample, is probably because the information tasks they faced at work were more complex and urgent and forced them to suddenly acquire more expertise. However, it does help to explain an interesting phenomenon we found during the LAIRAH project, when we discovered that humanities scholars could be very easily deterred from using digital resources. Numerous factors caused this: confusing interfaces, problems with navigation or searching, a need to download data and use it with another application, content that was incomplete, not extensive enough, of poor quality or not as expected (for example, if a literary resource did not contain appropriate editions, it was considered unacceptable to many users). Yet, we found that if a research task is vital to the individual, and they are convinced that a resource will deliver high quality information, they will persist with a digital resource and force themselves to learn new skills or struggle with a difficult interface or functionality. Thus, we found that some linguistic resources were reported to be very useful, even if poorly designed, dated and difficult to use, because there was nothing better available for specialists in that field. The problem is that the proportion of such determined and persistent users appears to be quite small.

It has become clear to us, however, that most users will be quick to abandon resources whose quality they are concerned about. This is partly as a result of minor problems that could be relatively easily avoided. Our study of successful digital resources, during the LAIRAH project, suggested that even the name of the resource could make a difference to use. If someone is searching for census data, they may not also think to use the term

'enumerator returns', and, unless there is very complex metadata, or semantic searching is possible, a resource with a confusing or unusual title may not, therefore, be found. The possible uses of digital resources designed by technical or academic experts were often not evident to potential users. Not everyone, for example, knows what Geographical Information Systems (GIS) are or how they might be employed. This is not a problem for the dedicated expert user, but may mean that a, potentially, much larger audience fails to understand the potential use of some resources (Warwick, Terras, et al., 2008). This is part of what we have called the 'designer as user problem' (Warwick, Terras et al., 2008). If digital resources are created by academic or technical experts and user testing is not carried out, the assumption tends to be made that the users of the resource will be just like the creators. The academic creator may assume that everyone will understand what the resource is for and what it contains without much explanation, because it is obvious to them. They may also assume (possibly abetted by technical staff) that complex functionality and search capability is needed to make the resource usable and if they can learn to use such functionality, then anyone can. It may be, however, that most people do not need, or perhaps even like, the complicated functionality and, perhaps, difficult interface necessary to make this possible (Warwick, Galina, et al., 2008). The simple, Google-like search box has become a standard way that users expect to interrogate most collections of information; this is partly because it works. Most users, especially humanities academic users, do not want to have to be trained to use digital resources, regarding it as a waste of time. Some librarians have even alleged, strictly off the record, that they suspect academics do not want to admit ignorance, especially in front of their students, and that this may be a more profound reason for their antipathy to training (for obvious reasons, a source for this cannot be cited). Most technicians, librarians and commercial publishers who market resources at librarians seem to believe that it is important that all resources must have an advanced search function. In fact, numerous studies have shown that most people never use this function (Rieger, 2009). It is, therefore, clear why the model of designer-as-user is not advisable. It may lead to the creation of a resource that is needlessly complex, expensive in developer time, potentially not what users want, and, therefore, at serious risk of being under-used as a result.

..
CASE STUDY The LAIRAH Project: log analysis of internet resources in the arts and humanities
..

Claire Warwick, Melissa Terras, Paul Huntington, Nicoleta Pappa, and Isabel Galina, UCL Department of Information Studies

The aim of the LAIRAH survey is to discover what influences the long-term sustainability and use of digital resources in the humanities through the analysis and evaluation of real-time use. We utilized deep log analysis techniques to provide comprehensive, qualitative and robust indicators of digital resource effectiveness. Our aims were to increase understanding of usage patterns of digital humanities resources, aid in the selection of projects for future funding and enable us to develop evaluation measures for new projects. Until we carried out our research, evidence of actual use of projects was anecdotal; no systematic survey had been undertaken, and the characteristics of a project that might predispose it for sustained use had never been studied.

Methods
Phase 1: log analysis

The first phase of the project was deep log analysis: we were the first team ever to analyse web transaction logs to measure user behaviour within digital humanities resources. Transaction and search log files were provided by three online archives that were supported by the Arts and Humanities Research Board (AHRB) (now the Arts and Humanities Research Council (AHRC)): the Arts and Humanities Data Service (AHDS) Arts and Humanities Collection, Humbul Humanities Hub and the Artefact Database for the Creative and Performing Arts. These provided rich data for comparing metrics between subject and resource type. The search logs showed which resources users were interested in and which ones users subsequently visited.

We analysed at least a year's worth of transaction log data (a record of webpage use automatically collected by servers) from each resource. This data provided a relatively accurate picture of actual usage, providing: information on the words searched (search logs), the pages viewed (user logs), the website that the user has come from (referrer logs) and basic, but anonymous, user identification tags, time and date stamps.

Phase 2: case studies

We selected a sample of 21 projects that the log analysis indicated to have

varying levels of use – chosen to give us coverage of different subject disciplines – to be studied in greater depth. We classified projects as 'well used' if the server log data from the AHDS and Humbul portals showed that they had been repeatedly and frequently accessed by a variety of users. We also mounted a questionnaire on these sites and asked which digital resources respondents found most useful. Although most users nominated information resources, such as libraries, archives and reference collections, such as the eDNB, three publicly funded UK research resources were mentioned, and, thus, we added them to the study. We also asked representatives of each AHDS centre to name which resources in their collections they believed were most used. In the case of Sheffield University, the logs showed that a large number of digital projects accessed were based at the Humanities Research Institute (HRI). We therefore conducted interviews about the HRI and its role in fostering the creation of digital humanities resources.

The projects were studied in detail, including any documentation and reports that could be found on the project's website, and a representative of each project was interviewed about project development, aims, objectives and their knowledge of subsequent usage. We analysed each project's content, structure and design. We asked whether it undertook any outreach or user surveys and how the results of surveys were integrated into project design. We also asked what kind of technical advice the project received, whether from institutional support people, from humanities computing centres or from central bodies, like the AHDS. All these measures are intended to determine whether there are any characteristics shared between 'well used' projects.

We also studied projects that appeared to be neglected or underused. A small group of humanities users were asked to investigate a sample of digital resources: half were well used and the others neglected, but their status was not initially revealed. A hands-on investigation was followed by a discussion of factors that might encourage or deter future use of such resources. We aimed to find out whether their lack of use was because users had not heard of a given resource or whether there were more fundamental problems of design or content that would make the resource unsuitable for academic work.

Findings

We found that roughly one-third of all projects appeared to be unused. When asked to evaluate unused resources, users were able to identify several problems with design and content. They were deterred from use because of unintuitive interfaces, the need to download data for use in another application, confusion

as to what the content might be used for and even a confusing name. They also needed more information about the content of resources, how and why it had been selected and the expertise of the project team.

Well used projects did share common features that predisposed them to success. The effect of institutional and disciplinary culture in the construction of digital humanities projects was significant. We found that critical mass was vital, as was prestige within a university or the acceptance of digital methods in a subject field. The importance of good project staff and the availability of technical support also proved vital. If a project is to be well used, it was also essential that information about it should be disseminated as widely as possible. The single most common factor in use of a project was a good dissemination strategy. Even amongst well used projects, however, we found areas that might be improved: these included organized user testing, the provision of, and easy access to, documentation, and the lack of updating and maintenance of many resources.

Recommendations

Digital humanities projects should undertake the following actions:

1. Keep documentation and make it available from the project website, making clear the extent, provenance and selection methods of materials for the resource.
2. Have a clear idea of whom the expected users might be; consult them as soon as possible and maintain contact through the project, via a dedicated e-mail list or website feedback.
3. Carry out formal user surveys and software and interface tests and integrate the results into project design.
4. Have access to good technical support, ideally from a centre of excellence in digital humanities.
5. Recruit staff who have both subject expertise and knowledge of digital humanities techniques, then train them in other specialist techniques as necessary.
6. Maintain and actively update the interface, content and functionality of the resource, and do not simply archive it.
7. Disseminate information widely, both within specialist subject domains and in digital humanities. ■

Trust

As we have seen, users need as much information about a resource as possible to understand what it might be useful for. However, underlying much of our research on users is the issue of trust in digital resources and technologies. The more information users can find about a resource, the more they are likely to trust it. As discussed above, humanities scholars have a complex repertoire of information skills that allow them to evaluate traditional information resources. These have grown up over several hundred years of the development of printed academic resources (Vandendorpe, 2009). A prestigious journal name or book publisher tells us that the content has been peer reviewed by other academic experts. Footnotes or references in the text reassure us that the writer has compared their findings with other work in the field and researched other sources. The academic affiliation of the author tells us about their expertise and standing in the field. The methodology of an article tells us how the work has been conducted, for example, how data was selected, sampled and analysed. Digital resources are only beginning to find ways to provide such information. In the LAIRAH report recommendations, we suggested that all digital resources should have a top-level link called 'About this Project', or something similar, under which creators should provide as much information as possible about its purpose and how it might be used; what its contents are and how comprehensive they are; if selections have been made from a larger corpus, how this has been done, why, and who has done so; who created the resource and where they are based; how technical decisions were made, for example, about the markup or metadata schema. The more effectively this is done, and the more easily it can be accessed, the more users are likely to trust digital resources. This is likely to become even more important in the near future. The UK's Research Excellence Framework will now allow digital resources to be submitted in all subject areas and not simply the publications written about them (Higher Education Funding Council for England, 2011). As a result, it will become even more vital that we gain a sense of the rationale for the choices made in the course of digital resource construction, so that assessors can make informed decisions about resource quality and impact in the wider world.

At present, however, trusted brands are very important. Many digital resources that are most familiar to users, such as e-journals or large digital reference collections, are produced by commercial publishers, who make significant investments in testing the appearance and functionality of their resources. This is also usually the case with digital resources in major

cultural heritage organizations, such as museums and galleries. This means that the standard of resource that academic users expect is often higher than most academic projects can manage, especially for interface design. This, coupled with the brand identity of museums and major publishers, reassures users about the quality of the content.

A pioneering study showed that visitors to websites make judgements about them in fractions of a second. We appear to make up our minds about digital resources too quickly to perform a conscious critical evaluation of it: our gut instinct tells us whether it looks 'right'. If users sense that something looks 'wrong' – which may simply mean that the interface looks unfamiliar, is difficult to use or lacks information about its creation and provenance – users may regard it as untrustworthy, neglect it and revert to more familiar resources, whether printed or digital (Warwick, Terras et al., 2008). This demonstrates why those creating digital projects must design a resource that works easily and looks as impressive as possible. The only way to do this, other than being lucky, is to carry out proper user testing.

One of the reasons users think that resources look 'wrong' is if they seem dated. If they try to use a resource and parts of it no longer work – links are broken, for example – they will lose yet more trust. Commercial resources are updated constantly, to make sure that information is current and the interface functional and consistent with current design trends. The problem for many digital resources based in the academic and cultural heritage sectors is that there may no longer be any funding to perform such updating if the content is freely available and was funded by a fixed-term grant. As we have seen, if users do not feel that a resource is to be trusted, because it appears to be dated, they are reluctant to use it. This is a waste of the (probably) very large amount of money that was spent on its creation. Institutions have only recently begun to develop strategies to deal with this problem.

This is especially serious for resources that involve crowdsourcing or web 2.0 technologies, where users become an integral part of the research process. For example, the award-winning Transcribe Bentham project, discussed in Chapter 2 of this volume, was funded by a short research grant. However, at the end of its funding period, over 1000 people had already taken part in transcribing manuscripts and become part of a thriving user community. Since this project is an important vector for engagement between UCL researchers and the public, to have closed it and locked out all our volunteers would have been disastrous and contrary to everything that UCL believes in, in terms of outreach and openness. As a result, short-term

internal funding had to be provided, while further external funds were sought. UCL recognizes the need both to maintain the infrastructure and to continue the activity with which it is engaging volunteers.

Longitudinal studies

Change over time is not something that is very often considered in terms of user studies. They are often carried out at particular points in time, and significant longitudinal studies are relatively rare. There tends to be an assumption, therefore, that user views of digital resources are somewhat fixed. In digital resource creation, one important principle that should be followed, if at all possible, is a cycle of user testing and feedback. Once tests have been carried out and modifications made, it is important to feed back to users what has been done in response to their views. This can either be done by direct communication, in the form of a change log or development blog on the website; an end of project workshop; or another written form of communication with the user community, such as an online newsletter or progress report. An iterative development cycle is, in itself, a useful way to communicate with users. If, for example, a focus group has been carried out to ascertain users' views of wireframes or design sketches, then a hands-on session with a prototypical system not only helps to indicate whether views initially expressed are true in a working version, but shows that the development decisions taken reflect initial users' views. Users like to be able to see that changes have been made as a result of their input and will often be very supportive of something that they helped to create. Our work on the VERA Project was an excellent example of this. The following case study gives the full details of the project, our part in which was to study the way that archaeologists use digital technologies in the field, especially to record what they have found.

··
CASE STUDY The VERA Project
··

Claire Fisher, British Museum, Melissa Terras, UCLDH, and Claire Warwick, UCLDH The Virtual Environments for Research in Archaeology (VERA) Project was funded as part of the Joint Information Systems Committee (JISC) and involved the Department of Archaeology and the School of Systems Engineering at the University of Reading, the York Archaeological Trust and the School of Library, Archive and Information Studies at UCL. The project was based around the

University of Reading's well established excavation at the Roman site of Silchester. The Silchester *Insula IX* project (www.silchester.rdg.ac.uk/index.html) provided the ideal test-bed for a Virtual Research Environment (VRE) project, because key to the smooth running of this large, urban excavation was the Integrated Archaeological Database (IADB, www.iadb.org.uk/index.htm). Used for recording, analysis, archiving and online publication of archaeological finds, contexts and plans, the IADB allows integrated access to all aspects of the excavation record. It was used to populate the VRE with data generated by a complex urban excavation.

The VERA Project set out to:

1. Investigate how digital input could be used to enhance the process of documenting, utilizing and archiving excavation data.
2. Create a suitable Web portal to provide an enhanced user experience.
3. Develop tools that could be integrated with existing practices of research archaeologists unfamiliar with VREs.
4. Test the tools in a real world setting.

UCL's role was to ensure that the needs of the archaeologists and associated specialists remained at the heart of developments.

The VERA IADB usability study was carried out at the 2007 VERA winter workshop at Reading. The development of the IADB has always been driven by its users and has developed alongside their working practices. However, this was the first time that user reactions to the IADB had been formally documented. Participants at the workshop were divided into two groups:

- those with no (or little) experience of using the IADB, designated 'novice users'
- those who have experience of using the IADB in their work, designated 'experienced users'.

The usability study provided the team with useful information about user perceptions, plus details of the typical tasks carried out by archaeologists and associated specialists. The novice users felt that they could quite quickly get to grips with the system; the experienced users carried out a wide range of tasks using the IADB and used it at (almost) all stages of various projects.

The Silchester project utilizes the skills of a large and geographically dispersed group of specialists. Each specialist uses the IADB for varying purposes, and one of the aims of the VERA Project was to enhance the ways in which each

researcher uses it. Interviews were carried out to explore how the existing users organize their work; to discuss their experiences of working with the IADB; to find out to what extent the IADB met their needs; and if any changes might make their work easier. The results from these interviews were used and fed into IADB development.

Excavation data has traditionally been entered into the IADB through manual digitization, usually once the excavation season is over. A key aim of the VERA Project was to investigate the use of information technology (IT) within the context of a field excavation and to ascertain whether it may be appropriated to speed up the process of data recording, entry and access. From 2005 onwards, a number of field trials had been carried out at the Silchester excavation, using a variety of digital recording methods, including digital pens and notebooks and hand-held internet browsers. The 2008 field season focused on the use of digital pens for direct digital data gathering. We used fieldwork observations, user needs discussions, a diary study and an end-of-season questionnaire to analyse user reactions to the digital pens.

We aimed to observe how well the digital pens fitted in to the workflow of the site and to record user feedback. The discussions provided the framework for creating the end-of-season review for the digital pens. A diary study was used to gather information about different archaeological roles and the way that they are supported by both digital and analogue technologies. These studies allowed the VERA team to explore how the implementation of new technology affected the workflow of the site. Lessons learnt included the central role of the traditional context-recording sheet and the need for any new technology to integrate with existing workflows. ■

Responses to the new technology

Introducing new ways of working into well established systems can be problematic, especially if the changes include the introduction of unfamiliar technology. UCL's involvement in the VERA Project illustrates how user case studies, analysis and feedback were used to develop recording systems and virtual research environments that fit into the current workflow of archaeologists and associated specialists.

The digging season was short – six weeks in the summer of each year – and we studied the dig for three years. This gave us an unusual opportunity to study change over time. Initially, digital methods were only trialled in a small part of the site. We found that they therefore seemed risky and abnormal to most people, and, thus, the methods, and we, were treated with

suspicion. Most people were relatively negative about the use of digital technologies – such as digital pens and paper – for finds recording, as opposed to traditional printed context cards. They also felt they had suffered from a lack of training. The following year, digital technologies, predominantly digital pens, were used throughout the site, and we provided training in their use, as well as feedback on what we had learnt the previous year. Diggers became more positive and began to understand the aims of the study, becoming more open to possible changes. In the final year, further improvements were made to the way digital data was entered and maintained as a result of user feedback, and, when other technologies, such as GPS, were introduced, they were adopted much more readily than we might have expected. Users could understand how their feedback had been integrated into the use of technology and that while systems were not perfect, they had improved, and we had made every effort to act upon user comments as far as possible. As a result, they became noticeably more positive about the use of digital technologies in each year of the study. This shows how important it is that users can see how their feedback has been used to improve a system: if they can see progress, it appears that they will make an effort to support the system they created. If it is not exactly what they would have wished, they will make an effort to deal with pragmatic decisions, if they can understand the reasons for them. In the case of Silchester, they understood that the cost of producing a fully digital recording system would have been prohibitive and were, thus, willing to work with a compromise – a semi-digital solution, which, nevertheless, resulted in faster, more accurate data entry than had been possible using manual recording.

Conclusion

It is clear, therefore, that we cannot, and must not, try to tell users what they ought to like, need or use. We also cannot expect people to abandon working practices instantly when they have suited them well over many years and, in some humanities fields, generations. As we saw at Silchester, if users are consulted, and researchers take the time to understand their working culture and how digital resources fit into it, there is the possibility that attitudes to, and levels of, digital resource use may change. However, we must ensure that users know what they need, to complete their work successfully. If digital resources fit well with what they want to do with them, users will adopt them. Attitudes to digital resources have changed massively in the last

decade, with far greater use of the internet for information seeking and the widespread uptake of resources, such as digital reference resources and e-journals. This is surely because they fit well with what humanities academics would like to do. For example, e-books have recently become more popular, because a new generation of digital reading devices are as light as a paperback, with screens that are more comfortable to read from than earlier e-readers. Thus, users are far more likely to adopt them, because they fit well with their usual reading behaviour and have notable advantages, such as the ability to carry several hundred 'books' in a small, light device.

The aim of those of us designing resources in digital humanities, therefore, remains analogous to this. We must understand the needs and behaviours of users. As a result of this understanding, we must design resources that fit well with what our users already do, while providing advantages in terms of convenience, speed of access, storage capacity and innovative information tools that digital publication affords. If we do so, there is every chance that such resources will be used and will help to make possible new kinds of scholarship that would be inconceivable without digital content, tools and delivery mechanisms.

Bibliography

Attfield, S., Blandford, A. and Dowell, J. (2003) Information Seeking in the Context of Writing: a design psychology interpretation of the 'problematic situation', *Journal of Documentation*, **59** (4), 430–53.

Barrett, A. (2005) The Information Seeking Habits of Graduate Student Researchers in the Humanities, *The Journal of Academic Librarianship*, **31** (4), 324–31.

Bates, M. (1989) The Design of Browsing and Berrypicking Techniques for the Online Search Interface, *Online Information Review*, **13** (5), 407–24.

Bates, M. (1996) Document Familiarity in Relation to Relevance, Information Retrieval Theory, and Bradford's Law: the Getty Online Searching Project Report No. 5, *Information Processing & Management*, **32** (6), 697–707.

Bates, M. (2002) The Cascade of Interactions in the Digital Library Interface, *Information Processing & Management*, **38** (3), 381–400.

Blandford, A. and Attfield, S. (2010) *Interacting with Information*, Morgan & Claypool.

Blandford, A., Rimmer, J. and Warwick, C. (2006) *Experiences of the Library in the Digital Age*, http://www.uclic.ucl.ac.uk/annb/docs/abjrcwCCDTpreprint.pdf.

Brown, S., Nonneke, B., Ruecker, S. and Warwick, C. (2009) Studying Orlando's

Interfaces, paper presented at *SDH/SEMI 2009*, Carleton University, Ottawa, Canada.

Brown, S., Ross, R., Gerrard, D. and Greengrass, M. (2007) *RePAH A User Requirements Analysis for Portals in the Arts and Humanities*, Arts and Humanities Research Council.

Doughty, G. (2001) *Teaching and Learning Technology Support Network*, www.elec.gla.ac.uk/TLTSN/.

Ellis, D. (1993) A Comparison of the Information Seeking Patterns of Researchers in the Physical and Social Sciences, *Journal of Documentation*, **49** (4), 356–69.

Grudin, J. and Pruitt, J. (2002) Personas, Participatory Design and Product Development: an infrastructure for engagement, *Proceedings of Participation and Design Conference (PDC2002)*, pp. 144–61, http://research.microsoft.com/en-us/um/people/jgrudin/.

Higher Education Funding Council for England (2011) *Assessment Framework and Guidance on Submissions*, HEFCE.

Huntington, P., Nicholas, D., Williams, P. and Gunter, B. (2002) Characterising the Health Information Consumer: an examination of the health information sources used by digital television users, *Libri*, **52** (1), 16–27.

Jones, C., Ramanau, R., Cross, S. and Healing, G. (2010) Net Generation or Digital Natives: is there a distinct new generation entering university?, *Computers and Education*, **54** (3), 722–32.

Keating, J. and Teehan, A. (2010) Appropriate Use Case Modeling for Humanities Documents, *Literary and Linguistic Computing*, **25** (4), 381–91.

Lindgaard, G., Dudek, C., Fernandes, G. and Brown, J. (2005) Attention Web Designers: you have 50 milliseconds to make a good first impression, *Behaviour & Information Technology*, **25** (2), 115–26.

Makri, S. Blandford, A., Gow, J., Rimmer, J., Warwick, C. and Buchanan, G. (2007) A Library or Just Another Information Resource? A case study of users' mental models of traditional and digital libraries, *JASIST*, **58** (3), 433–45.

Martin, J. (1996) The Computers in Teaching Initiative, *Ariadne*, Issue 5, www.ariadne.ac.uk/issue5/cti/.

O'Hara, K., Smith, F., Newman, W. and Sellen, A. (1998) *Student Readers' Use of Library Documents: implications for library technologies*, Proceedings of the SIGCHI Conference on Human Factors in Computing Systems, Los Angeles, CA, pp. 233–40, New York, ACM Press.

Rieger, O. (2009) Search Engine Use Behavior of Students and Faculty: user perceptions and implications for future research, *First Monday*, **14** (12).

Rimmer, J., Warwick, C., Blandford, A., Gow, J. and Buchanan, G. (2008) An Examination of the Physical and Digital Qualities of Humanities Research,

Information Processing and Management, **44** (3), 1374–92.

Rowlands, I., Nicholas, D., Williams, P., Huntington, P., Fieldhouse, M., Gunter, B., Withey, R., Jamali, H., Dobrowolski, T. and Tenopir, C. (2008) The Google Generation: the information behaviour of the researcher of the future, *Aslib Proceedings*, **60** (4), 290–310.

Ruecker, S., Radzikowska, M. and Sinclair, S. (2011) *Visual Interface Design for Digital Cultural Heritage*, Ashgate.

Shneiderman, B. and Plaisant, C. (2009) *Designing the User Interface*, Pearson.

Smith, H. and Hyman, R. (1950) The Biasing Effect of Interviewer Expectations on Survey Results, *Public Opinion Quarterly*, **14** (3), 491–506.

Stone, S. (1982) Humanities Scholars: information needs and uses, *Journal of Documentation*, **38** (4), 292–313.

Tiley, J. (1996) *TLTP: The Teaching and Learning with Technology Programme*, http://www.ariadne.ac.uk/issue4/tltp.

Vandendorpe, C. (2009) *From Papyrus to Hypertext: toward a universal digital library*, University of Illinois Press.

Warwick, C. (2004) Print Scholarship and Digital Resources. In Schreibman, S., Siemens, R. and Unsworth, J. (eds), *A Companion to Digital Humanities*, Blackwell.

Warwick, C., Terras, M., Huntington, P., Pappa, N. and Galina, I. (2007) *The LAIRAH Project: log analysis of digital resources in the arts and humanities. Final report to the Arts and Humanities Research Council*, www.ucl.ac.uk/infostudies/claire-warwick/publications/LAIRAHreport.pdf.

Warwick, C., Galina, I., Terras, M., Huntington, P. and Pappa, N. (2008) The Master Builders: LAIRAH research on good practice in the construction of digital humanities projects, *Literary and Linguistic Computing*, **23** (3), 383–96.

Warwick, C., Terras, M., Huntington, P. and Pappa, N. (2008) If You Build It Will They Come? The LAIRAH Study: quantifying the use of online resources in the arts and humanities through statistical analysis of user log data, *Literary and Linguistic Computing*, **23** (1), 85–102.

Warwick, C., Rimmer, J., Blandford, A., Gow, J. and Buchanan, G. (2009) Cognitive Economy and Satisficing in Information Seeking: a longitudinal study of undergraduate information behaviour, *Journal of the American Society for Information Science and Technology*, **60** (12), 2402–15.

Warwick, C., Terras, M., Fisher, C., Baker, M., O'Riordan, E., Grove, M. et al. (2009) iTrench: a study of user reactions to the use of information technology in field archaeology, *Literary and Linguistic Computing*, **24** (2), 211–24.

Social media for digital humanities and community engagement

Claire Ross

Introduction

 Since their introduction, social media sites and applications have attracted millions of users and have had a profound effect on behaviour, with many users integrating these resources into their daily practices. Social participatory media, such as social networks, blogs and podcasts, are increasingly attracting the attention of academic researchers and educational institutions. Because of the ease of use, social media offers the opportunity for powerful information sharing, collaboration, participation and community engagement. Despite this, currently, there is limited knowledge within academia of who is accessing and utilizing social media and crowdsourcing applications and for what purpose.

The digital humanities community was an early adopter of social media, utilizing it for scholarly communication, collaboration and dissemination. For early adopters in the digital humanities community, social media applications have quickly become a part of everyday digital life and, as such, risk either remaining unexamined or, worse, dismissed as a mundane or damaging phenomenon of little significance (Warwick, 2011). Work being undertaken at the UCL Centre for Digital Humanities (UCLDH) seeks to establish the study of various social networking technologies, such as microblogging and crowdsourcing, as an important element of digital humanities discourse. In order to understand how these tools and services are transforming scholarly practices, UCLDH is harnessing a range of social media applications, in order to investigate the use of social media in digital humanities, including conference backchannels, crowdsourcing and co-curation between research communities and the public. UCLDH projects, such as Transcribe Bentham[1] and QRator,[2] demonstrate that such technologies may be used in an academic

context to change how scholars interact with each other and how they make their research available to those outside academia.

This chapter presents a range of social media activities for digital humanities research, highlights the development of social media projects at the heart of UCLDH and stresses the opportunities and challenges of utilizing social media and crowdsourcing in an academic context to enhance community engagement.

Social media in academia

Social media refers to a collection of web based technologies and services, situated in the open and participatory culture of the internet, characterized by community participation, collaboration and sharing of information online: 'The key aspect of a social software tool is that it involves wider participation in the creation of information which is shared' (Minocha, 2009, 12). Wikipedia describes social media as:

> An umbrella term that defines the various activities that integrate technology, social interaction, and the construction of words, pictures, videos and audio. This interaction, and the manner in which information is presented, depends on the varied perspectives and 'building' of shared meaning, as people share their stories, and understandings.[3]

Social software and Web 2.0 are other terms used to describe tools and platforms that enable similar user interaction. The term 'Web 2.0' is attributed to Tim O'Reilly (2005) to describe the second phase of the web. This phase saw online communications shift from what had typically been one-way communication (e-mail, for example, is foremost a tool of one-to-one messaging) to a many-to-many style interaction. It has been variously described as the 'age of participation' (Schwartz, 2005), the 'age of engagement' (Cary and Jeffery, 2006) and an 'authorship society' (Rushkoff, 2005).

Many Web 2.0 services (blogging, microblogging, photo sharing, social bookmarking, social networking and wikis) are now referred to as social media. They have been used to facilitate research tasks and collaborative projects by a number of institutions. Social media encompasses a wide set of functional characteristics, within the context of computer-mediated communication and networked digital media. It uses audio, images, video and location-based services as channels to encourage, facilitate and provoke social interaction and user participation. Social media should not focus on the

technology, but the activity that is undertaken. Johnson et al. (2010, 13) agree, stating: 'Collectively, social media are above all the voice of the audience, endlessly expressive and creative'. While key technological features are fairly consistent, the customs that emerge from social media are varied.

The Online Computer Library Center (OCLC) states: 'while interaction occurs on social media sites, the primary purpose of the site is to publish and share content' (2007, 15). These characteristics point to increased possibilities for academic publication, as well as encouraging mechanisms for content production, communication and collaboration. Social media has been used to facilitate research tasks and collaborative projects by a number of institutions. In the last few years, much has been written about the ways these tools are changing scholarly practice (Johnson et al., 2010; BECTA/Crook et al. 2008; Davis and Good, 2009). Social tools have the potential to contribute something to the traditional research process; they also have the potential to challenge the ways in which research is done, as social media can confront and develop current ideas and practice (RIN, 2011). Indeed, scholarly communication and discourse in a digital environment are beginning to highlight the fact that traditional barriers between formal and informal scholarly communication are now permeable. It has been argued that engagement in social media environments provides more avenues for self-representation, expression or reflection and more organized forms of collaboration and knowledge building (Conole and Alevizou, 2010; BECTA/Crook et al., 2008). There has been a huge growth in interest from scholars, and social software is now being used at every stage of the research life-cycle (CIBER, 2010). Yet, while awareness of social media among members of the academic community is high, there is still a large gap between awareness and actual regular use of tools.

Surveys undertaken on the use of social media within universities can provide an indication of the level of uptake (JISC, 2008; Smith, Salaway and Caruso, 2009; Smith and Caruso, 2010; Lam and Ritzen, 2008). Collectively, they suggest that uptake is occurring, but that it is not yet extensive across all aspects of research and teaching provisions. Chapman and Russell's (2009) study on the current and active users of Web 2.0 – focusing on staff, students, tools and services in UK higher education (HE) institutions – found that active use appears to be still largely centred on early adopters, although students were more likely to be users. As the report states, an increasing proportion of new students to higher education (HE) are already using social media, but this does not apply to everyone; Web 2.0 digital literacy (and illiteracy) is still an issue that needs to be addressed (Chapman

and Russell, 2009). Even in teaching and learning, the impact of new technologies has not been as widespread or transformative as predicted (Pearce et al., 2010; Conole, 2004; Blin and Munro, 2008). Not all Web 2.0 tools and services are used to the same extent, and, some services, for example, blogs, microblogging and tagging, are more popular than others. It is important to caution against overgeneralizations from these surveys, in terms of extrapolating the uptake of both formal and informal Web 2.0 tools, as it is difficult to draw comparative conclusions systematically from surveys that use different research instruments.

Despite the potential applications of technologies in an academic context, their use raises some fundamental issues. There are some perceived barriers to uptake of social media applications in academia. One major barrier is lack of clarity, even among some frequent users, as to what the benefits might be. Other barriers evident from the literature include: concerns about expectations, experiences and competencies, with respect to using social media technologies (Conole and Alevizou, 2010); the perception that the use of these tools requires a large time investment; humanities scholars, in particular, feel they do not have the time to learn how to use them (Ross, Terras and Warwick, 2010); caution about trust issues, in terms of producing and sharing research in a medium which, as of yet, has no standardized way to formally attribute authorship; a lack of authority in an environment where anyone can comment, and it is difficult to determine whether contributions are valid or authoritative (RIN, 2011).

In the context of this last point, there is some fear that the quality of public and academic discussion and debate is being undermined. Keen (2007) and Carr (2010) have suggested that social media and the ubiquitous use of the internet are potentially damaging to our thinking, our culture and our society in general. There is also a perceived lack of confidence that appropriate instructional structures are in place to support these activities and an inherent scepticism as to whether these technologies will actually make a difference to academic practice. Identification and understanding of the barriers to broader uptake is essential, so that strategies can be devised to overcome them. While adoption of social media applications is growing in academia, there is a need to address these issues in a systematic way (Chapman and Russell, 2009; OECD, 2009).

Social media practices are beginning to have a direct impact upon scholarly dissemination. The ability to disseminate research widely, quickly and effectively is often cited as a key reason for academics to utilize social media (RIN, 2011). New practices are emerging in informal, online based

social communication spaces, outpacing development of practice within the formal modes of academic publishing. Many academics are using social media informally to facilitate opportunities for open exchange and presenting new ideas; SlideShare[4] and Scribd[5] are examples of how scholars are leveraging digital media to distribute informal scholarship. This enables other academics to access research as it happens and to participate in dialogue about research practice, which suggests that social media tools are creating a culture of openness in scholarship (Tatum and Jankowski, 2010).

In spite of some innovative features in online publishing, the structure of journal articles, books and monographs remains very much unchanged (Tatum and Jankowski, 2010). It has been suggested that traditional formats of scholarly publishing need to be re-addressed in light of the impact of social media applications, in particular, the way peer review is conducted (Fitzpatrick, 2009; 2010). Several innovative studies have been initiated to challenge traditional publishing formats, by creating an open form of peer review, in order to demonstrate how social media and open communication can transform formal academic publishing practice. *Nature* conducted an experimental trial with open peer review in 2006,[6] and *Shakespeare Quarterly* completed one in 2010, using a software program developed by MediaCommons[7] (Fitzpatrick, 2010). These projects are a step towards developing openness in scholarly communication; however, this is an issue that warrants further research. This chapter will now present an overview of three social media activities for digital humanities research, highlighting how, in an academic context, there are opportunities and challenges involved in utilizing social media and crowdsourcing, in order to enhance community engagement.

Social media for harnessing the wisdom of the crowd

The compound word 'crowdsourcing' combines 'crowd', in the sense of 'the wisdom of crowds' (Surowiecki, 2004), and 'outsourcing'. The latter was defined by Jeff Howe, in 2006, as 'the act of a company or institution taking a function once performed by employees and outsourcing it to an undefined (and generally large) network of people in the form of an open call' (Howe, 2006). Wikipedia – itself heavily dependent on crowd-sourced content – defines crowdsourcing as: 'Taking tasks traditionally performed by an employee or contractor, and outsourcing them to a group of people or community, through an "open call" to a large group of people (a crowd) asking for contributions'(http://en.wikipedia.org/wiki/Crowdsourcing).

It is argued that the capability of a complex system, such as a crowd, is much better than a single system or individual, as it can produce a kind of shared or group intelligence, based on collaboration or competition of the many individuals in this group (Kapetanios, 2008). However, in order to attain the 'wisdom of the crowds', Surowiecki (2004) argues that four requirements must be fulfilled:

1. Diversity: the crowd includes people with different backgrounds and perspectives.
2. Independence: each participant makes their decision, independent of the others.
3. Decentralization: the decisions are based on local and specific knowledge of the individuals, rather than of a central planner.
4. Aggregation: a function that turns individual judgements into a collective decision.

Crowdsourcing is an increasingly popular way of gathering content within an academic environment. Several authors have been working on a classification of crowdsourcing projects. For instance, Dawson's 'Crowdsourcing landscape' (2010) organizes crowdsourcing sites into 15 categories, which illustrate the breadth of crowdsourcing initiatives. Rose Holley (2010) provides a valuable overview of the definition and purpose of crowdsourcing and its relevance to libraries and examines several recent large-scale participatory projects to identify common characteristics for success. Numerous academics, however, assert that crowdsourcing, and the use of Wikipedia, in particular, is not appropriate for scholarly settings, due to its amateur and community-based nature (Black, 2007; Achterman, 2005; McArthur, 2006). These viewpoints do not take into consideration Wikipedia's ability to mediate a dialogue between differing perspectives held by contributors on any given subject. The ability to transform information and promote dialogue between disparate users provides Wikipedia with a definite advantage over traditional printed and static online content (Black, 2007; Deuze, 2006; Bryant, Forte and Bruckman, 2005; Lih, 2004). Recent research also indicates that Wikipedia is equal to, or even outperforms, comparable conventionally edited encyclopedias, in terms of accuracy (Giles, 2005; Besiki et al., 2008; Rajagopalan et al., 2010). The Australian Newspapers Digitisation Program,[8] Galaxy Zoo[9] and other Zooniverse[10] projects are often highlighted as key examples of academic crowdsourcing (Hannay, 2010; Holley, 2010).

Within UCLDH, we have been investigating the use of crowdsourcing as

a tool for aiding academic transcription and for stimulating public engagement with UCL's archive collections. Transcribe Bentham is a participatory project to test the feasibility of outsourcing the work of manuscript transcription to the general public, as the case study below sets out.

..
CASE STUDY Transcribe Bentham: crowdsourcing in practice
..

Tim Causer, Faculty of Laws, University College London, Justin Tonra, Department of English, University of Virginia, and Valerie Wallace, Center for History and Economics, Harvard University

The Bentham Project at University College London has harnessed the power of crowdsourcing to facilitate the transcription of the manuscript papers of Jeremy Bentham (1748–1832), the great philosopher and reformer. UCL Library houses 60,000 of Bentham's manuscripts, the majority of which have never been properly studied. The purpose of the Bentham Project is to produce a new authoritative edition of Bentham's works – the *Collected Works of Jeremy Bentham* – based partly on transcripts of these papers. The Project has been active since 1959, and, since then, around 20,000 of Bentham's papers have been transcribed and 28 volumes of his works have been published. The Project aims to produce around 70 volumes in total, and around 40,000 papers remain untranscribed.

The Bentham Papers Transcription Initiative, or Transcribe Bentham for short, was established in 2010 to quicken the pace of transcription, speed up publication, widen access to Bentham's papers, raise awareness of Bentham's ideas and contribute to the long-term preservation of this priceless collection in UCL Library's digital repository. Transcribe Bentham outsources manuscript transcription – a task originally performed by skilled researchers – to members of the public, who require no special training or background knowledge to log on and participate. Transcribe Bentham was funded by the Arts and Humanities Research Council for one year.

In order to begin the process of crowdsourcing the transcription of Bentham's manuscripts, two components were vital: high-resolution digital images of the manuscripts, which were photographed by UCL Learning and Media Services, and a tool to allow users to transcribe the text. The transcription tool was developed with simplicity in mind. Users type their submissions into a plain-text box, with the option of adding some basic formatting to their transcriptions. By highlighting a piece of text or a position in the text, and by clicking a button on

the transcription toolbar, users are able to identify particular characteristics of the manuscripts. These include spatial and organizational features, such as line breaks, page breaks, headings and paragraphs; linguistic features, like notes, unusual spellings and foreign-language text; compositional features, such as additions and deletions; and interpretive decisions about questionable readings and illegible text. This TEI (Text Encoding Initiative) XML encoding adds a further layer of depth and complexity to the transcripts, helping to render them searchable in a thorough and categorical fashion.

When a user completes a transcription and submits it for moderation, it is checked for textual accuracy and encoding consistency by a member of the project staff. If the transcript is deemed to be completed to a satisfactory degree, the transcript is locked to prevent further editing (though the formatted transcript remains available to view). If the moderator decides that the submitted transcript is incomplete, and could be improved with further editing from users, it remains available for editing on the Transcription Desk. Completed transcripts are uploaded to the digital collection of Bentham's papers maintained by UCL Library and are viewable alongside the respective manuscript images; they will also, eventually, form the basis of printed volumes of Bentham's collected works.

As manuscript transcription, particularly the transcription of Bentham's difficult handwriting, is a complex task, the project team aimed to create a cohesive and dedicated community of mutually supportive and loyal transcribers, rather than a crowd of one-time users. The strategy to build a dedicated user community was twofold. First, the team devised a far-reaching publicity campaign to raise awareness of the project and to recruit transcribers; second, the team designed a user-friendly, easily navigable interface, in order to retain users, while facilitating communication between users and staff. The interface which hosts the manuscript images and transcription tool is a customized Mediawiki. It not only provides the means of integrating the essential components of the Transcription Desk, but also allows for the inclusion of guidelines for users, project documentation, a discussion forum and social media that enables interaction and discussion. A reward system and progress bars help to sustain user motivation.

During its six-month testing period, Transcribe Bentham attracted 1207 registered users (excluding administration and project staff and seven blocked spam accounts), who cumulatively transcribed 1009 manuscripts, of which 569 – or 56% – were deemed to be complete and, thus, locked to prevent further editing. Progress has continued since the end of the testing period, and, as of 3 June 2011, 1273 volunteers have registered with the project. One thousand four

hundred and seventeen manuscripts have been transcribed, of which 1179 – or 83% – are complete; the proportion of completed transcripts has risen, partly due to the growing experience of volunteers and partly due to project staff working through and signing off on previously incomplete transcripts.

During the six-month testing period, the Transcription Desk received a total of 15,354 visits from 7441 unique visitors or an average of 84 visits from 41 unique visitors per day. The publication of a feature article in the *New York Times* (*NYT*) on 27 December 2010 had a vital and enduring impact upon Transcribe Bentham. It is helpful, therefore, to consider the project's testing period as having two distinct parts: period one, or the pre-*NYT* period, covering 8 September 2010 to 26 December 2010 (110 days); and period two, or the post-*NYT* period, covering 27 December 2010 to 8 March 2011 (72 days). Remarkably, 30% of all visits to the transcription desk during the six-month testing period came between 27 December 2010 and 4 January 2011.

Over the six-month testing period as a whole, volunteers transcribed an average of 35 manuscripts each week. It is estimated that if this rate were maintained, around 1800 transcripts could be produced by Transcribe Bentham volunteers in 12 months. These figures might seem unremarkable when compared to the results of other crowdsourcing initiatives, such as Galaxy Zoo, which has successfully built up a community of 250,000 users, who have classified over 100 million galaxies. However, transcribing Bentham's papers is complex and time-consuming. Volunteers are asked to transcribe and encode manuscripts which are usually several hundred – and, occasionally, several thousand – words in length, in which text is frequently at various angles and which can be complicated further by deletions, marginalia, interlinear additions and so on. During the six-month testing period, Transcribe Bentham's volunteers have produced around 5% of the 20,000 manuscripts transcribed by Bentham Project staff during 50 years; assuming that the average length of a manuscript is 250 words, volunteers have transcribed an estimated 250,000 words. As of 3 June 2011, volunteers have – on the same estimation – transcribed about 355,000 words.

Transcribe Bentham's long-term future is secure, and the Transcription Desk will remain available for the foreseeable future. The project will continue, therefore, to have a significant impact in several fields. It has raised awareness of Bentham's life and thought and produced transcripts which will contribute to the editorial work of the Bentham Project, including publication of printed editions of important Bentham texts and the creation of an invaluable, fully searchable digital collection, freely available on the web. The transcription tool behind the project will be released as a package on an Open Source basis for other projects to customize. Transcribe Bentham has also publicized

collaborative manuscript transcription widely, garnering a great deal of attention from the media and blogs, and has recently been honoured with an Award of Distinction in the prestigious Prix Ars Electronica. ■

Social media for enhancing a community of practice

A community of practice is formed by people of a shared domain, who engage in a process of collective learning by interacting on an ongoing basis (Wenger, 1998; Wenger, McDermott and Synder, 2002). The concept of 'communities of practice', developed by Lave and Wenger (1991), can be distinguished by five key features: their purpose, personnel, the nature of their boundaries, cohesive factors and longevity (Wenger, McDermott and Synder, 2002, 42). Social networks, work and research practice can have a significant impact on any community's engagement with new technology systems (Dunker, 2002; Kling, 1999; Theng, 2002; Cunningham, 2002) and academic communities of practice are no exception. Digital humanities can be regarded as a community of practice, as Terras (2006) demonstrated. There is an identifiable community operating in the fields of computing and the humanities (Terras, 2006, 242), because the discipline is made up of individuals who self-select, on the basis of a unified sense of purpose and 'expertise or passion for a topic' (Wenger, McDermott and Synder, 2002, 42), which become cohesive factors. Utilizing social media to support communities of practice can assist the effective sharing of knowledge across departmental, institutional and discipline boundaries, thus promoting collaboration and co-ordination, while also increasing productivity and organizational performance (Millen, Fontaine and Muller, 2002; Mojta, 2002).

The 'community of practice' approach highlights how technologies that support information use can produce richer knowledge, which can be empowering (Wenger, 1998). One such technology is that of blogging. There has been a lot of discussion about academic blogging practice (Walker, 2006; Davies and Merchant, 2007); over the past few years, there has been a sharp rise in the number of academics who use blogging for scholarly communication. Microblogging, a variant of blogging, which allows users to quickly post short updates to websites, such as twitter.com, has recently emerged as a dominant form of information interchange and interaction for academic communities. The simplicity of publishing short updates, in various situations and in a fluid social network based on subscriptions and response, makes microblogging a groundbreaking communication method that can be seen as a hybrid of blogging, instant messaging, social

networking and status notifications.

Within UCLDH, we have been investigating the use of microblogging for enhancing an academic community of practice. This project highlights the implications of utilizing Twitter as an international academic conference backchannel, using the International Digital Humanities community as a case study, taking, as its focus, postings to Twitter during three different international conferences in 2009.

CASE STUDY Babble or backchannel: conference tweeting in practice

Claire Ross, Melissa Terras, Claire Warwick and Anne Welsh, UCL Department of Information Studies

Microblogging, with special emphasis on Twitter.com[11] – the best known microblogging service – is increasingly used as a means of extending commentary and discussion during academic conferences. This digital 'backchannel' communication (non-verbal, real-time communication, which does not interrupt a presenter or event: Ynge, 1970) is becoming more prevalent at academic conferences, in educational use and in organizational settings, as it allows for the 'spontaneous co-construction of digital artefacts' (Costa et al., 2008, 1). Such communication usually involves notetaking, sharing resources and individuals' real-time reactions to events. The study of digital humanities conference tweets provides an insight into the digital humanities community of practice and into precisely how academics use Twitter in a conference based setting.

Formal conference presentations still mainly occur in a traditional setting; a divided space with a 'front' area for the speaker and a larger 'back' area for the audience, implying a single focus of attention. There is a growing body of literature describing problems with a traditional conference setting: lack of feedback, nervousness about asking questions and a single speaker paradigm (Anderson et al., 2003; Reinhardt et al., 2009). The use of a digital backchannel, such as Twitter, positioned in contrast with the formal or official conference programme, can address this, providing an irregular or unofficial means of communication (McCarthy and Boyd, 2005), which changes the dynamics of the room from a one-to-many transmission to a many-to-many interaction, without disrupting the main channel communication.

Digital humanists have, historically, been quick to adopt emergent media to aid their own tasks. This study analysed the use of Twitter as a backchannel for digital humanities' conferences, focusing on three different physical conference settings held from June to September 2009 (Digital Humanities, 2009; That Camp,

2009; and Digital Resources in the Arts and Humanities, 2009). During the conferences, unofficial Twitter backchannels were established, using conference specific hashtags (#dh09, #thatcamp and #drha09, #drha2009)[12] to enable visible commentary and discussion. The resulting corpus of individual 'tweets' provides a rich dataset, allowing analysis of the use of Twitter in an academic setting. It is possible to gain an insight into the user intentions of the digital humanities Twitter community through open-coded content analysis. To understand the interactions and user intentions of Twitter backchannel users, it was necessary to categorize the tweets. Tweets were manually labelled into seven categories: asking organizational questions; comments on presentations; discussions and conversations; establishing an online presence; jotting down notes; sharing resources; and unknown. The majority of tweets in the corpus fell into the category of jotting down notes, triggered predominately by the front channel presentation, suggesting that participants are sharing experiences and, to a degree, co-constructing knowledge. What is surprising is the lack of direct commentary on presentations. Although Reinhardt et al. (2009) argue that Twitter enables thematic debates and offers a digital backchannel for further discussion and commentary, the tweet data suggests that this does not appear to have happened to a significant extent at the digital humanities' conferences. This raises the question of whether a Twitter-enabled backchannel promotes more of an opportunity for users to establish an online presence and enhance their digital identity, rather than encouraging a participatory conference culture. Nevertheless, jotting down notes can be considered an active contribution to the community, enabling the expansion of communication and participation in the event.

Participation inequality has been observed in other collaborative online environments for more than a decade (Nielsen, 2006; Anderson, 2008) and would seem to apply to Twitter. A high amount of users produced only one Tweet during the three conferences, which lends support to the notion of a 90:9:1 rule (Nielsen, 2006) for new social media, where 90% of users are lurkers, 9% of users contribute from time to time and 1% participate a lot and account for the majority of contributions. The fact that this is demonstrated in the corpus suggests that despite the close-knit nature of the fairly small digital humanities researcher community, it may also be somewhat intimidating for those new to the field, conference or Twitter itself.

When looking at the corpus of Tweets, one striking characteristic of the content is that conference hashtagged Twitter activity does not constitute a single distributed conversation, but, rather, multiple monologues and a few intermittent, discontinuous, loosely joined dialogues, which users enter and exit

at will. It is possible to suggest that beyond being a tool for writing and communicating, microblogging platforms may serve as foundations for building or enhancing a community of practice. Digital technology is often suggested as a tool to support communities of practice (see Wenger, White and Smith, 2009; Yardi, 2008; Adams, Blandford and Lunt, 2005). Microblogging as a digital backchannel can be suggested as being such a tool, by facilitating a forum for community related discussion, resulting in great levels of reflections, discourse, deep content knowledge (Yardi, 2006) and distributed expertise throughout the community. Such collective interaction and learning results in the improvement of the knowledge of each individual in the community and contributes to the development of the knowledge within the domain. For this reason, this method can be regarded as promising for academic environments, in facilitating informal communication, learning and the co-construction of knowledge.

The use of Twitter as a platform for conference backchannels enables the community to expand communication and participation of events amongst its members. This enhanced participation allows the digital humanities community to co-create knowledge, ensuring that the 'collaborative knowledge of the community is greater than any individual knowledge' (Johnson et al., 2010, 31). The Twitter enabled backchannel constitutes a complex multidirectional discursive space, in which the conference participants make notes, share resources, hold discussions and ask questions, as well as establishing a clear, individual online presence. The predominance of notetaking suggests that the digital humanities community could be classed as social reporters, commenting on the conference presentations for outsiders, rather than collaborating during the conference. There was also a tendency for a small group of users to produce the majority of tweets, interacting with each other about other matters. This suggests the small, friendly nature of the digital humanities researcher community, but may also be somewhat intimidating for those new to the field or conference.

With the increasing prevalence of Twitter in academic conference environments, it is possible to present digital backchannel communication as a viable tool for the co-construction of knowledge within a community of practice. However, this argument is by no means complete or definitive. Those who participate in digital backchannel communication at conferences, whether organizers, speakers or attendees, must understand and confront their visibility, issues of user awareness and potential negative factors, in order to influence the use of the Twitter enabled backchannel as an effective conference tool which fully encourages a participatory conference culture. The Twitter enabled backchannel thus raises some interesting questions about the nature of

conference participation and whether or not it is helped or hindered by a digital backchannel. Rather than pointless babble, the Twitter record produced at each conference provides important evidence regarding how digital humanities – as a community of practice – function and interact. ■

Social media for co-construction of knowledge

As more academic institutions begin to utilize social media in both research and teaching practice, the emphasis on social media research is changing from whether academia should participate in the social web, to how to best use it effectively to engage academic and non-academic audiences in an online dialogue. There has been an increasing focus on the role that universities can play in contributing to engaging the public in academic research (see NCCPE, 2011). Public engagement in academia is often described as a 'cluster' of activities, including, but not restricted to, learning, programmes and research, which address specific social, economic and political needs (Hall, 2010). In recent years, an increasingly wide range of public-facing activities have become prominent, particularly in science communication. However, the objectives, meanings and practices covered by the umbrella term 'public engagement' are becoming more fluid and are now characterized by a considerable degree of under-definition and overlap. The Department for Innovation, Universities and Skills (DIUS) define public engagement as:

> an umbrella term that encompasses many kinds of activity including science
> festivals, centres, museums, and cafes, media, consultations,
> feedback techniques, and public dialogue. Any good engagement activity should
> involve aspects of listening and interaction. (DIUS, 2008, 20)

whereas the National Co-ordinating Centre for Public Engagement (NCCPE) offers a more general definition of public engagement, which is applied across academia or higher education:

> Public engagement brings research and higher education institutions together
> with the public. It generates mutual benefit – with all parties learning from each
> other through sharing knowledge, expertise and skills. Done well, it builds trust,
> understanding and collaboration, and increases the institution's relevance to,
> and impact on, civil society. (NCCPE, 2009)

Interestingly the majority of public engagement initiatives within UK

universities focus on face-to-face engagement, rather than using social media as an outlet.

UCL Centre for Digital Humanities, alongside the Centre for Advanced Spatial Analysis (CASA),[13] UCL Museums and Collections[14] and the UCL Public Engagement Unit,[15] have set out to develop the area of social media research for public engagement. Social media technologies are being used to integrate digital humanities research within and beyond academia; involve the general public in digital resource creation and design; and apply digital technologies to cultural heritage. The QRator project, in particular, demonstrates that such technologies may be used in an academic context to change the way that scholars interact with each other and make their research available to those outside academia. The QRator project aims to stress the necessity of engaging visitors actively in the creation of their own interpretations of museum collections, alongside academic researchers.

..

CASE STUDY QRator Project: enhancing co-creation of content in
practice
..

Claire Ross, UCL Department of Information Studies, and Steven Gray, UCL Centre for Advanced Spatial Analysis
Emergent mobile technologies and the proliferation of social media tools offer museum professionals new ways of engaging visitors with their collections. Museum audiences are no longer 'passive recipients of wisdom from on high, but want to participate, to question, to take part as equals, and to receive as high a standard of service as would be offered at any other type of leisure site'.[16] UCL's QRator project is exploring how handheld mobile devices, social media software and interactive digital labels can create new models for public engagement, personal meaning-making and the construction of narrative opportunities inside museum spaces.

The QRator project is located within the emerging technical and cultural phenomenon known as 'The Internet of Things': the technical and cultural shift that is anticipated as society moves to a ubiquitous form of computing, in which every device is 'on' and connected, in some way, to the internet. The project is based around technology developed at the Centre for Advanced Spatial Analysis, UCL, and is an extension of the 'Tales of Things' project (www.talesofthings.com), which has developed a 'method for cataloguing physical objects online which could make museums and galleries a more interactive experience' (Giles, 2010), via means of QR tags.

QRator provides the opportunity to move the discussion of objects from the museum label onto users' mobile phones, allowing the creation of a sustainable, world-leading model for two-way public interaction in museum spaces. UCL's Grant Museum of Zoology houses one of the country's oldest and most important natural history collections. The Grant Museum has a strong history as a teaching collection, but also functions as a key gateway for the public to engage with academic issues in innovative ways. The project aims to genuinely empower members of the public within the Grant Museum, by allowing them to become the 'curators'. QRator is an iPad based system that allows visitors and academic researchers to share their views on an exhibition and discuss provocative questions about the ways museums operate and the role of science in society. The iPads are linked to an online database, allowing the public to view 'curated' information and, most notably, to send back their own interpretation and views, via an iPad application. Unique to the UCL technology is the ability to 'write' back to the QR codes. This allows members of the public to type in their thoughts and interpretations of the object and click 'send'. Similar in nature to sending a text message or a tweet, the system will enable the Grant Museum to become a true forum for academic-public debate, using low cost, readily available technology, enabling the public to collaborate and discuss object interpretation with museum curators and academic research-ers. QRator encourages visitors to tackle big questions in the life sciences and engage with the way museums work. Questions include: 'Should human and animal remains be treated any differently?' And 'every medicinal drug you have ever taken was tested on animals. Is this a necessary evil?' Visitors can examine museum specimens, before leaving their interpretation on an iPad to create a digital 'living' label that other visitors can read and respond to. Visitor narratives subsequently become part of the museum objects' history and, ultimately, the display itself, via the interactive label system, allowing the display of comments and information directly next to the museum objects.

Many visitors expect, or want, to engage with a subject physically, as well as personally (Adams, Luke and Moussouri, 2004; Falk and Dierking, 2000). Visitors see interactive technology as an important stimulus for learning and engagement (Falk et al., 2002; Black, 2005), empowering users to construct their own narratives, in response to museum exhibits. Beyond expected content synthesis, these immersive activities can stimulate learning. Engaged within this immersive environment, museum objects become rich sources of innovation and personal growth (Fisher and Twiss-Garrity, 2007). When visitors experience a museum which actively encourages individual narrative construction, their activity is directed not towards the acquisition or receipt of the information

being communicated by the museum, but rather towards the construction of a very personal interpretation of museum objects and collections. The unpredictability of multiple narrative forms, created by the use of mobile devices and interactive labels, introduces new considerations to the process by which museums convey object and collection interpretation and opens up museums to become a more engaging experience.

The participation in collaborative narrative creation, centred on museum objects, can provoke creative, independent analysis, promoting a personal connection with museum exhibition subject matter that is unparalleled in more traditional and passive approaches (Silverman, 1995; Roberts, 1997; Hooper-Greenhill, 2000; Fisher and Twiss-Garrity, 2007). ■

Conclusion

This chapter has aimed to introduce the concept of social media in academia and to demonstrate its current use in the research process, whilst providing an overview of key social media projects within the UCL Centre for Digital Humanities. Social media tools and services hold real potential across all facets of scholarship. Social media use within academia is currently focused on early adopters, but there is much to be learnt about the impact these technologies are having on research and teaching. The widespread viability and sustainability of social media as tools for research practice, scholarly communication and public engagement in academic research remains to be determined. Successful projects and social media research practice are beginning to emerge. Nevertheless, it is not until social media implementation is fully incorporated into universities' strategic approaches to research communication that addresses changing scholarly com-munication models and engages communities in scholarly debate and knowledge sharing that a strong research base can been developed, in order to fully understand the impact on social media in the academy.

Bibliography

Achterman, D. (2005) Surviving Wikipedia: improving student search habits through information literacy and teacher collaboration, *Knowledge Quest*, **33** (5), 38–40.

Adams, A., Blandford, A. and Lunt, P. (2005) Social Empowerment and Exclusion: a case study on digital libraries, *ACM Transactions on CHI*, **12** (2), 174–200.

Adams, M., Luke, J. and Moussouri, T. (2004) Interactivity: moving beyond

terminology, *Curator*, **47**(2), 155–70.

Anderson, C. (2008) *The Long Tail*, 2nd edn, Hyperion.

Anderson, R. J., Anderson, R., Vandegrift, T., Wolfman, S. and Yasuhara, K. (2003) Promoting Interaction in Large Classes with Computer-mediated Feedback. In Wasson, B., Ludvigsen, S. and Hoppe, U. (eds), *Designing for Change in Networked Learning Environments: Proceedings of the International Conference on Computer Support for Collaborative Learning*, 119–23, Dordrecht, Netherlands, Kluwer Academic Publishers.

Becta (2008) *Analysis of Emerging Trends Affecting the Use of Technology in Education*, Becta Research Report.

Besiki, S., Twidale, M. B., Smith, L. C. and Gasser, L. (2008) Information Quality Work Organization in Wikipedia, *Journal of the American Society for Information Science and Technology*, **59** (6), 983–1001.

Black, G. (2005) *The Engaging Museum: developing museums for visitor involvement*, Routledge.

Black, E. W. (2007) Wikipedia and Academic Peer Review: Wikipedia as a recognised medium for scholarly publication?, *Online Information Review*, **32** (1),73–88.

Blin, F. and Munro, M. (2008) Why Hasn't Technology Disrupted Academics' Teaching Practices? Understanding Resistance to Change through the Lens of Activity Theory Original Research Article, *Computers & Education*, **50** (2), 475–90.

Bryant, S. L., Forte, A. and Bruckman, A. (2005) Becoming Wikipedian: transformation of participation in a collaborative online encyclopedia. In *GROUP '05: proceedings of the 2005 international ACM SIGGROUP conference on supporting group work*, 1-10, ACM Press.

Carey, S. and Jeffrey, R. (2006) Audience Analysis in the Age of Engagement. In Trant, J. and Bearman, D. (eds), *Museums and the Web 2006: proceedings*, Archives & Museum Informatics, www.archimuse.com/mw2006/papers/carey/carey.html.

Carr, N. (2010) *The Shallows: what the internet is doing to our brains*, W. W. Norton & Company.

Chapman, A. and Russell, R. (2009) *Shared Infrastructure Services Landscape Study. A Survey of the Use of Web 2.0 Tools and Services in the UK HE Sector*, http://ie-repository.jisc.ac.uk/438/1/JISC-SIS-Landscape-report-v3.0.pdf.

CIBER: Centre for Information Behaviour and the Evaluation of Research (2010) *Social Media and Research Workflow*, Charleston Observatory.

Conole, G. (2004) E-Learning: the hype and the reality, *Journal of Interactive Media in Education*, **12**, 1–18.

Conole, G. and Alevizou, P. (2010) *A Literature Review of the Use of Web 2.0 Tools in Higher Education 2010*, Higher Education Academy.

Costa, C., Beham, G., Reinhardt, W. and Sillaots, M. (2008) Microblogging in

Technology Enhanced Learning: a use-case inspection of PPE Summer School 2008. In Vuorikari, R., Drachsler, H., Manouselis, N. and Koper, R. (eds), *Proceedings of the Workshop on Social Information Retrieval in Technology Enhanced Learning*, Maastricht, The Netherlands.

Crook, C., Cummings, J., Fisher, T., Graber, R., Harrison, C. and Lewin, C. (2008) *Web 2.0 Technologies for Learning: the current landscape – opportunities, challenges and tensions*,
http://dera.ioe.ac.uk/1474/1/becta_2008_web2_currentlandscape_litrev.pdf.

Cunningham, S. J. (2002) Building a Digital Library from the Ground Up: an examination of emergent information resources in the machine learning community. In Lim, E.-P., Foo, S., Khoo, C., Chen, H., Fox, E., Urs, S. and Costantino, T. (eds), *Proceedings of the Fifth International Conference on Asian Digital Libraries (ICADL'02), Digital Libraries: People, Knowledge, and Technology*, LNCS 2555, Singapore, 301–2, Springer-Verlag, Berlin.

Davies, J. and Merchant, G. (2007) Looking From the Inside Out: academic blogging as new literacy. In Lankshear, C. and Knobel, M. (eds), *A New Literacies Sampler*, Peter Lang.

Davis, C. and Good, J. (2009) Choosing to Use Technology: how learners construct their learning lives in their own contexts, key findings from the first year of research. In Becta, *Part of the Harnessing Technology: the learner and their context*, http://dera.ioe.ac.uk/1524.

Dawson, R. (2010) *Crowdsourcing Landscape*,
http://crowdsourcingresults.com/competitionplatforms/crowdsourcing-landscape-discussion.

Deuze, M. (2006) Ethnic Media, Community Media and Participatory Culture, *Journalism*, **7** (3), 262–80.

DIUS (2008) A Vision for Science and Society: a consultation on developing a new strategy for the UK,
http://interactive.bis.gov.uk/scienceandsociety/files/A_Vision_for_Science_and _Society.pdf.

Dunker, E. (2002) Cross-cultural Usability of the Library Metaphor, *Proceedings of JCDL'02*, ACM Press, 223–30.

Falk, J. H. and Dierking, L. D. (2000) *Learning from the Museum: visitor experiences and making meaning*, AltaMira.

Falk, J. H., Cohen Jones, M., Dierking, L. D., Heimlich, J., Scott, C. and Rennie, L. (2002) *A Multi-Institutional Study of Exhibition Interactives in Science Centers and Museums*, Institute for Learning Innovation.

Fisher, M. and Twiss-Garrity, B. A. (2007) Remixing Exhibits: constructing participatory narratives with on-line tools to augment museum experiences. In

Trant, J. and Bearman, D. (eds), *Museums and the Web 2007: proceedings*, Toronto, Archives & Museum Informatics, www.archimuse.com/mw2007/papers/fisher/fisher.html.

Fitzpatrick, K. (2009) Planned Obsolescence: publishing, technology and the future of the academy, MIT Press, *Mediacommons*, http://mediacommons.futureofthebook.org/mcpress/plannedobsolescence/.

Fitzpatrick, K. (2010) Open vs. Closed: changing the culture of peer review. In Pierazzo, E. (ed.), *Digital Humanities 2010, Conference Abstracts*, Office for Humanities Communication, Centre for Computing in the Humanities, King's College London, 146–7.

Giles, J. (2005) Internet Encyclopaedias go Head to Head, *Nature*, **438**, 900–1.

Giles, J. (2010) Barcodes Help Objects Tell their Stories, *New Scientist*, April, www.newscientist.com/article/dn18766-barcodes-help-objects-tell-their-stories.html.

Hall, P. (2010) Community Engagement in South African Higher Education, *Kogisano*, (6), 3–53.

Hannay, T. (2010) What can the Web do for Science?, *Computer*, **43** (11), 84–7.

Holley, R. (2010) Crowdsourcing: how and why should libraries do it?, *D-Lib Magazine*, **16** (3/4), www.dlib.org/dlib/march10/holley/03holley.html.

Hooper-Greenhill, E. (2000) *Museums and the Interpretation of Visual Culture*, Routledge.

Howe, J. (2006) Crowdsourcing: a definition., Wired Blog Network: Crowdsourcing, http://crowdsourcing.typepad.com/cs/2006/06/crowdsourcing_a.html.

JISC: Joint Information Systems Committee (2008) *Great Expectations of ICT: how higher education institutions are measuring up*, JISC Research Report.

Johnson, L., Witchey, H., Smith, R., Levine, A. and Haywood, K. (2010) *The 2010 Horizon Report: Museum Edition*, The New Media Consortium.

Kapetanios, E. (2008) Quo Vadis Computer Science: from Turing to personal computer, personal content and collective intelligence, *Data & Knowledge Engineering*, **67** (2), 286–92.

Keen, A. (2007) *The Cult of the Amateur: how the democratization of the digital world is assaulting our economy, our culture, and our values*, Doubleday Currency.

Kling, R. (1999) What is Social Informatics and Why Does it Matter?, *D-lib Magazine*, **5** (1), www.dlib.org/dlib/january99/kling/01kling.html.

Lam, I. and Ritzen, M. (2008) *The Ne(x)t Generation Students: needs and expectations*, ICWE GmbH.

Lave, J. and Wenger, E. (1991) *Situated Learning: legitimate peripheral participation. Learning in doing: social, cognitive, and computational perspectives*, Cambridge University Press.

Lih, A. (2004) Wikipedia as Participatory Journalism: reliable sources? Metrics for evaluating collaborative media as a news resource. In *Proceedings of the 5th International Symposium on Online Journalism, April 16-17, 2004, University of Texas at Austin*, http://online.journalism.utexas.edu/2004/papers/wikipedia.pdf.

Lintott, C., Schawinski, K., Slosar, A., Land, K., Bamford, S., Thomas, D., Raddick, M., Nichol, B., Szalay, A. and Andreescu, D. (2008) Galaxy Zoo: morphologies derived from visual inspection of galaxies from the Sloan Digital Sky Survey, *Monthly Notices of the Royal Astronomical Society*, **389** (3), 1179–89.

McArthur, T. (2006) Citing, Quoting and Critiquing the Wikipedia, *English Today*, **22** (3), 2–2.

McCarthy, J. F. and Boyd, D. (2005) Digital Backchannels in Shared Physical Spaces: experiences at an academic conference. In Gerrit C. van der Veer, Carolyn Gale (eds), *Proceedings of the 2005 Conference on Human Factors in Computing Systems, CHI 2005, held on April 2-7, 2005, Portland, Oregon, USA*, ACM.

Millen, D. R., Fontaine, M. A. and Muller, M. J. (2002) Understanding the Benefits and Costs of Community of Practice, *Communications of the ACM: Special Issue on Online Communities*, **45** (4), 69–73.

Minocha, S. (2009) *Study on the Effective Use of Social Software by UK FE & HE to Support Student Learning & Engagement*, JISC, www.jisc.ac.uk/media/documents/projects/effective-use-of-social-software-in-education-finalreport.pdf.

Mojta, D. (2002) Building a Community of Practice at the Help Desk. In *Proceedings of the 30th Annual ACM SIGUCCS Conference on User Services SIGUCCS 02 (2002), November 20–23, 2002, Providence, RI, USA*.

NCCPE: National Co-ordinating Centre for Public Engagement (2009) *Draft Definition of Public Engagement*, www.publicengagement.ac.uk/.

NCCPE: National Co-ordinating Centre for Public Engagement (2011) *National Co-ordinating Centre for Public Engagement*, www.publicengagement.ac.uk/.

Nielsen, J. (2006) Participation Inequality: encouraging more users to contribute, *Alertbag*, 9 October.

OCLC: Online Computer Library Center (2007) *Sharing, Privacy and Trust in Our Networked World*, OCLC, www.oclc.org/reports/pdfs/sharing.pdf.

OECD-CERI/ Pedró, F. (2009) New Millennium Learners in Higher Education: evidence and policy implications. In *International Conference on 21st Century Competencies, held on 21–3 September 2009, OECD, Brussels*, OECD.

O'Reilly, T. (2005) *What is Web 2.0. Design Patterns and Business Models for the Next Generation of Software O'Reilly*, www.oreillynet.com/pub/a/oreilly/tim/news/2005/09/30/what-is-Web-20.html.

Pearce, N., Weller, M., Scanlon, E. and Kinsley, S. (2010) Digital Scholarship

Considered: how new technologies could transform academic work, *Education*, **16**,(1), www.ineducation.ca/article/digital-scholarship-considered-how-new-technologies-could-transform-academic-work.

Rajagopalan M. S., Khanna, V., Stott, M., Leiter,Y., Showalter, T. N., Dicker, A. and Lawrence, Y. R. (2010) Accuracy of Cancer Information on the Internet: a comparison of a Wiki with a professionally maintained database, *Journal of Clinical Oncology*, **28** (15), 605.

Reinhardt, W., Ebner, M., Beham, G. and Costa, C. (2009) How People are using Twitter during Conferences. In Hornung-Prähauser, V. (ed.), *Creativity and Innovation Competencies on the Web: proceedings of 5. EduMedia conference, May 4th and 5th, 2009, Salzburg Research Forschungsgesellschaft and St.Virgil Salzburg,* Salzburg, St.Virgil Salzburg.

RIN: Research Information Network (2011) *Social Media: a guide for researchers. A Research Information Network Guide*, RIN.

Roberts, L. C. (1997) *From Knowledge to Narrative: educators and the changing,* Smithsonian Institution Press, London, Washington DC.

Ross, C., Terras, M. and Warwick, C. (2010) Unpublished Linksphere report.

Rushkoff, D. (2005) *Get Back in the Box Thought Virus #2: Open Source and the authorship society*, David Rushkoff, http://rushkoff.com/2005/11/12/get-back-in-the-box-thought-virus-2-open-source-and-the-authorship-society/.

Schwartz, J. (2005) The Participation Age, *Jonathan's Blog*, http://blogs.sun.com/jonathan/date/20050404.

Silverman, L. H. (1995) Visitor Meaning Making in Museums for a New Age, *Curator*, **38** (3), 161–9.

Smith, S. D., Salaway, G. and Caruso, J. B. (2009) *The ECAR Study of Undergraduate Students and Information Technology 2009*, Educause Center for Applied Research, www.educause.edu.

Smith, S. D. and Caruso, J. B. (2010) *Study of Undergraduate Students and Information Technology 2010*, Educause Center for Applied Research, www.educause.edu.

Surowiecki, J. (2004) *The Wisdom of Crowds*, Doubleday.

Tatum, C. and Jankowski, N. (2010) *Openness in Scholarly Communication: conceptual framework and challenges to innovation,* http://thebook.virtualknowledgestudio.nl/table-of-contents/.

Terras, M. (2006) Disciplined: using educational studies to analyse 'humanities computing', *Literary and Linguistic Computing*, **21** (2), 229–46, http://eprints.ucl.ac.uk/4810/.

Theng, Y. L. (2002) Information Therapy in Digital Libraries, *Proceedings of Undergraduate Students and Information Technology*, **8**, Educause.

Walker, J. (2006) Blogging from Inside the Ivory Tower. In Bruns, A. and Jacobs, J.

(eds), *Uses of Blogs*, Peter Lang.

Warwick, C. (2011) *Twitter and Digital Identity*, unpublished.

Wenger, E. (1998) *Communities of Practice: learning, meaning, and identity*, Cambridge University Press.

Wenger, E., McDermott, R. and Snyder, W. M. (2002) *Cultivating Communities of Practice: a guide to managing knowledge*, Harvard Business School Press.

Wenger, E., White, N. and Smith, J. (2009) *Digital Habitats: stewarding technology for communities*, CPsquare.

Yardi, S. (2006) The Role of the Backchannel in Collaborative Learning Environments. In *Proceedings of the 7th International Conference of Learning Sciences, June 27-July 1, 2006*, Indiana University, International Society of the Learning Sciences.

Yardi, S. (2008) Whispers in the Classroom. In McPherson, T. (ed.), *Digital Youth, Innovation and the Unexpected*, The John D. and Catherine T. MacArthur Foundation Series on Digital Draft for Comment 28: Media and Learning, 143–64, Cambridge, MA, MIT Press, http://mitpress.mit.edu/catalog/browse/browse.asp?btype=6&serid=170.

Ynge, V. (1970) On Getting a Word in Edgewise. In Campbell, M.A. (ed.), *Papers from the Sixth Regional Meeting of the Chicago Linguistic Society, April 1-18, 1970*, Chicago Linguistic Society, 567–78.

Notes

1 www.ucl.ac.uk/transcribe-bentham.
2 www.qrator.org.
3 http://en.Wikipedia.org/wiki/Social_media.
4 www.slideshare.net/.
5 www.scribd.com/.
6 www.nature.com/nature/peerreview/debate/nature05535.
7 http://mediacommons.futureofthebook.org/mcpress/ShakespeareQuarterly_ NewMedia/2010/02/13/scanningcurrent-practices-of-scholarly-peer-review/.
8 www.nla.gov.au/ndp/.
9 www.galaxyzoo.org/.
10 www.zooniverse.org/.
11 www.casa.ucl.ac.uk/.
12 www.ucl.ac.uk/museums/.
13 www.ucl.ac.uk/public-engagement/.
14 www.ucl.ac.uk/public-engagement/.
15 www.ucl.ac.uk/public-engagement/.
16 www.ucl.ac.uk/public-engagement/.

CHAPTER 3

Digitization and digital resources in the humanities

Melissa Terras

Future generations of scholarship in the arts and humanities will depend upon the accessibility of a vast array of digital resources in digital form.

(Hockey and Ross, 2008, 69)

Introduction

Digitization – the conversion of an analogue signal or code into a digital signal or code – is the bedrock of both digital library holdings and digital humanities research. It is now commonplace for most memory institutions to create and then deliver digital representations of cultural and historical documents, artefacts and images to improve access to, and foster greater understanding of, the material they hold. This chapter focuses on the developing role of digitization to provide resources for research within the humanities, highlighting issues of cost, purpose, longevity, use and value and providing a round-up of sources for guidelines and standards. The recent interest from, and investment by, commercial information providers is juxtaposed with institutional concerns about the creation of digital resources for the humanities and two case studies – one, succinct and focused; one, federated and large scale – are provided, regarding specific projects which have undertaken a digitization programme, in order to provide digital resources, predominantly for use by humanities scholars.

Why digitize? Reasons for digitization

Digitization is now commonplace in most memory institutions, such as libraries, archives and museums. Most digital resources for the humanities begin with a period of digitization; as digital representations of cultural and historical documents, artefacts and images are created, generally for online delivery to users. Anything visual that is accessible to photography can be digitized, and there are many digitization processes, including: image

scanning, microfilming and then scanning the microfilm; photography, followed by scanning of the photographic surrogates; rekeying (typing in) of textual content; OCR (Optical Character Recognition) of scanned textual content; encoding textual content to create a marked-up digital resource; and advanced imaging techniques for large format or specialist items (Deegan and Tanner, 2002, 34). Sound and moving images can also be digitized, by re-recording video and audio onto digital media. The digitization process creates the core content for a digital resource, but additional infrastructure (such as a database, a website front end and an explanatory apparatus or additional teaching material) is required, in order to deliver the content successfully to users. Digitization is never a substitute for proper, structured collections management; although the development of detailed, up-to-date catalogues and metadata of institutional holdings may be a by-product of digitization, this should not be the primary motive for carrying out the digitization in the first place (Hughes, 2004, 51–2).

The creation of digital images is, by far, the most popular type of digitization, as the majority of items being digitized are documents, photographs, artworks or objects, which require a simple, two-dimensional digital surrogate to be created, before anything more sophisticated can be achieved computationally. The range of digitized material captured as digital images is as broad as the range of material held in libraries, archives, museums and private collections, including (but not limited to) printed books, printed journals, manuscripts, maps, photographs, photographic transparencies, music manuscripts, woodcuts, line drawings, paintings, archaeological site plans, archaeological finds, blueprints and architectural illustrations or plans, medical illustrations, documents, correspondence, newspapers and papyri. If processable, searchable text is required, further work is needed to generate this from an image of a text. Text can be 'rekeyed', where images of individual pages are used as the basis for an operator manually typing in content. This is generally quality controlled by having two individuals key in the text, with the resulting texts being compared. Optical Character Recognition (OCR) software can also be used to convert an image of text into a searchable string, but the success of this is dependent on the quality of the image available and the nature of the document in question: clearly printed black-and-white text can be easily OCRed; handwritten copperplate on parchment cannot, due to the intricacies of the script and differentiation between one hand and the next. Other outlier digitization methods include the digitization of sound and the moving image and three dimensional scanning of objects (as covered later in

this volume). As the object to be digitized becomes more complex, the digital surrogate becomes increasingly more time-consuming and computationally expensive to create and manipulate, and resulting file sizes increase exponentially. This is another reason why two-dimensional digital imaging of materials is the most popular and enduring digitization technique: it is a relatively fast, easy and, therefore, comparatively inexpensive process, compared to more advanced techniques. However, the cost of image-based digitization is certainly not negligible and depends on expensive technical infrastructure, equipment and expertise. Its time-consuming nature (it can take an hour to properly digitally capture and describe each item) also makes the costs of digitization quickly mount.

There are many reasons institutions bother to undertake the costly and time-consuming endeavour of digitizing a collection. From an institutional point of view, the opportunities to provide and enhance digital resources 'for learning, teaching, research, scholarship, documentation, and public accountability' (Kenney and Rieger, 2000, 1) are immense. Deegan and Tanner (2002) succinctly summarize the wide range of reasons given for digitization and the advantages that digitization of materials can hold for institutions and projects:

> immediate access to high-demand and frequently used items; easier access to individual components within items (e.g. articles within journals); rapid access to materials held remotely; the ability to reinstate out of print materials; the potential to display materials that are in inaccessible formats, for instance, large volumes, or maps; 'virtual reunifaction' – allowing dispersed collections to be brought together; the ability to enhance digital images in terms of size, sharpness, colour contrast, noise reduction, etc.; the potential to conserve fragile/precious objects while presenting surrogates in more accessible forms; the potential for integration into teaching materials; enhanced searchability, including full text; integration of digital media (images, sounds, video, etc.); the ability to satisfy requests for surrogates (photocopies, photographic prints, slides, etc.); reducing the burden of cost of delivery; the potential for presenting a critical mass of materials. (2002, 32–3)

Additional benefits not listed include the expertise acquired by internal staff; the potential for commercial licensing and the raising of revenues through this new channel; raised profiles of institutions and increased public interest in institutional holdings; the potential for experts and users alike to comment on original source material; and the harnessing of crowdsourced

labour to undertake tasks sorting and analysing the digitized collection.

The potential benefits digitization can bring vary from institution to institution and are dependent on the needs, facilities and requirements of each individual digitization project. For example, at the Victoria and Albert Museum, converting the picture archive (from which users request surrogate copies of images for research) into digital form means that prints now take only a short time to produce (Stevenson, 2006, 88). For the National and University Library of Iceland, digitization has allowed the virtual re-unification of dispersed manuscript and book collections of an entire range of Icelandic sagas, ballads, poetry and epigrams, aspiring 'to give access to the "collection of record" for the chosen subject' (Sagnanet, n.d., http://sagnanet.is/). For the First World War Poetry Digital Archive at the University of Oxford (www.ww1lit.com/), digitization has allowed the virtual collection of geographically dispersed primary source material, such as manuscripts and letters, from five major British poets from World War 1.

There may also be good reasons not to attempt digitization. Hughes details issues which may bring a sharp halt to digitization projects, including unresolved copyright issues, lack of adequate funding, lack of institutional support, technical drawbacks and the potential for digitization to damage or compromise fragile or rare original materials (2004, 50–2). Additionally, Hughes debunks common myths about digitization, stressing that digitization is not preservation and is not a substitute for proper preservation strategies, as digital masters contribute to preservation only in reducing wear and tear in the original, and surrogates can never replace the original. Digitization is not a cost effective way to save space, as, although digital files will take less physical space to store than the physical collection, the costs involved in long-term storage of the digital files are still prohibitive. Digitization does not save money, as the technical and intellectual investment required to undertake digitization is large, costs are never recouped through subscription or accession fees, and there are unpredictable costs involved in maintaining digital files in the long term. Not every object in every collection is worth digitizing, and digitization should focus on items that will give the most benefit to users (Hughes, 2004, 51–2). Those planning to undertake a digitization project are advised to consider why they are planning to invest the finances and effort in providing digital resources, so that the results can be designed for the institution and the institution's core users. Institutions and projects generally cannot afford to digitize everything; careful planning and careful selection of material to be digitized is necessary (see Hughes, 2004, 31–53).

The growth of digitized heritage content

It may seem that digitization is a recent phenomenon, but the current state of affairs, where libraries, archives, museums, galleries and even private collections are expected to make available their holdings in digital form, follows a period of experimentation with, and appropriation of, available digital technologies, which dates back almost 40 years. Institutions began to utilize computer systems in the 1970s to create catalogues and databases (van Horik, 2005). In the early 1980s, in-house imaging projects of limited scope and interest were undertaken by individual institutions experimenting with the application of the newly available (but still expensive) technologies (González, 1992). Towards the end of the decade, large-scale projects were launched by various institutions, including pilot projects aiming to investigate the appropriation of digital technologies to the handling of large volumes of information and the establishment of best practice in providing digitized content (Terras, 2008; Terras, 2010). Moving forward into the 1990s, a complex interplay between different forces encouraged unprecedented investment and development in digitization within the heritage and cultural sector: the development of the world wide web and increased access to the internet; the increase in performance and decrease in cost of digital technologies; an increase in awareness of the possibilities of information technology; resulting changes in public policy, which increased the availability of funding for memory institutions undertaking technological projects and provided infrastructure to facilitate digitization efforts; and the changing perceptions within memory institutions themselves, regarding how technology could be appropriated to meet user needs and to offer new possibilities. Towards the close of the 20th century:

> Countless millions of pounds, dollars, francs and marks [were] ploughed into digital projects that ... involved the conversion of library, museum and archive collections ... To the librarian at the very least, [the 1990s] could be termed the 'decade of digitisation'. (Lee, 2002, 160)

Alongside the creation of digital surrogates came the creation of digital repositories and libraries to host digitized content (Deegan and Tanner, 2002) and the production of best practice guidelines for digitizers to follow.

From the millennium onwards, centrally funded initiatives, such as the European eContentplus programme (http://ec.europa.eu/information_society/activities/econtentplus/index_en.htm), or the UK's JISC Content and

Digitisation programme (www.jisc.ac.uk/digitisation), have aimed to 'change the world of authoritative e-resources through investment in digitising content' (JISC, 2007), by creating a focused knowledge base of high quality resources from established projects, institutions and repositories, under the funding agency's watchful eye, demanding observance of strict technical guidelines, with aims for re-use in national repositories. This can be juxtaposed with the emergence of infrastructure from large, commercial firms to digitize holdings of institutions wholesale. By avoiding the 'cherry picking' tactics of the funding councils, they aim to digitize everything possible, with the view that searching mechanisms – allowing intelligent and useful analyses of large-scale digital collections – will soon become sophisticated enough to allow users to find the potential needles in their digital haystacks. Such digitization programmes are rife with copyright problems (indeed, the Authors Guild is currently mounting legal action against the Hathi Trust – a large-scale collaborative repository of digital content from research libraries, including content digitized via the Google Books project and local initiatives, see Association of Research Libraries, 2011, for related documents and coverage) and can often cause complaint and consternation from traditional memory institutions and researchers (Jeanneney, 2007), although many are carried out in co-operation with world-leading, large institutions to allow large-scale digitization of holdings that they just could not afford to do on their own.

The largest of such commercial digitization projects is currently being carried out by the search engine information provider Google (www.google.com), which has brokered agreements with some of the world's largest and best equipped libraries to carry out a mass digitization scheme of some of their holdings. Known as 'Google Print' at its launch in October 2004, the service is now known as 'Google Books' (http://books.google.com/), providing the facility to read books online, by giving access to images of the digitized texts compressed in PDF format. At present, this service is free to all users, but access to some materials can be restricted, depending on agreements with specific institutions and the geographical location of users. Google is currently amassing the largest ever corpus of human knowledge in digital form and aims to have digitized all the world's books – estimated at nearly 130,000,000 – by the close of the decade (Inside Google Books, 2010). The Google Book project is contentious amongst publishers, libraries and authors alike, as copyright is often not respected, financial revenues are lost, the quality of images created is often poor, there is no mechanism to report errors, and there is a worry about

future access to material owned by a commercial company, who will exploit its dominance for commercial gain.

As a result of both the commercial and publicly funded efforts to provide high quality material online, it is now difficult to remember a time when institutions did not provide digitized representations of their holdings; and the results of years of investment of effort and resources by the cultural, heritage and commercial sector now provide a rich, online environment for users to browse, analyse and study:

> Do you want to read Shakespeare's Hamlet in the first quarto edition of 1603? You have only to go to the British Library site and click on the heading 'Treasures in Full'. Do you need to consult a Finnish journal for a certain date in 1805? Go to the University of Helsinki Library site and the appropriate issue will appear on your screen. To consult descriptions of monuments in Egypt and Nubia, click on the site of the Maison dr L'Orient et de la Méditerranée. And so forth.
> (Jeanneney, 2007, 19)

The move from bespoke, small-scale digitization to large-scale repositories of digitized cultural content will prove transformative and disruptive to current modes of research and learning. Alongside these institutional and commercial efforts, there is now also a growing trend for volunteers to digitize ephemera and heritage content and utilize Web 2.0 technologies, such as the image-hosting site Flickr (www.flickr.com), to build up large collections relating to niche interests, such as specific periods of graphic design or exhaustively documenting a type of technology (Terras, 2009). As internet technologies mature, the cross-over between digitized contributions from institutions and individuals will increasingly blur, as the general public will engage more and more with digitized collections:

> What the Bodleian Library is doing now, in digitising large portions of our vast collections, is like the human genome project. Thousands of people can evaluate and use creatively the digital resources to discover new ideas and make innovations. Many hands make light work and those many hands will profoundly touch Britain's future capacity for learning, research and innovation.
> (Thomas, 2010, quoted in Tanner, 2011, 104)

Best practice in digitization

Digitization programmes aim to create consistent images of documents and artefacts, which are fundamentally individual and inconsistent, presenting a variety of physical attributes and capture requirements to the digitizer. As a result, guidelines produced for the scanning and photographic process, the cataloguing of material and the delivery and long-term storage of digitized objects, documents and artefacts aim to ensure that the digitization process is as uniform, and the quality of images produced is as predictable, as possible.

Digitization guidelines, whether practical, managerial or technical in nature, are the first point of reference for those about to undertake a digitization project, and there is no need, nowadays, for a project to establish every detail themselves. (An overview of the main imaging guidelines produced from the 1990s onwards, and a history of the development of these guidelines, can be found in Puglia and Rhodes, 2007). Institutional decisions will have to be made regarding every aspect of the digitization process, and projects should attempt to undertake digitization to sector standards. 'Best practices' are simply working procedures that can provide a safety net for practitioners, as they navigate all aspects of the digitization workflow. Following these markers will give a reasonable expectation of success and add value to projects, in terms of their long-term consistency (Hughes, 2004, 199).

Useful, trusted sources of up-to-date technical standards include those produced by established and well known institutions and government agencies. The Federal Agencies Digitisation Guidelines Initiative (www.digitizationguidelines.gov/), started in 2007, is a collaborative effort to define common guidelines, methods and practices for digitizing historical content. Their 'Technical Guidelines for the Still Image Digitization of Cultural Heritage Materials' (2010) are those used by the Library of Congress and beyond. The IMPACT Centre of Competence website provides information specifically related to digitization and OCR techniques (www.digitisation.eu). In the UK, the Joint Information Systems Committee (JISC) Digital Media Service (www.jiscdigitalmedia.ac.uk, formerly known as the Technical Advisory Service for Images) provides excellent, freely available, online, up-to-date guides, regarding all aspects of digitization, with a slant towards the provision of digital images for use in education. (Those within the UK's higher education sector can use the JISC Digital Media Helpdesk to ask specific questions regarding digitization projects which are not addressed in the wide coverage of information provided online). There are also many other sets of guidelines available from

individual universities, libraries and archives, such as those developed by Europeana (Sotošek, 2011). When establishing a digitization project, it is necessary to ascertain what the current standards are and if there are any guidelines currently provided by a related institution or funding body.

There is a broad spectrum of acceptable digitization practices. Becoming aware of the wealth of material and guidance currently available should be the first stage for those attempting to undertake a digitization project: 'Examining existing guidelines will allow the extrapolation of the best and most recent standards currently available that can be modified to fit the intended purpose, institution, and budget' (Hughes, 2004, 200). There are also some primary texts on the subject that no project should begin digitization without consulting: these are listed at the end of the chapter.

Digitization and the humanities

What do we know about the needs of humanities scholars, with regards to digitization? A key aspect of the literature about humanities scholars is that their information needs and seeking behaviours are not like those in the sciences or social sciences. Lönnqvist (1990) suggests that 'scholars in the humanities do not have homogenous information seeking behaviour or homogenous information needs' (1990, 29). However, many designers of digital resources have assumed that humanities scholars have predictable needs (Bates, 2002). Research completed by Stone (1982) and Watson-Boone (1994) showed that humanities users need a wide range of resources, in terms of their age and type. This remains true in a digital environment (Warwick, Terras et al., 2008), where humanities users continue to need printed materials and physical objects, as well as electronic resources, which, by their nature, may imply a much greater range of materials than those used by scientists (British Academy, 2005). A range of studies have shown that humanities scholars who use digital resources tend to be demanding of the quality of resources and are capable of constructing complex search strategies, given appropriate training (Bates, 1996; Dalton and Charnigo, 2004; Whitmire, 2002). Further discussion, regarding users and user studies of humanities resources, can be found in Chapter 1 of this volume.

Content-based digital resources produced for humanities scholars generally start with a period of digitization of primary source material, in order to 'create, represent, organize, analyse, and communicate scholarly content' (Rieger, 2010). It is rare that digital resources claim to limit themselves to purely humanities scholars (most are online and so, at least,

can be found by a wider internet audience); rather, it is the case that the niche areas, which are catered for in depth, will be of genuine and sustained interest to a reasonably small cohort of humanities scholars, with a particular research focus. For example, Vindolanda Tablets Online (http://vindolanda.csad.ox.ac.uk/) provides an online edition of scholarly volumes, regarding writing tablets excavated from the Roman fort at Vindolanda in northern England. While there are general resources on the site, which may be of interest to the general public and schools, the core of the material is high resolution digital images of the ancient documents themselves, with additional commentary, transcription and explanation, provided in a critical apparatus for each individual text. The project began with a prolonged period of digitization at the British Museum by project staff, providing 2500 individual scans of all the unpublished and published ink tablets (Bowman and Thomas, 2003, 14). The website, constructed collaboratively by Oxford's Academic Computing Development Team and the Centre for the Study of Ancient Documents, repurposes previously published commentaries on the texts, whilst providing updated information about the documents. The project started off with a core of digitized content, around which additional material was added to facilitate its analysis, study and discovery, within a website created to allow detailed searching.

Likewise, Old Bailey Online is a well used digital resource in the humanities, which has, at its core, a digitized, searchable text of the Proceedings of the Old Bailey, 1674–1913. The searchable text was created by scanning in microfilm of the original Proceedings and ordinary's accounts, with the scanning being outsourced to a professional service. The 190,000 images of the documents were then used to produce text, both by 'double rekeying' (whereby the text is typed in twice, by two different typists, and then the two transcriptions are compared by computer) and OCR software. With the exception of around 200 pages of the most difficult 17th century proceedings (which were transcribed by project staff), these processes were outsourced to a professional company, generating 120,000,000 words of text (Emsley, Hitchcock and Shoemaker, 2011). Following the digitization process, the text needed further encoding (to allow detailed searching), a bespoke search engine was implemented and the website was developed. The project started off with a core of digitized content, but in order to be able to exploit the material, a digital infrastructure was also required. The project has been open about usage statistics, perhaps because they are impressive: in November 2010 alone, it had over 600,000 unique visitors (Howard, Hitchcock and Shoemaker, 2010).

These projects are indicative of the type of digital resources which have been developed for humanities scholars (a further two are given in the case studies below). The projects allow improved searching and analysis of primary sources, facilitating a researcher in their task and allowing new ways to synthesize, juxtapose and create knowledge. Although many digitization projects in the digital humanities are developed with a core constituency in mind, the resulting resources can be used by a wider audience, and the ramifications of opening up access to humanities, arts and cultural content is just starting to be understood:

> Widespread access to digitized resources contributes to the vibrant cultural and intellectual life of the nation, promoting education and enjoyment for all whilst bestowing a range of benefits to local and national economies. There is also a social and economic benefit in helping to bridge the digital divide by providing digitized content to the world. (Tanner, 2011, 115)

Current issues in digitization

Although there are now established technical guidelines, the technological bedrock of digitization keeps shifting, and user expectations, regarding digitized content, are also always changing. Research questions remain about the use and usefulness of digitized content and the cost of digitization, delivery and maintenance of digitized collections.

What is it that users require from digitized heritage content? Users, who will tend to spend most of their online time on professionally produced commercial websites, are displaying increasingly sophisticated knowledge of information environments and expect the surrogates and representations provided by information institutions – and the infrastructure which hosts, provides and displays them – to keep up with modern developments (Warwick, Terras et al., 2008a). Providing large digitized collections of raw material and some fairly simple access tools is not enough to allow users to get the most out of digitized collections. Understanding how users approach digitized content, what their requirements are and what they *do* with the digitized content afterwards is at an early stage (Hughes, 2011).

This is not helped by most institutions being secretive about user statistics for digitized content, with the assumption being that the large costs of digitization programmes are seldom matched by large numbers of users accessing the resulting content. The dearth of evidence which gives hard,

clear statistics about how such digitized collections are used is worrying, considering the financial and temporal investment necessary to undertake a digitization project. There has been criticism that digitization programmes have 'sprung up in piecemeal fashion', which has largely been led by 'supply rather than demand, spurred by opportunity instead of actual need' (JISC, 2005).

The sustainability of digitized content is also concerning. It is highly expensive to maintain a digitized resource, and, without careful maintenance, online resources quickly become outmoded and unusable (Warwick, Galine et al., 2008). Most large-scale institutional digitization is funded by grant-giving authorities, which means the funding stream is time-limited and finite, with little opportunity for receiving ongoing funding and few means to generate their own income from the collection. This can mean that:

> digital resource projects struggle as they transition from grant funding to a longer-term plan for ongoing growth and development. On the surface, the issue may appear to be strictly financial, as projects urgently seek new sources of revenue to cover their costs; but more often the issues run deeper, as projects must justify their value not just to their funder, but to their host institution, to their users and to others whose support they require.
>
> (Maron and Loy, 2011, 4)

This has been exacerbated by the current challenging international economic environment, 'as dramatic funding reductions in the higher education and cultural heritage sectors put strain on every section of the pipeline, from funder, to institution, to communities of users' (Maron and Loy, 2011, 4). Fewer and fewer funding calls are emanating from funding councils, and very few calls exist to provide continuation funding for established projects. Funding for pure digitization has switched to funding to create digital research projects: funding merely to digitize collections is now very scarce. Funders are requiring ever more institutional resources to be pledged, even before funding is granted, for example, asking for the project to be embedded within a University library or institutional repository for long-term sustainability of up to ten years after the grant has ended. Evidence of 'impact' of funded projects is now being asked for from digitization projects (AHRC, 2006), at a time when the Browne review (Browne, 2010) has called for evidence of the 'value' of the arts and humanities to society. Alas:

> Value is subjective, changes over time and has different meanings that are contingent on external factors. Value of digital collections, and digital humanities in general, is particularly difficult to assess.
>
> (Hughes, 2011, 6)

Whereas the 1990s were the 'decade of digitization', we are now in the decade of digital belt-tightening, self-reflection and honest assessment of achievements in using digitized content within the humanities. The impact this will have on the growth and sustainability of digitized heritage content, at a time when commercial digitizers are ploughing ahead with mass digitization projects, when scholars are becoming more and more dependent on the affordances of digitized resources, remains to be played out:

> The value, impact and use of collections take time to evolve and to be understood, and this needs to be reconciled in a world of responsive, short-term funding opportunities.
>
> (Hughes, 2011, 10)

Summary

Digital resources in the humanities are predominantly dependent on an initial period of digitization of primary sources, and increasing amounts of digitized arts, humanities and heritage content are becoming available. However, current issues regarding the impact, sustainability and cost of digitizing resources for humanities-based research and teaching may hinder further digitization programmes in the current economic climate. This is unfortunate, as further digital content is required to allow scholars and the general public to utilize computational technologies to their full advantage:

> Technology exists to drive forward a vision of intelligent environments that supply the right information to the right person at the right time. Paradoxically, what is missing is the depth of digitized content to make such technical developments more significant than mere mobile playthings. The treasure house of content has to be digitized much more comprehensively Much has been achieved, but there are opportunities for much more impact, benefit and a greater return on the investment made in creating digital collections if we continue to invest in the knowledge economy by digitizing our wealth of information resources.
>
> (Tanner, 2011, 103)

This chapter has provided an overview of the basis, development and current status of digitization, especially for use in the humanities domain. Although digitization is now an established practice within the library, archive and heritage field, the future funding, availability and impact of digital resources in the humanities, beyond the commercial sector, remains to be determined.

Further reading

Cornell University Library's online tutorial, *Moving Theory Into Practice, Digital Imaging Tutorial* (2003). This provides an illustrated overview of the digitization process,
www.library.cornell.edu/preservation/tutorial/contents.html.

Digital Heritage: applying digital imaging to cultural heritage (MacDonald, 2006). This contains various chapters written by those working on important, well established projects in digitization across all aspects of culture and heritage.

Digital Images for the Information Professional (Terras, 2008). Terras focuses on the use of digital images across the library and archive sector, including all aspects of image-based digitization.

Digital Imaging: a practical handbook (Lee, 2002). This mostly deals with managerial issues, rather than the implementation of specific technologies, but is an excellent reference to aid those in charge of making institutional decisions regarding digitization.

Digital Perspectives (Rukowski, 2010). This is an edited collection, discussing various managerial and practical aspects of digitization.

Digitizing Collections: strategic issues for the information manager (Hughes, 2004). This details both practical and strategic issues that staff in memory institutions need to understand, before making cultural material available online.

Evaluating and Measuring the Value, Use and Impact of Digital Collections (Hughes, 2011). This is an excellent overview of the issues surrounding how to measure the impact of digitization.

Introduction to Imaging: issues in constructing an image database (Besser and Trant, 1995). This was updated in 2003 (Besser, 2003) and remains a useful, if short, introduction to digitization basics.

The JISC Digital Media Service (www.jiscdigitalmedia.ac.uk). This is an online resource and remains the first port of call for up-to-date, well explained, authoritative information and guidance for those wishing to undertake a digitization programme.

Moving Theory into Practice: digital imaging for libraries and archives (Kenney and

Rieger, 2000). This provides an overview of digitization projects and the issues which confront them.

Preparing Collections for Digitization (Bülow and Ahmon, 2011). This is a useful source of guidance on preparatory activities that are a necessary part of any digitization project.

..
CASE STUDY Digitization case study: Europeana Travel
..

Lesley Pitman, Librarian and Director of Information Services, UCL SSEES Library at University College London

In May 2009, UCL Library Services became one of the lead partners in Europeana Travel (http://europeanatravel.eu/) – a two-year digitization project funded by the Commission of the European Union, through their eContentplus programme (http://ec.europa.eu/information_society/activities/econtentplus/index_en.htm), following a call the previous year for cultural content in the area of digital libraries.

The European Digital Library Foundation proposed a number of themes for possible projects for this call, including cities, crime and punishment, and travel and tourism. These were all intended to be of broad general interest and to expand the range of high quality cultural resources available through Europeana, which was then in its early development stage. In response, a partnership of national and university libraries from across Europe were brought together, united by two things: strong collections on the theme of travel and tourism and considerable experience in high quality digitization. This partnership, which became the Europeana Travel Project, was significant in bringing together university and national libraries from across Europe. It was supported by the European Digital Library (EDL) and two founding members of the EDL Foundation: CENL, representing European national libraries; and LIBER, representing a broader range of research libraries across Europe, including many university libraries. The range of libraries and countries represented in the project was impressive and allowed for an extraordinarily wide range of digitized content, within the overall theme of travel and tourism. The partners were the following: the National Libraries of Estonia (the project co-ordinators), Finland, Latvia, Poland, Austria, Slovakia, The Netherlands and Wales; the National and University Library of Slovenia, the University Libraries of Lund, Regensburg, Innsbruck, Trinity College Dublin and UCL, the State and University Library of Lower Saxony, and the University and National Library of Debrecen, plus the EDL Foundation, as the provider of services to end-users through

Europeana. Finally, Eremo srl (www.eremo.net/) were appointed as scientific managers.

UCL's role was a significant one, as content provider, but also as work package leader for two distinct work packages; library staff, therefore, found themselves deeply committed to the project from the very beginning. The Commission provided 50% of the funding, and the rest was to be contributed by partner institutions.

Material to be digitized by project partners covered numerous different subjects, languages and formats, including historic maps, postcards, travel tales, diaries, photograph albums, folk songs, rare books and archives. All content was accepted, on the basis that it was free of IPR (intellectual property rights) issues. UCL contributed three categories of content from the collections of the UCL School of Slavonic and East European Studies Library (www.ssees.ucl.ac.uk/libarch.htm). They were a collection of almost 300 rare travel books, dating from 1557 to 1860, with a focus on travels in Eastern and central Europe and Russia; a collection of 200 maps of the same region and period and some archive materials relating to Sir Arthur Evans, the archaeologist, who had bequeathed his writings on south-eastern Europe to the School on his death in 1941.

Europeana Travel had five principal aims: to digitize library content on the theme of travel and tourism for use in Europeana; to establish an aggregator, through which Ligue des Bibliothèques Européennes de Recherche (Association of European Research Libraries, LIBER) libraries which require such a service can provide content to Europeana, and to see a sustainable basis for the aggregator's continuing functioning; to deepen collaboration between the *Conference of European National Librarians* (CENL) and LIBER, in support of Europeana; to mobilize the efforts of the research libraries in support of Europeana; and to provide examples of best practice in digitization methods and processes, constituting a learning opportunity for all libraries wishing to supply digitized material to Europeana.

To achieve its aims, the project was divided into a number of work packages: UCL led the first work package, which was concentrated in the first six months of the project and had as its objective, the planning of the digitization processes and the mechanisms for sharing good practice. The processes and mechanisms put in place in that work package were then used to monitor progress in the second work package, which was concerned with the actual digitization in partner libraries and was led by the Slovenian National Library. An important feature of the project, as with all Europeana projects, is that the content is digitized locally, and the digital images are held on local systems, with only the metadata and thumbnails harvested by Europeana. Both work packages were

greatly facilitated by the high level of experience and expertise among project partners.

UCL's other major role was as leader of the third work package, which was tasked with creating an aggregator for the content coming from the university libraries, to parallel the service provided by the European Library for the national libraries. This was important both to encourage further participation in Europeana by university libraries and to support Europeana itself, as its processes relied on dealing with aggregators, rather than numerous, individual, contributing libraries. The close work on aggregation between UCL (on behalf of LIBER) and the European Library, throughout Europeana Travel, has allowed for further projects to be developed to bring the two aggregators together: the Europeana Libraries Project (www.europeana-libraries.eu/) has since been developed, with substantial input from UCL Library Services. Finally, two further work packages dealt with dissemination to a professional audience and the wider public, and with project management. The public deliverables of the project can all be found on the project website (www.europeanatravel.eu). They include reports on aggregation issues for university libraries, digital preservation and minimum technical standards required for participation in Europeana, including the report *Best Practice Examples in Library Digitisation, March 2011* (Sotošek, 2011), which is useful for others involved in large-scale digitization projects, as it documents current best practice in the areas of image capture and equipment, handling of originals, metadata generation, OCR, access, workflow, quality assurance and cost modelling for digital preservation and user evaluation – all as practised by the project partners.

UCL Library Services has benefited hugely from its participation in this project. It has had the opportunity to work with, and learn from, some of Europe's leading experts in digitization and to contribute its own expertise in project planning and in digital repositories. The funding has allowed some of its rarest and most interesting special collections to be made easily accessible, via its own digital library and to the wider community that uses Europeana, helping to support UCL's work in research, teaching and public engagement. ∎

..

CASE STUDY Assyrian empire builders: governors, diplomats and
soldiers in the service of Sargon II, King of Assyria
..

Karen Radner, Professor in Ancient Near Eastern History, Department of History,
University College London
With 1200 original texts in the form of clay tablets inscribed in the cuneiform

script, the correspondence between Sargon II, King of Assyria (721–705 BC), and his governors is the largest corpus of state letters known from the ancient world. It provides exceptional insight into the mechanisms of communication between the top levels of authority and the delegation of power in an ancient empire that stretched from the Mediterranean coast to Western Iran and from Anatolia to the Persian Gulf. Until now, this exciting correspondence has only been known by specialist researchers. The website *Assyrian Empire Builders* (www.ucl.ac.uk/sargon/) aims to change that, making available Sargon's state letters, together with resources for their study and materials on their historical and cultural context.

This web resource is part of the dissemination strategy for the research project 'Mechanisms of Communication in an Ancient Empire: the correspondence between the King of Assyria and his magnates in the 8th century BC'. Funded by the Arts and Humanities Research Council (2008–12), the project has its home in UCL's History Department, where Ancient Near Eastern history has been taught since the 1930s. The website's aim is twofold: to provide reliable and easily accessible information on Assyria in the second half of the 8th century BC and to promote the use of Sargon's letters as a source for political, administrative, cultural and military history. The site addresses a broad audience and, while requiring no previous knowledge, it has much to offer, even for specialist researchers. There are three key sections of the site: 'About the Project' (providing information on scope, funding and copyright), 'Essentials' (providing highlights and overviews to attract and appeal to a broad audience without any previous expertise) and 'Royal Correspondence' (providing access to the text corpus).

All 1200 letters are available in transliteration (renderings of the cuneiform text in Latin script) and English translation, adapted from the editions in four volumes of the State Archives of Assyria series (published 1987–2003) and reproduced with the authors' permission. The series' editor, Professor Simo Parpola of the University of Helsinki, kindly supplied the ASCII heritage dataset

Figure 3.1 *This letter was found with its envelope intact, which was opened only in the British Museum. The letter was sent to a state official, by a man who had lost his post; according to the letter itself, it was one of a whole series of missives, with which the author was bombarding the official, without ever receiving a reply to his pleas: 'Why is my lord silent (while) I wag my tail and run about like a dog? I have sent three letters to my lord. Why does my lord not consent to send an answer to (my) letter? Let my lord return me to my office. As much as I served your father, so let me now serve you!' (British Museum, 81-7-27, 199 and 199A = SAA 15 288 & SAA 15 289; photo by Greta Van Buylaere). Reproduced with permission of the British Museum. SAA 15 = Fuchs, A. and Parpola, S. (2001) The Correspondence of Sargon II, Part III (State Archives of Assyria 15), Helsinki University Press.*

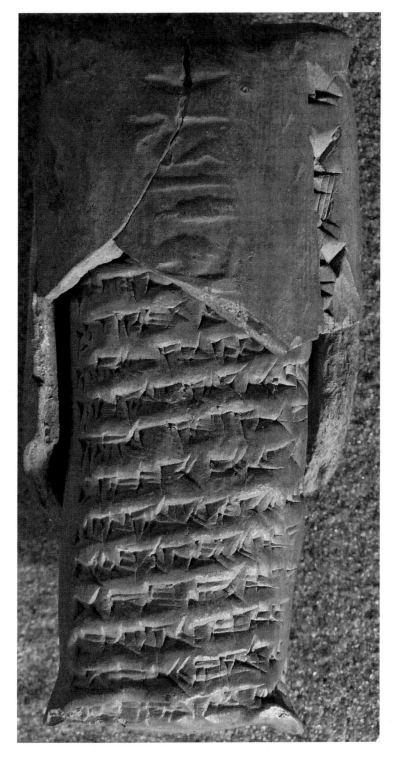

used to create these publications. This data was converted into XHTML/UTF-8 unicode files and used to generate a fully searchable online text corpus that is linked to the interactive glossaries and indices distilled from it. This has created a powerful research tool that far exceeds the possibilities of the print editions. All letters in Assyrian language can also be displayed in cuneiform script, using the font CuneiformNA, which can be downloaded from the site; this is especially useful for teaching.

The text corpus was created in collaboration with Professor Steve Tinney of the University of Pennsylvania, Philadelphia, who designed the underlying programing and is part of the Open Richly Annotated Cuneiform Corpus (ORACC; http://oracc. museum.upenn.edu/) – a workspace and toolkit for the development of a complete corpus of cuneiform that is quickly finding worldwide acceptance as the discipline standard for the online presentation and management of cuneiform sources. The Sargon Letters data can be directly harvested and utilized by all other projects operating within the ORACC umbrella, e.g. the site Cuneiform Texts Mentioning Israelites, Judeans, and Related Population Groups, maintained by scholars at the University of Tel Aviv (http://oracc.museum.upenn.edu/ctij).

While this part of the site is the most attractive for researchers, the section 'Essentials' is designed to appeal to a more general audience. Containing introductions to the political and cultural history of the second half of the 8th century BC, the content is grouped into the subdivisions: Kings, Governors, Diplomats, Soldiers, Countries, Cities and Archives. Each essay is about 1200 to 1500 words and divided into three to four parts, each of which is illustrated by a photo, drawing or map. Suggestions for further reading are provided; the bibliography features editions of primary sources and key studies of the last two decades in English, German, French and Italian, grouped in thematic subdivisions. When available, links to online publications, Google Books and related websites are given. In addition, a number of colleagues have given permission to make their work available.

Thirty-seven of Sargon's letters are presented in a 'Highlights Section'. The clay tablets resemble a mobile phone in size and shape and are inscribed in cuneiform, either using the Assyrian or Babylonian language. Our high resolution photographs of text samples in the British Museum are composites that show the front, back, top, bottom and sides in a single image, with measurements and scales. The individual photographs were taken over a few days in autumn 2008 in the Students' Room of the Middle East Department and the resulting .jpg images combined into composites using Photoshop. The tablets were chosen for their excellent state of preservation content and provide a good starting point for studying the original sources.

The website provides interactive lists of all words used in the translations that are not self-explanatory and all proper names mentioned in Sargon's letters, giving etymologies for all personal names and mini biographies for all individuals. Wherever possible, place names are identified with their modern equivalents and linked to Google Earth and Google Maps.

The site template was created by web designer Ruth Horry. The content is written and maintained by the UCL project team (Karen Radner, Mikko Luukko and Silvie Zamazalova), who regularly add pages for the 'Essentials' section and update the bibliography. The site went online on 23 December 2009. Google Analytics is used to monitor access rates and user interests. So far, the site has attracted 23,980 visits by 14,994 visitors from 143 countries, whose average time on the site is 2:17 minutes (20 October 2011). These numbers signal a dramatic change in the letters' accessibility, especially if one bears in mind that the print run of the four State Archives of Assyria volumes was 1000 copies each. The site is among Google's first ten search results for all obvious search terms, such as 'Assyrian Empire' and 'Sargon II'.

Assyrian Empire Builders: governors, diplomats and soldiers is, therefore, increasing access to a resource previously known only to specialist researchers, utilizing internet technologies and digitized content to encourage academic debate and novel research, whilst both fostering teaching with, and raising the profile of, this unique collection. ■

Bibliography

AHRC (2006) Impact Strategy,
 www.ahrc.ac.uk/About/Policy/Documents/impact%20strategy.pdf.

Association of Research Libraries (2011) *Authors Guild v. HathiTrust et al. Resources*,
 www.arl.org/pp/ppcopyright/orphan/agvhathi/agvhathi_resources.shtml.

Bates, M. J. (1996) The Getty End-User Online Searching Project in the Humanities:
 report no. 6: overview and conclusions, *College and Research Libraries*, **57** (6),
 514–23.

Bates, M. J. (2002) The Cascade of Interactions in the Digital Library Interface,
 Information Processing & Management, **38** (3), 381–400.

Besser, H. (2003) *Introduction to Imaging.* In Hubbard, S. with Lenert, D. (eds), rev.
 edn, Getty Research Institute,
 www.getty.edu/research/conducting_research/standards/introimages/index.html.

Besser, H. and Trant, J. (1995) *Introduction to Imaging: issues in constructing an image
 database*, Getty Art History Information Program.
 www.getty.edu/research/conducting_research/standards/introimages/index.html.

Bowman, A. K. and Thomas, J. D. (2003) *The Vindolanda Writing Tablets Volume III*, British Museum Press.

British Academy (2005) *E-Resources for Research in the Humanities and Social Sciences – a British Academy policy review*, www.britac.ac.uk/policy/eresources/e-resources.cfm.

Browne, J. (2010) *Independent Review of Higher Education Funding and Student Finance*, http://hereview.independent.gov.uk/hereview.

Bülow, A. and Ahmon, J. (2011) *Preparing Collections for Digitization*, Facet Publishing.

Dalton, M. S. and Charnigo, L. (2004) Historians and their Information Sources, *College & Research Libraries*, **65** (5), 400–25.

Deegan, M. and Tanner, S. (2002) *Digital Futures: strategies for the information age*, Library Association Publishing.

Emsley, C., Hitchcock, T. and Shoemaker, R. (2011) Old Bailey Online – about this project, *Old Bailey Proceedings Online*, www.oldbaileyonline.org.

Federal Agencies Digitisation Guidelines Initiative Still Image Working Group (2010) *Technical Guidelines for the Still Image Digitization of Cultural Heritage Materials*, www.digitizationguidelines.gov/guidelines/FADGI_Still_Image-Tech_Guidelines_2010-08-24.pdf.

González, P. (1992) The Digital Processing of Images in Archive and Libraries, Large Scale International Projects. In Thaller, M. (ed.), *Images and Manuscripts in Historical Computing: proceedings of a workshop on 15 November 1991, organized by the International University Institute, Firenze*, Max Planck Institute.

Hockey, S. and Ross, S. (2008) Conclusion. In Hughes, L. (ed.), *The AHRC ICT Methods Network: an evaluation*, OHC.

Howard, S., Hitchcock, T. and Shoemaker, R. (2010) *Crime in the Community Impact Analysis Report*, www.jisc.ac.uk/whatwedo/programmes/digitisation/impactembedding/oldbayley.aspx.

Hughes, L. (2004) *Digitizing Collections: strategic issues for the information manager*, Facet Publishing.

Hughes, L. M. (2011, forthcoming) *Evaluating and Measuring the Value, Use and Impact of Digital Collections*, Facet Publishing.

Inside Google Books (2010) *Books of the World, Stand up and be Counted*, http://booksearch.blogspot.com/2010/08/books-of-world-stand-up-and-be-counted.html.

Jeanneney, J-N. (2007) *Google and the Myth of Universal Knowledge, A View from Europe*, University of Chicago Press.

Joint Information Systems Committee (JISC) (2005) *Digitisation in the UK: the case for UK framework*,

www.jisc.ac.uk/publications/programmerelated/2005/pub_digi_uk.aspx.

Joint Information Systems Committee (JISC) (2007) *Digitisation Programme*, www.jisc.ac.uk/digitisation_home.html.

Kenney, A. R. and Rieger, O. Y. (2000) *Moving Theory into Practice: digital imaging for libraries and archives*, Research Libraries Group.

Lee, S. (2002) *Digital Imaging, a Practical Handbook*, Facet Publishing.

Lönnqvist, H. (1990) Scholars Seek Information: information-seeking behaviour and information needs of humanities scholars, *International Journal of Information & Library Research*, **2** (1), 195–203.

MacDonald, L. (ed.) (2006) *Digital Heritage, Applying Digital Imaging to Cultural Heritage*, Elsevier.

Maron, N. and Loy, M. (2011) *Funding for Sustainability: how funders' practices influence the future of digital resources*, JISC Strategic Content Alliance, http://sca.jiscinvolve.org/wp/files/2011/06/examination_funder_policies_practices_UK.pdf.

Puglia, S. and Rhodes, E. (2007) Digital Imaging – how far have we come and what still needs to be done?, *RLG DigiNews*, **11** (1), www.rlg.org/en/page.php?Page_ID=21033#article2.

Rieger, O. (2010) *Framing Digital Humanities*, www.uic.edu/htbin/cgiwrap/bin/ojs/index.php/fm/article/view/3198/2628.

Sagnanet (n.d.) *The Collection and Participating Libraries*, http://sagnanet.is/saganet/?MIval=/sgn_start_description_of_data&language=english.

Sotošek, K. S. (2011) Best Practice Examples in Library Digitisation, *Europeana Travel*, http://europeanatravel.eu/downloads/ETravelD2%202final.pdf.

Stevenson, J. (2006) Digitisation Programmes in the V&A. In MacDonald, L. (ed.), *Digital Heritage, Applying Digital Imaging to Cultural Heritage*, Elsevier.

Stone, S. (1982) Humanities Scholars: Information Needs and Uses, *Journal of Documentation*, **38** (4), 292–313.

Tanner, S. (2011) The Value and Impact of Digitized Resources for Learning, Teaching, Research and Enjoyment. In Hughes, L. M. (ed.), *Evaluating and Measuring the Value, Use and Impact of Digital Collections*, Facet Publishing.

Terras, M. (2008) *Digital Images for the Information Professional*, Ashgate.

Terras, M. (2009) Digital Curiosities: resource creation via amateur digitisation, *Literary and Linguistic Computing*, **25** (4), 425–38.

Terras, M. (2010) The Rise of Digitization: an overview. In Rukowski, R. (ed.), *Digital Perspectives*, Sense Publishers.

Thomas, S. (2010) Interview for Inspiring Scholarship, Inspiring Research, Bodleian Library. In Hughes, L. M. (ed.), *Evaluating and Measuring the Value, Use and Impact*

of Digital Collections, Facet Publishing.

van Horik, R. (2005) Permanent Pixels: building blocks for the longevity of digital surrogates of historical photographs, doctoral thesis, Delft University of Technology, DANS Studies in Digital Archiving 1, DANS (Data Archiving and Networked Services).

Warwick, C., Terras, M., Huntington, P. and Pappa, N. (2008) If You Build It Will They Come? The LAIRAH Study: quantifying the use of online resources in the arts and humanities through statistical analysis of user log data, *Literary and Linguist Computing,* **23** (1), 85–102.

Warwick, C., Galina, I., Terras, M., Huntington, P. and Pappa, N. (2008) The Master Builders: LAIRAH research on good practice in the construction of digital humanities projects, *Literary and Linguistic Computing,* **23** (3), 383–96.

Watson-Boone, R. (1994) The Information Needs and Habits of Humanities Scholars, *Reference Quarterly,* **34** (2), 203–16.

Whitmire, E. (2002) Disciplinary Differences and Undergraduates' Information Seeking Behaviour, *Journal of the American Society for Information Science and Technology,* **53** (8), 631–8.

Image processing in the digital humanities

Melissa Terras

Image processing in many ways has been the 'hottest' topic in Humanities computing in recent years.

(Thaller, 1992a, 1)

Introduction

 Digital images can be analysed, interrogated or sorted through the use of 'image processing' algorithms to reveal patterns or features, highlight characteristics not visible to the human eye or sort through large amounts of image data faster than would be possible by a human operator. There is a niche interest, with a long history in using computational technologies to facilitate the analysis and understanding of cultural and heritage objects, through manipulation of their digital image surrogates. This chapter aims to provide an overview of image processing techniques and how they have been applied in the arts, humanities and heritage sectors.

Most applications of image processing within the humanities are for research purposes; and the approaches chosen are generally bespoke, requiring specific application of techniques to suit the individual images and research question. Additionally, most research carried out in this area is in collaboration with computer or engineering scientists, who can best advise on technological approach and application. Two case studies are provided, giving details of specific projects, which involve adopting and creating specific image-processing methodologies to aid in research in the humanities; these are both the product of interdisciplinary teams.

What is image processing?

Image processing – the manipulation of digital images by a computer to change the images for effect, display or analysis – is a large and complex field within engineering and computing science (Gonzalez and Woods,

1993). The earliest computer processing of images began in the 1950s at the National Bureau of Standards on the SEAC (Standards Eastern Automatic Computer) – the first electronic computer in the US Government with an internally stored program and enough memory[1] to manipulate the underlying image data. There followed much investment in digital imaging technologies, specifically to improve communications in space exploration and for defence in the Cold War. The United States of America's National Aeronautics and Space Administration (NASA) attempted to enhance and process communications for space exploration. The need to automate the processing of surveillance photographs for defence encouraged the development of automated techniques for image enhancement, restoration, editing and basic manipulation of size, colour, brightness and contrast. Digital imaging, as both an academic and commercial research and product development field, was truly established in the early 1960s. The term 'computer graphics' was coined by computer scientists working at Boeing Corporation (Fetter, 1964) to describe attempts at the synthesis and manipulation of digital visual content. From that point, falling costs of computer components, coupled with rising storage and processing capacities of computers, meant that access to computational power became more commonplace, allowing (and requiring) much research and development to be carried out on the intricacies of image-generating software and systems (see Terras, 2008, for further information about the history of digital images and image processing).

There are a large number of applications of image processing to a vast area of human activities. Automated processes can be used to analyse images – both to pick out patterns that the human eye cannot see and to search through and analyse corpora of images too vast for an operator to process manually. Automated visual inspection systems are used to improve product quality and productivity in industry. Remote sensing is used in agriculture, forestry, geology and hydrology to analyse and inspect the earth's natural resources, via scene analysis of images returned from satellites. Various types of imaging techniques are used for the purpose of medical diagnosis. Automated aerial surveillance techniques are used to monitor areas of the earth's surface for defence purposes. Content-based image retrieval techniques are used to search for particular images in large image archives. Finding and retrieving images on the internet remains a popular research challenge. For examples of these applications, plus further instances of how image processing is now routinely used, see Acharya and Ray (2005, 3–7) and Marques (2011, 5–7).

Most image-processing techniques involve treating the digital image as a two-dimensional signal[2] and applying standard techniques, which analyse, sort, re-order or otherwise mathematically interpret the underlying grid of pixels. The output of image processing techniques may be either an image or a set of results related to the image. Typical tasks undertaken by image processing include: geometrical transformations of an existing digital image, such as rotation, cropping, enlargement or reduction; colour calibration and correction, such as changing an image from RGB colour to greyscale and digitally combining ('compositing') images. Analysis techniques that can be used to compare, contrast and query the content of images include: image registration, where two or more images are aligned; image recognition, which is used to determine whether or not an image contains some specific object, feature or activity; and image segmentation, where an image is automatically partitioned into multiple segments, which simplifies the representation and makes it easier to analyse. Although there are now standard techniques to do many basic tasks in image processing, it is a rich area of research in computing and engineering, with much continuing interest in improving the automated processing of digital image data.

Basic 'what-you-see-is-what-you-get' (WYSIWYG) image manipulation tools have been available on desktop PCs since the early 1990s, with Adobe PhotoShop being the industry standard. However, image manipulation, through tools such as PhotoShop, is not what is meant here by image processing; although some image processing routines end up in WYSIWYG software, image processing research is about developing the procedures and algorithms to manipulate image-based material (rather than employing them for purely visual effect). The most popular programing environment for this area is MATLAB (MATrix LABoratory):[3] a widely used computational tool, which provides both a programing language and interactive interface to allow the implementation of algorithms, the plotting of functions and the manipulation of matrices in numerical computing. While there are image processing software libraries available for MATLAB, which provide algorithms typically used in the processing of images (see Marques, 2011, for an overview), the language element of the system allows researchers to develop their own analysis techniques and to build on the research of others. This allows for bespoke image processing techniques to be implemented, which can be tailored to the research question and images in question.

Image processing and the humanities

There has been a relatively long history of the use of computational technologies to facilitate the analysis and understanding of cultural and heritage objects. This can be accomplished through digital imaging in two ways. Either the nature of the capture of the digital image can be adjusted through advanced digitization, allowing the creation of digital images, which expand our understanding by capturing information the human eye or brain is not capable of processing independently; or digital images can be analysed and interrogated computationally through image processing to reveal patterns or features in the image, which would not otherwise be noticeable. The two procedures are often linked, with specific digitization processes carried out to provide high resolution digital images, which can then be used as the basis for image processing analysis. Image processing can also be used to help sort collections of images, in order to search for images which have specific features. Various image processing techniques have been used within the arts, heritage and culture domain since the early 1980s, when early pilot digitization projects explored the technicalities and possibilities of digitization and image processing (Thaller, 1992b; see also Chapter 3). Reflecting on projects from that period, research tended to be focused on a specific object or collection, and the techniques employed varied, according to the problem in hand.

Image processing allowed conservators to experiment with many different restoration approaches, without physically handling paintings beyond the digitization process (Freifeld, 1986). The original, varnish-free colours of the Mona Lisa were established through high resolution imaging and processing to recover its original appearance and to bring out long-hidden details (Asmus et al., 1987). Image processing has been used extensively in archaeology to analyse aerial images of potential sites and aid in their classification (Forte, 1992). Image processing allowed the analysis of watermarked paper to help establish the identity of the printers of early printed books (Gants, 1998). Image processing was used to create watermarks or identifying elements within an image, to hinder the unauthorized use of the digital image in publication or distribution (Gladney et al., 1996). Image processing can also be used to segment images into constituent parts, which can be useful, say, in the study of stained glass windows, allowing possibilities for the production of surrogates, inspecting and interpreting of the windows. Filters were used to remove background noise and to produce 'clean' images, which researchers used as a further, alternative information source (MacDonald et al., 2006). Image processing

has been used, in conjunction with advanced digitization techniques, to help analyse the Antikythera Mechanism (an ancient mechanical computer designed to calculate astronomical positions) (Freeth et al., 2006). Image processing is being used to track the appearance of medieval coins on eBay to aid in their identification and prevent the selling of stolen collections (Jarrett, 2012). A full bibliography for these, and other applications of imaging technologies to humanities problems throughout the 1980s and 1990s, is available in Nowviskie (2002). Further examples are also available in MacDonald (2006). In all of these cases, the use of image processing techniques has allowed novel research to be undertaken on primary source material, providing new insights into culture and the arts.

There is a strong interest in the use of image processing to aid the reading of damaged and deteriorated textual material. The Archivo General de Indias Project (González, 1992) developed different algorithms to improve the quality of digitized images, allowing users to select the range of tonalities viewable, blackening letters and separating them from the image background. Image processing is now routinely used to improve the readability of portions of manuscripts which have become unreadable, due to a reduction of contrast (caused by oxidation, humidity, etc.) or to aid in reading the eroded surface of objects, such as incised documents, coins or inscriptions, where letters cut into the surface are no longer clearly visible (Terras, 2006; Tarte et al., 2010). Manuscript material which has been erased can be virtually restored using image processing techniques to reconstruct overwritten portions of text (Twycross, 2006), and image processing can aid in the virtual unrolling of papyri (Tarte, 2012). Image processing is often used in conjunction with advanced image capture techniques, such as multispectral imaging (where image data is captured at a large number of spectral measurements, possibly outside the visible range, rather than just red, green and blue, which are the dominant colours relevant for human vision) to aid in the reading of excised texts, such as the Archimedes Palimpsest (Salerno, Tonazzini and Bedini, 2007). Work is underway to establish robust protocols for this procedure in the heritage sector (Giacometti et al., 2011). The proceedings of a symposium on the 'Digital Imaging of Ancient Textual Heritage: technological challenges and solutions', held in Helsinki in 2010, detail these, and other, image processing approaches to facilitate the reading of ancient documentary material (Eikonopoiia, 2010).

CBIR and image searching

It is worth pausing here to consider an area of image processing which was of great interest to the cultural and heritage sectors throughout the 1990s, but has now fallen out of favour for use with heritage content: Content-based Image Retrieval (CBIR). CBIR is an automated process that aims to retrieve images from a large collection on the basis of features (such as colour, texture and shape). This is entirely different from the retrieval of images by manually assigned keywords, as CBIR depends on the automated comparison of the image data itself, rather than searching through metadata about the image.

In the literature, the earliest use of the term 'Content-based Image Retrieval' seems to have been by Kato (1992), to describe his experiments into automatic retrieval of images from a database by a colour and shape feature. There was a huge interest in CBIR as digitization rolled out across the heritage sectors, as it was believed it could provide intuitive, fast ways to sort through vast quantities of visual data (See Cawkell, 1992; Cawkell, 1993; and Eakins and Graham, 1999, for an overview of CBIR and its use and appropriation in heritage institutions). An early adopter included the State Hermitage Museum in St Petersburg, Russia, who partnered with IBM to provide an online mechanism to sort through images by colour and by areas of colour, using IBM's experimental Query By Image Content (QBIC) search technology. This search facility is still online (www.hermitagemuseum. org/fcgi-bin/db2www/qbicSearch.mac/qbic?selLang=English), and it is worth playing with the tool to get an idea of why CBIR never became a popular front end to digital image databases:

> [T]he technology still lacks maturity, and is not yet being used on a significant scale. In the absence of hard evidence on the effectiveness of CBIR techniques in practice, opinion is still sharply divided about their usefulness in handling real-life queries in large and diverse image collections. Nor is it yet obvious how and where CBIR techniques can most profitably be used.
>
> (Eakins and Graham, 1999, 3)

The hype surrounding CBIR did not live up to its implementation. There is, undoubtedly, further research opportunity in the automatic querying of large-scale image databases, which remains a focus of much interest in engineering, computing science and industry. Google has recently implemented 'search by image' (http://images.google.com/), allowing images to be dropped into the search bar as a search term, to aid in their

identification and to provide further information about them (Google, n.d.). The reverse-image look-up engine TinEye (www.tineye.com/) informs the user where images appear elsewhere on the internet. However, until this technology matures, and users become more used to searching using visual items, rather than textual strings, it is likely to remain a technological curiosity within the cultural and heritage sectors. There are also ample opportunities for digital humanities – and pure humanities – scholars to contribute to, and influence, research in this area, given the different use, appreciation and understanding of image-based material to those in pure computer science. The research field has much to gain from interdisciplinary perspectives on image material.

Image processing and interdiscplinary research

If image processing has been applied to humanities research for so long, why is it not better known, or part of most syllabi, for teaching digital humanities? Why have most people undertaking digital humanities research never undertaken any image processing? (Image manipulation in PhotoShop is not counted here as *bona fide* image processing). Why are these techniques not better understood, or better known, within the digital humanities community?

Firstly, unlike technological approaches, such as text encoding or digitization, there are no guides to good practice in image processing; there can be no guides, as each application is bespoke, depending on the research question and the individual image requiring analysis. This means that there is no simple 'painless introduction'. To apply image processing methods to a research question, an individual must have experience in mathematics, programing and image processing applications. The tools currently available to facilitate research in this area are either limited – tending to be tied to specific research projects, in particular research groups – or fairly technical, with a high barrier to entry (such as MATLAB). Image processing thus remains sequestered to the pantheon of tools available to computer and engineering scientists only, as most humanities scholars do not have the technical background to apply the techniques themselves.

Secondly, the projects listed above all involved interdisciplinary research teams, where computing and engineering scientists advised humanities experts, curators and archaeologists on how to apply the image processing techniques in question. There can still be some resistance from traditional humanities scholars to interdisciplinary research teams, but for this kind of

research, collaboration is essential. Those in the humanities who are interested in pursuing this area are advised to make contact with individuals undertaking 'vision' or 'imaging' research within the computational sciences, in order to establish partnerships.

Finally, much of the use of image processing in the arts, humanities, library, archive and museum sectors borrows tools and understanding from computing and engineering science, which can be a problem for the latter working in those areas, if there is no room in a research project to develop new techniques and approaches. Some projects do develop novel imaging processing algorithms specific to their own application, which can, in turn, be applied in other areas (not only in the arts and humanities: the work on the Vindolanda texts, as described in the case study below, has informed other work on medical imaging). A humanities research project will be attractive to scientists, only if there is room for a scientific research contribution. Finding interested partners who are willing to collaborate, and can see the potential of this type of research, is part of the problem (Terras, 2010; Terras, 2012).

As a result of these difficulties, image processing is not a terribly well known technique within the digital humanities, and:

> the promised research opportunities that are inherent in the new technologies has[sic] not been matched by tools that enable historical scholarship. Even the image databases themselves that are available ... are limited in scale, detail, fidelity, resolution, and flexibility – indeed, in the processes ... we are probably in the same stage that text was in the 1980s.
>
> (Hockey and Ross, 2008, 65)

There is a lot of potential for image processing in the humanities, but issues about encouraging knowledge about, and uptake of, the techniques remain.

Using the results of image processing in humanities research

In addition to using image processing techniques to produce alternative evidence for research in the humanities, there can be issues in using manipulated images for research and the illustration of academic findings. Van den Berg, Brandhorst and van Huisstede (1992), in an early paper on the use of image processing in art history, argued that the main issues in the use of image processing in the study of the arts and humanities are not technical, but intellectual – 'what do we study and how do we study it?' – and

conceptual – 'how do we present the results of our studies?' (1992, 5). Questions have since been raised about the authenticity of digitized and processed image-based material and how careful we should be when drawing research conclusions from it (Tarte, 2011). There are ethical concerns to be aware of when using image processing to produce manipulated images, which will be used as primary evidence in research:

> [S]cholars dependent on the digital environment should ensure that they understand the representations of artefacts that they base their research upon we must begin to build up our theoretical understanding of notions of digitisation and representation so we can articulate our dependencies and be sure about our methodologies when relying on digital surrogates. In particular, it should be acknowledged that digital images [of artefacts] have a complex relationship to their source material. Additionally, digital images created in ways which would never have existed using traditional photography, or human vision, such as multi spectral or infra-red images, should be treated as they are: representations, and surrogates, rather than replicas of original material. If we cannot understand the means of production of the surrogates, can our interpretations ever be robust? Only through becoming digitally and informationally literate can we trust that our images of artefacts are free from artefacts and errors. (Terras, 2012, 62)

As a start, all changes made to images, however slight, should be noted in technical metadata, to explain the image's provenance. All processing techniques should be detailed within research outputs that depend upon them. Assessing image quality is usually dependent on human observation, and this is a subjective notion, dependent on observer based quality judgements (Engeldrum, 2000); clear documentation and understanding of the processes used to create research evidence is the only approach to combat subjectivity and uncritical dependence. By doing so, we may reach an understanding of the 'modality and materiality of digital historical objects', as 'new roles and a set of defining characteristics emerge beyond their role as servant to the "real" as representation, presence, affect, experience, and value' (Cameron, 2007, 70).

Conclusion

The use of image processing techniques within the humanities and heritage sectors has allowed novel research and encouraged further understanding

and interpretation of primary sources, such as paintings, documents and artefacts. Although there is a history of these techniques being employed in the humanities since the earliest days of digitization, it is not a coherent, standalone research area, with an easy route to adoption. Successful application of image processing tools generally depends on the development of bespoke algorithms tailored for the individual research question. As a result, image processing is usually undertaken as part of an interdisciplinary team, as most scholars with a humanities background do not have the necessary skill set to develop and test image processing algorithms for a given research task. The further adoption of image processing techniques in the arts and humanities will prove promising for research, although we are only starting to develop a theoretical framework to understand what it means to depend on processed, digital surrogates of primary sources for research evidence.

CASE STUDY The Griphos Project: reassembling ancient frescoes

Research team: Benedict Brown, Katholieke Universiteit Leuven, Department Elektrotechniek – ESAT-PSI, Antonio García Castañeda, Department of Computer Science, University College London, David Dobkin, Department of Computer Science, Princeton University, Thomas Funkhouser, Department of Computer Science, Princeton University, Lara Laken, Auxilia, Radboud University Nijmegen, Szymon Rusinkiewicz, Department of Computer Science, Princeton University, and Tim Weyrich, Department of Computer Science, University College London. Case study prepared by Benedict Brown, Melissa Terras and Tim Weyrich.

The reconstruction of fragmented objects is of great interest in archaeology, where artefacts are often found in a fractured state. Vast quantities of fresco material, commonly excavated from archaeological sites in thousands of pieces, remain in storage indefinitely, unexamined and unstudied, as resources are simply not available to complete time-consuming manual searches for any fragments that match. Frescoes are usually of unknown design, with many pieces of the same colour, with few clear distinguishing features and often with missing sections. Fragments are generally fragile, and excessive handling is undesirable, at best, and highly damaging, at worst.

The Griphos Project (in Greek, *griphos* means 'puzzle' or 'riddle') was established to develop computational methods to aid in the reconstruction of fresco fragments. Griphos has been utilized, so far, to help piece together Bronze Age wall paintings from the site of Akrotiri on the volcanic island of

Thera (modern-day Santorini, Greece) and Roman frescoes from a luxurious mansion in the Roman city of *Municipium Tungrorum* (modern-day Tongeren, Belgium). The computer scientists developing the system work closely with archaeologists and conservators, and the project team incorporates partners from University College London, Princeton University, the Katholieke Universiteit Leuven, the University of Athens, the University of Ioannina and the Vlaams Instuut voor het Onroerend Ergoed.

Figure 4.1 *Modified off-the-shelf 3D scanner for rapid fresco fragment acquisition*

The first step in aiding the sorting of fresco fragments is digitization. Each fragment is placed face-down on a turntable, scanned via a 3D scanning system (see Figure 4.1), turned face-up and scanned again. Alignment is performed automatically, with the operator verifying the results and correcting any errors. A flatbed scanner is used to capture high resolution colour images and texture information of the front surface of each fragment, with the back surface being scanned once for documentation purposes. This yields a throughput of approximately ten fragments per hour, made possible through the bespoke, end-to-end design of the acquisition pipeline.

The digital surrogates of the fresco pieces are utilized in the Griphos software, which functions as a virtual table top, on which the user places fragments and arranges them for assembly, documentation or further inspection. Griphos maintains a high level of realism in an interactive viewer, which combines full 3D models and layered 2D representations. The user can have many different virtual table tops, each containing an arbitrary number of fragments, to allow multiple, competing reconstructions alongside the current physical arrangement (see Figure 4.2 on the next page).

Griphos provides a variety of tools to study the relationship between fragments. Related pieces may be grouped together manually or snapped to each other automatically, based on computationally matched proposals, which can then be evaluated and interactively explored. An initial placement may be refined using algorithms, which provide a convenient visualization of the alignment quality, showing a colour-coded plot of where fragments touch, intersect or contain gaps. A grid is provided to aid in reconstructing hypothetical layouts and in generating overviews of fragment combinations, which saves time, as these were previously prepared by hand.

Figure 4.2 *The Griphos application offers tools which evaluate match hypothesis amongst digitized fragments*

There are currently 1516 fresco fragments from Tongeren, which, statistically, means there are millions of possible match suggestions. Griphos proposed 302 matches, of which 170 were previously known, helping establish the most likely combinations for further examination. Confirming them took an expert four weeks of digital sifting, before verifying the matches against the original material. Based on discussions with expert archaeologists, we can state, with confidence, that our combination of acquisition- and match-browsing provides a dramatic increase in efficiency and lowers the cost of matching, compared to traditional methods. (It is difficult to quantify this exactly, as experts have been trying to piece together the fragments for years, and there is little documentation available regarding this process and the physical state of the fragment corpus.)

In addition to its value for identifying combinations of fresco pieces, the application of our system to an entire excavation has confirmed several other major advantages over traditional matching, including demonstrating that digital matching can be undertaken by unskilled workers with minimal archaeological training and that matching can be safely done with minimal handling of fragile primary source material. Moreover, physical access to the material is only needed for acquisition and final verification and assembly; the software can be used to search for fragment matching remotely, at any time.

This opens up possibilities for future crowdsourcing of the matching process, and our team is currently exploring viable options. The virtual table tops are quicker to produce, more accurate, easier to read and easier to update than traditional outline drawings of fresco fragments. A by-product of the Griphos system is high quality digital surrogates of each fragment piece (1/4mm resolution 3D models and 600dpi images) organized in a database that can be used for further study, as well as for producing reproductions for catalogues and publications.

In addition to helping to piece together wall paintings from these two sites, the databases of digitized fragments are large enough to evaluate the performance of the system under development and the appropriateness of the computational algorithms which have been appropriated for this task. The proposed matches have proved important for analysing our ranking results and finding ways to improve them. While much of our previous work has focused on improving the quality of our matching algorithms, by improving the ranking of proposals (Funkhouser et al., 2011), based on edge shape, colour, surface variations and other cues (Toler-Franklin et al., 2010), current efforts move on to the search for clusters and globally consistent assemblies of fragments (García Castañeda et al., 2011), as well as the analysis of fracture processes and characteristic fracture patterns (Shin et al., 2012).

Our consortium is currently trying to raise funding for the acquisition and assembly of a new fresco at Akrotiri. This would provide controlled conditions to evaluate the success of the system in piecing together a 'virgin' fresco. Further information about the Griphos Project can be found at http://gfx.cs. princeton.edu/proj/thera/. ∎

CASE STUDY Developing image capture and processing techniques to enhance the legibility of incised texts

Ségolène Tarte, Oxford e-Research Centre, University of Oxford, Mike Brady, Department of Engineering Science, University of Oxford, Alan Bowman, Centre for the Study of Ancient Documents, Classics Faculty, University of Oxford, and Melissa Terras, Department of Information Studies, University College London
Incised texts are often very difficult to read. Deciphering such texts draws on a wide range of expertise that papyrologists develop throughout their career. These skills are as much related to visual perception of the artefact and its text as they are to palaeographical, linguistic and historical knowledge. Computational tools can be used to aid papyrologists in their complex task, by

providing alternative visual clues and evidence regarding textual incisions on documentary material. This case study presents methodologies that have been adopted to enhance the legibility of the Roman wooden stylus tablets from Vindolanda, on Hadrian's Wall, which consists of incisions left in wood through a now-perished coat of wax. The first step in deciphering these three-dimensional texts is by using advanced digitization techniques, called Shadow Stereo, and reflectance transformation imaging to capture and encode multiple images of the text under varying illumination conditions for further processing and visualization. In addition, image processing algorithms were developed to isolate the features of the text and aid in their interpretation.

Digitization of such artefacts is the first step in the development of an interpretation of the document. Observing the experts trying to interpret the stylus texts informed us as to how the tablets could be digitized, whilst retaining, in particular, one major piece of information that papyrologists exploit when deciphering it – namely, the volumetric nature of the text. Experts who have access to the actual tablet they intend to transcribe have developed a very specific and intuitive strategy to enhance the visibility of the incisions that the stylus left in the wood. They lay the tablet flat on their hand, lift it up at eye level against a light source and apply pitch-and-yaw motions to the artefact. This effectively enhances the visibility of the incisions, by accentuating the highlights and shadows that the raking light generates; the lower the light, the longer the shadows projected by the text in (inverted) relief, created by the incisions carved on the surface of the tablet. The principle that is put into application here is the 'shadow-stereo' principle, by which concave shapes are revealed from shading, and the motion of the shadows exposes the location of the incisions (Brady et al., 2005). This process can be digitally imitated: a digital camera is affixed above a tablet, and a high resolution digital picture is taken for each one of a set of pre-established positions of a light source around the tablet. Each light position is described by an elevation angle and an azimuth angle, where the azimuth angle corresponds to an angle deviation from the horizontal in the plane of the tablet and the elevation angle describes the height of the light, with respect to the plane of the tablet. Both angles are measured from the centre of the tablet.

The collected data for each tablet was further used to digitally recreate the shadows and their motion. By adopting an appropriate model of image formation, not only can one store the set of images efficiently, without having to store each image, one can also interpolate between light positions, thus simulating lighting conditions, where a picture was not actually captured. The image model that is adopted relies on this technique of 'reflectance transformation' (Malzbender, Gelb and Wolters, 2001; Goskar and Earl, 2010). This

digital model can be remotely used by experts who do not have access to the original text, allowing them to digitally pitch-and-yaw this avatar of the artefact to aid them in interpreting the text: by exploiting the play of light with the 3D nature of the textual representation, we are able to enhance the text's legibility.

Image processing algorithms were developed to isolate textual features. Noise removal homogenizes the background of images by removing patterns or behaviours that are irrelevant; we can increase legibility, by neutralizing some of the distracting noise present in the images, through homomorphic filtering and wood-grain removal. Image segmentation algorithms were then used to extract the meaningful areas or features of the image and, thereby, identify where the text is located on the complex, abraded surface of the texts. There is no room to provide adequate explanation of these techniques in this case study, but to summarize: background correction is first performed; then ways to achieve text feature extraction. Phase congruency, which exploits the fact that visual features are detected for some properties of the local phase of the image in the Fourier Domain, and Markov Random Fields, which take a statistical approach to region labelling for image segmentation, were employed. Explanation of these techniques can be found in Tarte et al. (2010), for those interested in further detail.

Figure 4.3 (on the next page) is an example of a simple image manipulation technique on a set of images of a wooden Roman stylus tablet, where the textual information is made of the incisions in the wood. From a set of images captured from the same vantage point and with different light positions, one can enhance the visibility of the text, by extracting for every pixel position: the brightest pixel (where the tablet is lit the strongest) and the darkest pixel (where the shadows are the darkest). Due to the properties of light shone upon a 3D object, the pixel values on the flat textless areas remain approximately constant, whereas the pixel values at incisions vary widely. Consequently, subtracting the brightest and darkest images yields an image where the incised text (which is where the variations in light are the greater) is made more visible.

Most techniques utilized in this project were inspired by approaches adopted by medical image processing. However, these methods had to be largely adapted to our specific application; in general, the images of artefacts and their features of interest are not only different from, and noisier than, medical images, but, also, the type of visual expertise required to detect the textual features differs greatly from that of radiologists. The challenge of image processing and capture for ancient incised documents is multiple and specific to both the imaging method and the artefact. Our research suggests that by observing and understanding the nature of the classicist's visual expertise, we will be able to

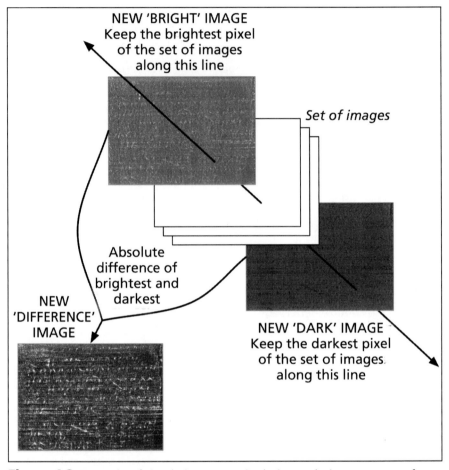

Figure 4.3 *Example of simple image manipulation technique on a set of images of a wooden Roman stylus tablet*

integrate prior knowledge into a model of visual perception adapted to the classicist's needs, hence, supporting them in building meaning out of a pure signal – in building an interpretation of an artefact. Digital imaging and image processing can create novel, alternative visual clues as to writing contained within incised texts, assisting papyrologists in reading damaged, ancient texts.

This work was undertaken as part of the Image, Text, Interpretation: e-science, technology and documents project (also known as eSAD: e-science and ancient documents) at the University of Oxford, with input from University College London, which was funded under the AHRC-EPSRC-JISC Arts and Humanities e-Science Initiative. Further resources can be found at http://esad.classics.ox.ac.uk/. ■

Bibliography

Acharya, T. and Ray, A. K. (2005) *Image Processing: principles and applications*, Wiley.

Asmus, J., Bernstein, R., Dave, J. V. and Myers, H. J. (1987) Computer Enhancement of the Mona Lisa, *Perspectives in Computing*, **7** (1), 11–22.

Brady, M., Pan, X., Schenck, V., Terras, M., Robertson, P. and Molton, N. (2005) Shadow Stereo, Image Fltering and Constraint Propagation. In Bowman, A. K. and Brady, M. (eds), *Images and Artefacts of the Ancient World Vol. 4, British Academy Occasional Paper*, Oxford University Press/British Academy.

Brown, B., Toler-Franklin, C., Nehab, D., Burns, M., Vlachopoulos, A., Doumas, C., Dobkin, D., Rusinkiewicz, S. and Weyrich, T. (2008) A System for High-Volume Acquisition and Matching of Fresco Fragments: reassembling Theran wall paintings, *ACM Transactions on Graphics (Proc. SIGGRAPH 2008)*, **26** (3), 84: 1–84: 9, http://doi.acm.org/10.1145/1360612.1360683.

Cameron, F. (2007) Beyond the Cult of the Replicant: museums and historical digital objects – traditional concerns, new discourses, *Theorizing Digital Cultural Heritage, A Critical Discourse*, Cameron, F. and Kenderdine, S. (eds), MIT Press.

Cawkell, A. E. (1992) Imaging Systems and Picture Collection Management: a review, *Information Services & Use*, **12** (4), 301–25.

Cawkell, A. E. (1993) Picture-Queries and Picture Databases, *Journal of Information Science*, **19** (6), 409–23.

Eakins, J. and Graham, M. (1999) *Content-Based Image Retrieval: a report to the JISC Technology Applications Programme*, Institute for Image Data Research.

Eikonopoiia (2010) Ancient Greek Written Sources. In Holappa, M (ed.), *Proceedings of the Symposium on Digital Imaging of Ancient Textual Heritage: technological challenges and solutions held on 28–29 October 2010, organized by the Centre of Excellence (Academy of Finland)*, Helsinki, www.eikonopoiia.org/files/Eikonopoiia-2010-Proceedings.pdf.

Engeldrum, P. G. (2000) *Psychometric Scaling*, Imcotek Press.

Fetter, W. A. (1964) *Computer Graphics in Communication*, McGraw-Hill.

Forte, M. (1992) Image Processing Applications in Archaeology: classification systems of archaeological sites in the landscape. In Andresen, J., Madsen, T. and Scollar, I. (eds), *Computing the Past*, Aarhus University Press.

Freeth, T. et al. (2006) Decoding the Ancient Greek Astronomical Calculator Known as the Antikythera Mechanism, *Nature*, **444** (7119), 587–91.

Freifeld, K. (1986) Art Analysis: probing beneath the image, *IEEE Spectrum*, June, 66–71.

Funkhouser, T., Shin, H., Toler-Franklin, C., Castaneda, A. G., Brown, B., Dobkin, D., Ruskinkiewicz, S. and Weyrich, T. (2011) Learning How to Match Fresco Fragments, *Eurographics 2011 Special Area Track on Cultural Heritage*, April, http://doi.acm.org/10.1145/2037820.2037824.

Gants, D. (1998) The Application of Digital Image Processing to the Analysis of Watermarked Paper and Printers' Ornament Usage in Early Printed Books. In Speed Hill, W. (ed.), *New Ways of Looking at Old Texts Vol. 2*, Renaissance English Text Society.

García Castañeda, A., Brown, B., Rusinkiewicz, S., Funkhouser, T. and Weyrich, T. (2011) Global Consistency in the Automatic Assembly of Fragmented Artefacts. In Dellepiane, M., Niccolucci, F. and Pena Serna, S., Rushmeier, H. and Van Gool, L. (eds), *12th International Symposium on Virtual Reality, Archaeology, and Cultural Heritage*, Eurographics Association, Goslar, Germany, 73–80.

Giacometti, A., Terras, M., Gibson, A. and Mahony, S. (2011) Multi-Spectral Image Processing Methods for Analysing Ancient Documents, Paper presented at the *Society for Digital Humanities/Société pour l'étude des médias interactifs (SDH/SEMI) annual conference at the 2011 Congress of the Social Sciences and Humanities held on 28 May 2011 to 1 June 2011, organized by the University of New Brunswick and St. Thomas University*, unpublished.

Gladney, H. M., Lee, J.C., Kelmanson, M. L., Lirani, A. C., Magerlein, K.A., Pavani, A. M. B. and Schiatarella, F. (1996) Toward On-Line, Worldwide Access to Vatican Library Materials, *IBM Journal of Research and Development*, **40** (2), www.research.ibm.com/journal/rd/402/mintzer.html.

González, P. (1992) The Digital Processing of Images in Archive and Libraries, Large Scale International Projects. In Thaller, M. (ed.), *Images and Manuscripts in Historical Computing: proceedings of a workshop held on 15 November 1991, organized by the International University Institute, Firenze*, Max Planck Institute.

Gonzalez, R. C. and Woods, R. E. (1993) *Digital Image Processing*, Addison-Wesley Publishing.

Google (n.d.) *Search by Image*, www.google.com/insidesearch/searchbyimage.html.

Goskar, T. A. and Earl, G. P. (2010) Polynomial Texture Mapping for Archaeologists, *British Archaeology*, **111**, 28–31.

Hockey, S. and Ross, S. (2008) Part 4: Conclusion. In Hughes, L. (ed.), *The AHRC ICT Methods Network*, Arts and Humanities Research Council, 59–74.

Jarrett, J. (2012, forthcoming) Coinage, Digitization and the World-Wide Web: numismatics and the COINS Project. In Nelson, B. H. and Terras, M. (eds), *Digitizing Medieval and Early Modern Material Culture, New Technologies in Medieval and Renaissance Studies*, University of Arizona Press.

Kato, T. (1992) Database Architecture for Content-Based Image Retrieval. In Jambardino, A. A. and Niblack, W. R. (eds), *Image Storage and Retrieval Systems*, Proc SPIE.

MacDonald, L. (ed.) (2006) *Digital Heritage, Applying Digital Imaging to Cultural Heritage*, Elsevier.

MacDonald, L., Findlater, K., Tao Song, R., Giana, A. and Suganthan, S. (2006) Imaging of Stained Glass Windows. In MacDonald, L. (ed.), *Digital Heritage, Applying Digital Imaging to Cultural Heritage*, Elsevier.

Malzbender, T., Gelb, D. and Wolters, H. (2001) Polynomial Texture Maps. In Pocock, L. (ed.), *SIGGRAP'01: Proceedings of the 28th Annual Conference on Computer Graphics and Interactive Techniques*, 12–17 August 2001, ACM, Los Angeles, CA.

Marques, O. (2011) *Practical Image and Video Processing Using MATLAB*, Wiley IEEE Press.

Nagabhushana, S. (2006) *Computer Vision and Image Processing*, New Age International Publishers.

Nowviskie, B. (2002) Select Resources for Image-based Humanities Computing, *Computers and the Humanities*, **36** (1), (February).

Salerno, E., Tonazzini, E. and Bedini, L. (2007) Digital Image Analysis to Enhance Underwritten Text in the Archimedes Palimpsest, *International Journal on Document Analysis and Recognition*, **9** (2–4), 79–87.

Shin, H., Doumas, C., Funkhouser, T., Rusinkiewicz, S., Steglitz, K., Vlachopoulos, A. and Weyrich, T. (2012) Analyzing and Simulating Fracture Patterns of Theran Wall Paintings, *ACM Journal of Computing and Cultural Heritage (JOCCH)*.

Tarte, S. (2012, forthcoming) The Digital Existence of Words and Pictures: the case of the Artemidorus Papyrus, *Historia*, **3**.

Tarte, S., Bowman, A., Brady, M. and Terras, M. (2010) Image Capture and Processing for Enhancing the Legibility of Incised Texts. In Holappa, M. (ed.), *Eikonopoiia: Digital imaging of ancient textual heritage: technological challenges and solutions, 28–29 October 2010, Helsinki, Centre of Excellence (Academy of Finland)*, http://llc.oxfordjournals.org/content/early/2011/05/13/llc.fqr015.abstract. www.eikonopoiia.org/files/Eikonopoiia-2010-Proceedings.pdf.

Tarte, S. M. (2011) Digitizing the Act of Papyrological Interpretation: negotiating spurious exactitude and genuine uncertainty, *Lit Linguist Computing*, **26** (4), 349–58.

Terras, M. (2006) *Image to Interpretation: intelligent systems to aid historians in the reading of the Vindolanda texts*, Oxford Studies in Ancient Documents, Oxford University Press.

Terras, M. (2008) *Digital Images for the Information Professional*, Ashgate.

Terras, M. (2010) The Digital Classicist: disciplinary focus and interdisciplinary vision. In Bodard, G. and Mahony, S. (eds), *Digital Research in the Study of the Classical Antiquity*, Ashgate.

Terras, M. (2012) Artefacts and Errors: acknowledging issues of representation in the digital imaging of ancient texts. In Vogeler, G., Fischer, F., Fritze, C., and Vogeler, G. (eds), *Codicology and Papyrology in the Digital Age, II*, Institut für

Dokumentologie und Editorik, http://kups.ub.uni-koeln.de/4337/.

Terras, M. (2011) Being the Other: interdisciplinary work in computational science and the humanities. In Deegan, M. and McCarty, W. (eds), *Collaborative Research in the Digital Humanities*, Ashgate.

Thaller, M. (ed.) (1992a) Images and Manuscripts in Historical Computing. In Thaller, M. (ed.), *Proceedings of a workshop on 15 November 1991, organized by the International University Institute, Firenze*, Max Planck Institute.

Thaller, M. (1992b) The Processing of Manuscripts. In Thaller, M. (ed.), *Images and Manuscripts in Historical Computing: proceedings of a workshop on 15 November 1991, organized by the International University Institute, Firenze*, Max Planck Institute.

Toler-Franklin, C., Brown, B., Weyrich, T., Funkhouser, T. and Rusinkiewicz, S. (2010) Multi-Feature Matching of Fresco Fragments, *ACM Transactions on Graphics (Proceedings of SIGGRAPH Asia 2010)*, **29** (6), December, Article 185, http://dx.doi.org/10.1145/1882261.1866207.

Twycross, M. (2006) Virtual Restoration and Manuscript Archaeology: a case study, *Audio Recording, Methods Network Expert Seminar: virtual history and archaeology on 19–21 April 2006, organized by the University of Sheffield*, www.arts-humanities.net/audio/meg_twycross_virtual_restoration_manuscript_archae.

van den Berg, J., Brandhorst, H. and van Huisstede, P. (1992) Image Processing and the (Art) Historical Discipline. In Thaller, M. (ed.), *Images and Manuscripts in Historical Computing, Proceedings of a Workshop on 15 November 1991, organized by the International University Institute, Firenze*, Max Planck Institute.

Notes

1 SEAC had 512 words of memory, with each word being 45 bits in size, giving an equivalent of 23,040 bits, or 2880 bytes of memory, which is just over 2 Kb or 0.003 megabytes (Mb). This is enough equivalent memory to store just over 3000 words in ASCII text format.

2 An image may be defined as a two-dimensional function $f(x, y)$, where x and y are plane (spatial) co-ordinates, and the amplitude of 'f', at any pair of co-ordinates (x, y), is called the Intensity, or Gray, level of the image at that point. When x, y and the amplitude values of 'f' are all finite, discrete quantities, then the image is called a digital image. The process of a digital image by a digital computer is called digital image processing (Nagabhushana, 2006, 3).

3 www.mathworks.co.uk/products/matlab/index.html.

CHAPTER 5

3D recording and museums

Stuart Robson, Sally MacDonald, Graeme Were
and Mona Hess

Abstract

In this chapter, we introduce the key principles, advantages and limitations of 3D imaging of surfaces and look at its existing and potential applications in museums. Being able to scientifically capture objects 'in the round' can support conservation programmes and enable close comparison of similar objects. In order to assess the potential of 3D recording to permit new interpretations and reach new global audiences for the museum world, this chapter has four contributors, who are conversant in the technology, curation, museum management, anthropology and practice of object handling and 3D capture.

The chapter is supported by case studies drawn from significant projects recently completed at UCL. The first, *E-Curator*, established the value of 3D models for sharing detailed information about museum objects among curators and conservators. The second project, *Pacific Alternatives*, involved the 3D capture and virtual reconstruction of a Solomon Islands war canoe held at the British Museum, exploring the potential for digital repatriation to the community.

Introduction

3D recording of museum and archaeological artefacts is by no means new. There are numerous examples from the photogrammetric community of the use of stereo photographic images and optical or mechanical instruments, originally designed for map-making, to produce content in the form of 3D contour plots (Atkinson, 1968; Desmond and Bryan, 2003). Funding bodies

have often required such scientific records of key artefacts, buildings and even complete sites.

During the last decade, the increased availability and affordability of digital cameras, lasers and 'structured light projection' devices, combined with low cost personal computers, has resulted in an active 3D capture research community. Scientific recording capabilities have been enhanced, but it also has become increasingly possible for anyone with a digital camera and laptop computer to produce 3D digital models from multiple images (Remondino and El-Hakim, 2006). This has opened up opportunities and challenges for the museum community. This chapter provides an overview of available technologies, potentials and issues in using 3D scanning within a museum setting.

The technological context

There are many types of photographic records of museum objects, ranging from blurred snap shots by casual visitors to scientific imagery created by professional photographers and curators. A similar situation exists with 3D imaging. Sensors for 3D surface imaging fundamentally consist of a light source used for illumination and one or more cameras, which record the light reflected by the surface. In the manufacturing industry, accurate geometric recording is a necessity, and systems have evolved to conduct this. Alongside these professional systems sit low cost options, where all that is necessary is a webcam and either a laser pointer or a data projector.

To ascertain which 3D surface capture techniques are appropriate for a given situation, it is essential to understand the aim and purpose of recording an individual museum object. The interaction between light and object surface is crucial, as it determines how accurately and completely the object can be recorded. For example, very shiny objects which reflect light in a highly directional way can be highly challenging to capture, as the sensing system is saturated with light at some angles, but has almost no return at others, whilst transparent objects and specimens in glass or liquids may not be recordable at all. Costs involved often relate to the time and skills required to produce a specified output, rather than the original purchase cost of the system.

A common technique is photogrammetry, where two or more overlapping images are taken from different locations. Measurements of a distribution of common imaged features – usually discrete points – are made, from which both the image and surface geometry can be solved. If a multitude of

overlapping images – often termed an 'image network' – are taken, it is possible to mathematically estimate the optical properties of the camera and to produce accurate 3D surface measurements with consumer-grade digital cameras (Luhmann et al., 2006). This procedure, termed 'self-calibrating bundle adjustment', is fundamental to many automated 3D image reconstruction procedures, when it is teamed with automated image feature and area-matching processes (Remondino and Menna, 2008). Given that colour images are taken, it is a relatively straightforward process to photogrammetrically map the colour in the images onto the 3D surface. However, one key point, concerning the use of photogrammetry, is that the scale of the developed model is unclear, unless known lengths or a known separation between a camera pair is included. Examples of software packages include Photomodeller,[1] Microsoft's Photosynth[2] and Autodesk's 123DCatch.[3]

Another common technique is laser scanning, where a laser light source, comprising either a spot or a line, is scanned over a surface. Light directed back to a detector, which is typically a camera fitted with a linear sensor, forms a triangle between laser, camera lens and surface location. Measurement of the distance between the laser and the camera lens, the angle of the laser and the location of the detected light spot, allows computation of the surface location by Pythagoras' theorem. Accurate knowledge of the separation between the laser and lens provides scale. This device, termed a triangulation laser scan head, delivers a 2D profile, which must then be swept over the surface of interest, either by hand (David);[4] using an internal mirror (KonicaMinolta);[5] or by tracking the scan head with a mechanical arm (Faro),[6] optically (Nikon)[7] or with a measurement robot (Arius3D).[8] This technique can be highly accurate and flexible, with the best systems capable of co-ordinating complex 3D surfaces to the order of 20 micrometres (μm), equivalent to the diameter of the smallest human hair. The diameter and interspacing of the projected laser spots defines the amount of spatial detail that can be captured and is generally lower than that achievable with a professional digital camera. The highly directional illumination from the laser system tends to compound the issue of shiny surfaces, mentioned previously. If multiple lasers of different wavelengths are used, it is possible to extract colour information, along with the surface geometry (Blais et al., 2003).

An alternative approach uses structured light, which encompasses a very broad range of optical capture techniques. The most common examples include either a single camera and pattern projector, such as the PicoScan,[9]

or two cameras and a projector, where dots (Jones and Pappa, 2002; GSI Prospot)[10] or fringes (Huntley and Coggrave, 2002) are used to illuminate the surface. Reconstruction of the imaging geometry and the imaged patterns allow 3D surfaces to be estimated from the observed distortions in the dot patterns or fringes. The most accurate systems are those which have been optimized for the measurement of manufactured surfaces, for example, PhaseVision, GOM[11] and Breuckmann.[12] Measurement capabilities are dependent on the surface area to be measured, but typical devices are able to co-ordinate areas of 0.5m x 0.5m, to the order of 50μm. As with laser scanning systems, such devices are highly dependent on the optical properties of the surface to be measured.

Another structured light method, which is gaining in popularity, is Reflectance Transformation Imaging (RTI). In this method, a single camera is used to take a sequence of static images. Each individual image is illuminated by a single point light source from a known angle, such that the resultant collection of images will each differ in illumination (Malzbender, Gelb and Wolters, 2001). This data is then used to mathematically synthesize an interactive light that can be adjusted by the user to highlight key surface features, in the same way that a torch might be used. Such reconstructions are particularly useful for the examination of fine surface detail and improving the legibility of text (Earl, Martinez and Malzbender, 2010), although it should be stressed that RTI does not directly reconstruct the 3D surface, but provides a reconstruction of the way that light falls across the surface.

In choosing an approach, workflow has to be considered. The sensing system must be able to image the surface: this requires either the sensor or the object to be moved and rotated to bring each part of the object surface into the imaging field of view. Each change in geometry, as the object is moved, will enable the recording of a 3D surface patch, and the resultant set of surface patches must be exactly matched (registered) together, in order to produce the complete 3D model. Additionally, noise in the 3D data must be filtered, colours balanced and overlapping data removed. The third step is typically manual and includes the editing of any errors caused by interaction with light and surface properties, for example, laser spots that coincide with object edges and sharp boundaries result in a cut-off half spot or line, which gives rise to a systematic error in the 3D data. Where the object surface is complex, holes, due to surface occlusion, may arise in the data, and these can be optionally filled by interpolation.

Software is required for 3D surface processing[13] and modelling. Ten years ago, this software was extremely expensive and the domain of a handful of

specialist companies, such as Polyworks[14] and Geomagic.[15] A recent step change in software available, through Open Source computing initiatives, has delivered viable replacements for high-end packages. One of the most notable recent additions, developed through EU funding, is 3DCoform's Meshlab.[16] In situations where the user wishes to compare datasets, system manufacturer GOM[17] now offers its inspection software free of charge, and, in the Open Source domain, there is CloudCompare,[18] which is a research output from French energy company EDF. A commercial package, affordably priced, is RhinoCAD,[19] which not only supports a broad range of freeform modelling, but is also capable of direct connection to many digitizing devices. Such products have the capability to significantly reduce the cost of 3D adoption, where data processing and analysis effort far exceed that required for information capture.

The days when a 3D model would be delivered and the user would be unable to view and interact with it on their computing system, either through a lack of available software or compatible hardware, are hopefully behind us. A significant improvement in access is offered by webGL[20] through HTML5, for plugin-less viewing on common web browsing technology. Even more exciting are new mobile and 3D display devices, with the display quality and processing power to allow both real and virtual museum visitors to sample 3D models, in order to enrich their visitor experience.[21]

Effective adoption of 3D technology is dependent on the development and understanding of sustainability and best practice. This is particularly true of the 3D digital object selection, modelling and visualization chain, where communication between disciplines is one of the key features. For example, how can dimensional standards, founded in the science of metrology, be translated into the visual assessment made by highly skilled professional curators? A sustainable future needs to develop best practice, which can accommodate increases in the number, scientific value and online demand for 3D models, whilst capturing metadata, which details both their heritage and scientific provenance. What is certain is that such developments will need new professional skills that cross-link conservator and technician.

Potential for the museum community

Photography was adopted by museums very soon after its invention, so most museums have photographic studios and professional photographers

within their communities. Similarly, the need to reach out via the internet has quickly produced specialist new media centres. Can 3D recording also move from delivering specialist one-offs to become a routine process, able to deliver both scientific and public outputs? To explore this potential, a workshop and subsequent conference, entitled *3D Colour Laser Scanning in Museums*,[22] was hosted at UCL in 2007 and 2008, attracting an international audience. Both events explored three main areas of museum activity where 3D recording might have applications: display and exhibition; education and interpretation; and conservation. Delegates from the museum and heritage sector – conservators, curators, exhibition designers and educators – identified the potential benefits of creating and using 3D imaging, as well as concerns and fears about its use. We discuss the details of this, in the context of the E-Curator Project case study section.

A 3D model may be used in a display as a surrogate for the real thing, when, for example, a real museum object is out on loan or away for conservation. 3D models and prints open up the possibility of creating exact replicas, which can 'stand in' for fragile objects, offer handling opportunities, help demonstrate how an object was used or generate museum replicas for sale.[23] Thinking more broadly, the 3D model offers the potential to subvert, transform or enhance all kinds of museum activity, from the courier trip to the exhibition catalogue, where individually tailored content can be collected on a local mobile device or indexed for subsequent viewing on a personal web page. It can also offer exciting new ways of increasing visitor numbers and public engagement, thus raising profile and generating new income streams, for example, as interactive digital postcards or through the provision of 3D image library content founded on stories stimulating the collection of groups of digital objects.

Curators see 3D recording as offering real potential for research: enabling museum objects to be accurately measured and recorded in the round and in great detail; highlighting comparisons and distinctions; and facilitating long-distance discussions. The 3D record represents a 'digital fingerprint' of the real object. There is also the potential to better document and characterize materials, by complementing analytical methods, such as fluorescence and pigment analysis. This could aid identification of objects in geographically scattered collections, enable low-cost global interaction and collaboration between curators and academics and lead to new understandings of material culture.

Conservators see the potential for scientific 3D records to capture and present shape and colour, with accuracy that has not previously been

possible. 3D images can be used to detect features and their surface deterioration not visible to the naked eye, for monitoring weathering, erosion, changes in colour over a long period and during treatment. They can be used as a non-invasive tool for spatial comparison, at both a qualitative and quantitative level, and to document irreversible changes and events. 3D printing offers the potential to restore missing parts of objects with replica elements and provide replica objects for loan. For example, reconstruction of Rodin's 'The Thinker', following its theft and recovery, relied heavily on scanning to fabricate missing parts (Beentjes and van der Molen, 2011). There is a use in training future generations of conservators. Working with 3D images and virtual spaces might broaden professional assumptions about how museum spaces might be constructed and presented, if curators and exhibition designers were able to more easily imagine, and co-create, installations without walls or cases. Exhibition catalogues could become digital artefacts, with material in a show linked to scans of related objects, sites or contexts.

3D models offer new ways of interacting with, and understanding, museum objects within the museum, providing eye-catching contextual information for traditional displays and new ways of visually grouping and presenting different layers of interpretation. It is well documented that large amounts of text-based interpretation are ineffective (Serrell, 1997; Hein, 1998); 3D display is a potentially powerful way of encouraging visual thinking, communication and learning. In particular, such models offer potential for communicating dynamic concepts, such as creation or degradation (for example, 'Mummy: the inside story'),[24] for highlighting small details or demonstrating a range of possibilities. They could augment the museum viewing experience by giving visitors greater control over what they look at, the ability to turn fragile objects upside down and to see them in high magnification and other privileges normally reserved for curators and conservators. They offer the potential to display, in one place, different parts of a physically dispersed object, with obvious teaching and learning applications. There is great opportunity for using 3D content in conjunction with other emerging technologies, such as touch tables, multi-projector systems and virtual environments.

Once online, the 3D model is released from the museum environment, giving virtual visitors round-the-clock access and freedom to study, exhibit, deconstruct and reconstruct objects in any way they choose. There is endless potential for museum artefacts to be accessed and repurposed by new audiences: stored in 3D image libraries; embedded in computer games;

inserted into online, personal movies; harvested for school projects. Museum educators, in particular, see real potential to explore the enhanced learning provided by a combination of real world and virtual experience – object-in-hand combined with object-on-screen. For example, it is possible to print out physical 3D models with deliberate errors for comparison with real and onscreen objects.

Concerns for the museum community

Enthusiasm for the potential of 3D imaging is tempered by significant concerns about its use. These include the cost of technology and the overall process, the risk of damage to real objects during the 3D recording process and the need for training. Internationally agreed standards for image capture, processing and storage are required, as is transparency and rigour in documentation and metadata capture. Digital objects need to be curated as carefully as real ones, necessitating training in new skills and the adaption of established curatorial procedures.

There is a real need for user research and evaluation, with both on-site and online audiences. There is a risk of being beguiled by expensive new technologies, without testing them properly, or of embarking on large-scale scanning without looking at the long-term costs and benefits. The creative use of more traditional technologies might yield better results in the longer term; for example, it may be safer to record a really fragile object using traditional photography. On the other hand, there is a danger that the expense of the existing equipment and software, and the time cost in producing 3D outputs, will leave results in the sector being slow to experiment with and invest.

More fundamentally, 3D models might alter perceptions of real objects and highlight issues of control and ownership. User expectations are often shaped by the gaming industry, where, in the next five years, games and entertainment-driven 3D home-capture systems will become standard. Will such use of 3D systems lead to an inevitable trade-off between accuracy and entertainment and between the quality of the scan and the ease of use? Whilst opening up a wealth of opportunities, this shades a deeper fear that increased availability of virtual objects will deter, rather than encourage, real visits to museums or that the availability of 3D models will be likely to deter or occlude study of the object itself.

Questions of control and ownership lie behind many of these concerns. Professionals are worried about protecting 'their' objects once online, about

copyright and reproduction rights and about the potential for widespread forgery. At the same time, there is a realization that, whilst it is easy to talk about the potential for global access, in reality, putting multiple 3D models online would only increase access for an affluent minority with high speed computers.

The professional context

Many of the possibilities and issues highlighted by museum professionals remain to be fully explored (see the case studies in this chapter). One area for discussion is the question of what constitutes a record of a museum artefact or specimen. Most of the traditional methods of recording objects within museums – the accession register, the taxonomy, the individual label, the card index, the written or printed catalogue, the drawing or photograph, the cast or model – predate the 20th century. Computerized cataloguing software and agreed standards, such as SPECTRUM[25] and LIDO/CDOCdig (Pitzalis, Cord and Niccolucci, 2011), for recording a range of artefact types, have only been introduced in the last two decades, and most museums have only succeeded in partially digitizing their existing documentation records. Frequently, there is no system for cross-indexing objects and images or for the conservation records of those objects. For many museums, the addition of a wholly new type of record: the 3D image, its associated model and, perhaps, printed form, too, presents a raft of additional problems and questions about how to integrate these new datasets with existing systems.

At the same time, it is clear that colour 3D models, despite some of the current technical limitations discussed below, offer the potential to record the physical shape and appearance of objects considerably more scientifically than ever before. If such records could be linked to, and curated alongside, the real object, they would offer the potential to record an object's history, its activity and its decay, in a way not previously possible. No record can be truly 'objective', and every scan can be read in multiple ways, but the availability of a scan may offer new professional insights into an object; a more intimate view of it. Might this new potential to record objects visually free professionals from relying so much on terminologies and thesauri, on the exclusivity of text, with its requirement for glossaries, explanations and translations? Or does it simply establish the need for a different type of literacy, new skills, search tools and more refined equipment?

The 3D record might change not only our way of describing and owning objects, but also our way of looking at them. Viewing interfaces for 3D

models allows onscreen manipulation of not just the surrogate object, but also a range of surrogate curatorial tools. In place of an office or laboratory with natural light and a bookcase, a desk with a microscope, a torch (simulating raking light illumination) and a magnifying glass, there is now a computer with an internet connection, a mouse and keyboard. Clearly, this offers real potential for multiple users across the world to study an object that previously only one privileged person could have access to, at any one time. But how does the quality of that viewing compare to the privileged access to the real object? Conservators and curators involved in E-Curator (see E-Curator case study) found it inferior in several ways. Certainly, there is currently no way to fully replicate the nonvisual information gained from physically handling the object; the sense of its weight, its warmth, the texture of its surface, its smell. But with some of these problems overcome, how might the availability of this real-seeming scan affect our relationship with the real thing? The increasing availability of illustrated online catalogues, such as the British Museum's Collection Database Online,[26] has made it necessary for curators to access real objects less often, though perhaps more purposefully, for example, in order to verify surface finish or colour variation not evident in the online imagery; it seems likely that 3D scans would increase that tendency.

The topic of digital object display has been raised, in the context of viewing art, by Armstrong (2006), who argues that when examining artworks in the museum, we may step forward and peer at certain techniques of the artist: their brush strokes, application of paint on canvas, flecking, etc. Digital heritage technologies can also replicate this type of informed looking, mediated through computer software (e.g. 3D display/viewer on screen) and mouse: panning across the surface of a digital image, zooming in on technical details and rotating the object, so as to see it from a different angle. Of course, image resolution is critical: for the art student, very high resolution images may not be a necessary factor in art appreciation. For the conservator, however, being able to see minute surface details on artworks is central to monitoring the condition of the object and providing appropriate care. This was a core question for both the E-Curator and Pacific Alternatives case studies (see below).

3D records of museum artefacts present a real challenge to museum notions of authenticity, in that, although surrogates, they are potentially more engaging than the real artefacts they purport to represent. As discussed below, 3D model data has the potential to be endlessly processed and crafted. Gaps can be filled, colours enhanced, detail added and the data

resampled to match display and printing device characteristics. Unless each step is clearly recorded, it can be impossible to distinguish the original data from later enhancements. In a society where two-dimensional images are increasingly 'airbrushed' and blemishes removed, it is increasingly difficult to trust the authenticity of images. Will this trend continue and affect the way we choose to present historic artefacts? Or will we increasingly value the irregular surfaces, the evidence of decay, the lack of colour that characterize many of our museum collections?

If 3D recording technologies are to be adopted within the museum and heritage sector, new skill sets will be needed. Early adopters of the technology, to date, have tended to be from a scientific background – they are conservators or IT specialists, sometimes both. The nature of the scanning process, with its need to move and position real artefacts safely and scan and record with great attention to detail, requires a range of technical, manual and visual skills that no existing professional courses currently provide. The scientific nature of the capture process and the unfamiliarity of the software is likely to be off-putting to the many curators and object specialists with an arts background.

..
CASE STUDY E-Curator (www.ucl.ac.uk/museums/research/ecurator)
..

Stuart Robson, University College London, Sally MacDonald, University College London, Graeme Were, University of Queensland, and Mona Hess University College London

Scope

This study describes the development of a new virtual research tool for the arts and humanities community. Led by UCL Museums and Collections, E-Curator commenced in October 2007 and focused on the extent to which 3D colour laser scans of artefacts might enhance our understanding of physical objects. We asked whether highly accurate 3D scans allowed us to push forward the boundaries of the traditional 2D photograph, catalogue entry and condition report. We were interested to explore whether such deployment would enable curators and conservators to compare high resolution 3D colour records, collected at different institutions, stored remotely or collected over a period of time under different conditions, in order to assess and monitor change.[27] The objective was to establish protocols for retrievable data acquisition and

processing to facilitate remote web based access to museum e-artefacts and, thereby, enhance international scholarship.

3D imaging

An Arius3D 150 foundation system laser scanner, housed in UCL's Civil, Environmental and Geomatic Engineering Department, enabled the team to experiment with state-of-the-art colour 3D documentation and the collaborative sharing of virtual 3D images of museum artefacts. The scanner has a unique scanning head, equipped with three discrete red, green and blue lasers, simultaneously measuring surface reflectance at three distinct wavelengths and surface geometry (XYZ co-ordinate location and surface normal vector), by triangulation to record the laser reflection at each illuminated location. At its highest spatial resolution, the scanner provides one 3D point per 100 μm. The scanning head is mounted on a co-ordinate measuring machine (CMM), which allows highly accurate and repeatable scanning over an object surface within an environmentally controlled space, which provides a physically stable space for both the museum artefact and the scanning system.

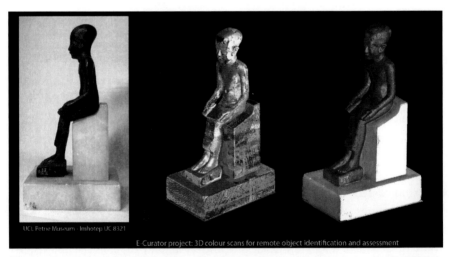

UCL Petrie Museum - Imhotep UC 8321

E-Curator project: 3D colour scans for remote object identification and assessment

Figure 5.1 *From physical to virtual object: Imhotep bronze statuette (UC8321) of the UCL Petrie Museum of Egyptian Archaeology. Left: Photograph of the object; middle: single scans, aligned in false colour mode; right: aligned 3D colour scan.*

Metadata

To describe the 3D representations of the museum artefacts as having a clear 'provenance': this includes both a description of the history and ownership of

the object and data that describes the production of the digital 3D scan of the object. The developed metadata set, based on SPECTRUM, provides a relevant framing for artefacts, such as historical and archaeological particulars, conservation, exhibition and display information.

Project outcome

The project took a practical, multidisciplinary approach to traceable storage and transmission of 3D scanned datasets. An internet-capable 3D visualization tool was designed, using state-of-the-art colour laser scanning technology for digitizing museum objects, in combination with an e-science developed data storage and retrieval solution, as a shared platform, accessible by museum specialists on low-cost computing hardware. E-Curator uses Storage Resource Broker, which is a widely available e-Science technology. The platform supports the sharing of very large high-resolution 3D datasets and related metadata of a variety of museum artefacts in a distributed computing environment. The E-Curator prototype enables an external user to access and search different objects across UCL Museums and Collections. It was developed in discussion with a team of museum curators and conservators, who were able to compare the handling of a range of real objects with their virtual copies onscreen.

Figure 5.2 *Left: In a participatory approach to user-designed systems, users were asked to browse their objects on a prototype of the E-Curator application; the direct feedback further influenced the software design. Right: Entry site of the E-Curator prototype, with objects from UCL Museums and Collections*

Summary

A particular strength of the E-Curator project lay in the participation of stakeholders in all stages of the design and development process. The project introduced curators and conservators to the potential use and transmission of

3D data sets. Although the project used the best available technology in 3D colour scanning, and had produced object records that provided significant new information over and above photographs used in museum practice, it became clear that for 3D colour scans to be of real use to the museum and conservation specialists, a higher spatial resolution and more realistic colour rendition, especially in areas of high reflectivity, was needed. Another requirement was the ability to combine several different types of image data, in order to allow for more detailed examination and comparison. Despite the lack of previous experience of dealing with scan data and metadata, curators and conservators were ready to engage with the potential of the technology and keen to see it developed further. ■

Anthropological context

Digital heritage technologies now offer an increasingly sophisticated range of tools for museum curators to manage, display and analyse their collections. Of the plethora of digital assets produced for museums, high quality 3D colour images of objects held in museum collections raise exciting questions from an anthropological and museological perspective. Some of these concentrate on the problems of liberal access to digital objects via the internet, raising issues of authorship, copyright and theft of the digital copy (Brown, 2005). Others have commented how high resolution 3D reproductions of objects shift the boundaries between original and copy, citing Walter Benjamin's seminal essay on 'The Work of Art in the Age of Mechanical Reproduction' ([1935] 1970) to question the shedding of the aura of the original in its digital rendition, for example, what are the subtle differences between an original, its digital surrogate and the infinite number of identical copies of that digital surrogate (Brown, 2007; Cameron, 2007)? For many, high-resolution digital reproductions defeat the core mission of the museum: an institution whose primary purpose is to deliver high levels of visitor experience. Visitors come to museums, precisely to immerse themselves amongst originals. Digital objects strip away the experiential aspect of 'the visit' from objects and seem to be lesser substitutes for the real. Instead, they are deemed to augment real life objects, to add value, as they allow us to hold them in a digitally mediated grasp (Hawkey, 1999).

While these critical responses centre on the value of digitally mediated experience for visitors, our case studies focus on aspects of museum practice, collaboration and knowledge. What we find particularly significant is the transition from 2D images (e.g. static images, such as photographs) to 3D

models, and the perceptual challenges this brings about, which elicits new understandings of objects and people in the process. The 3D recording of cultural artefacts facilitates a new kind of knowing, by embracing an analytical understanding of objects through imaging tools and the sharing of knowledge that augments real-life engagement with material culture (Were, 2008, 122). This is because we can consider digital objects in terms of their relationships: networks of people and of things that are located in places that extend far beyond the real object itself. Digital objects make these relations visible, through tagging, online annotations, search engines and hyperlinked text. They emphasize the relational nature of the museum and its collections, foregrounding the dispersal of cultural objects that once existed in one particular time and place. Networks that emanate from digital objects allow for a new coming together, reinvigorating dissipated identities and cultural loss through repatriation into new digital collections, which can bring together and present widely dispersed material. This has been the hallmark of many large digitization projects, such as European Cultural Heritage Online (ECHO)[28] and Europeana.[29]

If the museum is to be regarded as an ocular-centric space (Alpers, 1991), then emphasis placed on the visual appears paramount in the context of digital objects. E-Curator aimed to deliver exactly these requirements, through the production and use of state-of-the-art high resolution models. We demonstrate how 3D models of key museum objects could be transmitted electronically to other museums for condition-reporting purposes, before or after loans. Here, both real and digital objects circulate, as well as iterations of them, when scanned again and returned to the host museum. The new ecology of 3D digital objects ties into the rapid advancement of technology in the museum (Parry, 2008) as a technology of control and order (Foucault, 1971).

One area where anthropologists have only begun to research is the phenomenological aspects of 3D digital objects. Given that many museum visitors are offered the opportunity to immerse themselves in virtual environments or play with 3D digital objects set up in exhibition spaces (much like gaming software), a key issue arises from a person's handling of the media: what kind of sensory and aesthetic perceptions are attached to digital images? What, if any, are the tactile, aural and olfactory, as well as visual, dimensions of digital objects that a person experiences through a computer monitor, keyboard and mouse? In this sense, how do we hold on to digital objects? And what knowledge can be gained by engaging with them in a phenomenological way? Recent work has demonstrated how UK

undergraduate students perceived 'holding' digital objects, mediated through a virtual learning environment, and, in 'handling' certain types of digital objects, this elicited many sensory responses related to the real object (Were, 2008). This research is significant, because it allows us to understand how 3D digital objects carry with them prior associations and knowledge, elicited through close scrutiny, provided by the imaging software tools. Indeed, the question of the capacity of digital objects to carry and elicit cultural knowledge was the impetus for the second case study. How people perceive digital objects, in terms of likeness and the knowledge and value they gain from handling them, was a critical question at the heart of the Pacific Alternatives Project.

Museums today are faced with an ever growing need to increase access to their collections and justify their relevance to communities and stakeholders. Digital heritage technologies meet part of this need by offering interactive museum websites, remote access or platforms for digital access to collections, as well as virtual walk-throughs of exhibitions. While the development of digital heritage technologies has helped foster connections with a public who felt excluded on grounds of distance, time and cost related to travelling to museums, not to mention social-economic background, what kind of challenges do digital technologies raise for indigenous people seeking to gain access to digital objects remotely, via the internet?

Digital heritage has huge potential for transforming peoples' lives. The civilizing mission of the museum, brought to people through the click of button, offers opportunities for education, regeneration and development. How the internet transforms rural and remote communities is an area of high priority. There are many possibilities, especially in the Pacific, where a mobile telecommunications company has rolled out internet and mobile phone coverage to rural areas of Papua New Guinea, Vanuatu, Samoa and Tonga. High-resolution 3D digital objects of cultural treasures held in collecting institutions in the West could be accessed through internet connections, providing opportunities to restitute cultural knowledge of the past. The case study on the scanning of the Solomon Islands war canoe provides a compelling case study of the collaborative nature of this work and the benefits to source communities and museums.

CASE STUDY Pacific Alternatives: the Solomon Islands war canoe 3D
scanning project

Stuart Robson, University College London, Sally MacDonald, University College London, Graeme Were, University of Queensland, and Mona Hess University College London

Project aims

This project was funded by the Research Council of Norway, under the auspices of the Pacific Alternatives Project. The team involved collaboration between anthropologists, geomatic engineers, museum curators and collections staff from three institutions: the British Museum, University of Bergen and the University College London.

The Solomon Islands war canoe project set itself the challenging task of 3D scanning an entire 11-metre war canoe, held in the ethnographic collections at the British Museum, and then repatriating it to its community of origin in the Pacific. The war canoe is a significant object, not just due to its length, but also for its complex hull design: wooden planks lashed together and sealed with a type of puttynut. A shell inlay patina covers the bow and stern of the canoe, while cordage lashings inside the canoe secure the ribbing. In generating a 3D digital image of the canoe, the project aimed to capture, in high resolution, these key technical features of the canoe. This was important, because the people of Vella Lavella – a small island in the western Solomon Islands, where the canoe was originally built – had, to a certain extent, worked from black-and-white colonial photographs to revive canoe-building skills. The digital repatriation of a high resolution 3D digital scan thus presented an opportunity to rediscover and recommunicate, to the community of origin, technical knowledge that they had otherwise forgotten.

3D capture

The technical task was particularly complex, due to the size and nature of the canoe and its construction, the space requirements for the portable 3D scanning equipment inside the storage space and the complex digital images. The metric scanning took two weeks to scan the outer and inner hull of the plank canoe, and the digital reconstruction process took a number of months to undertake. The two tall prows at either end of the canoe had once been cut off to allow for its transportation and storage. Moreover, the canoe's shell decorations had also

been removed and stored in boxed-up parts, alongside the canoe in the museum store. Scanning these components separately allowed the canoe to be digitally reconstructed using 3D graphic software – with prows and decorations seamlessly attached – thus making the object complete for the first time since its acquisition in the 20th century.

Figure 5.3 *From left to right: 3D hand-held laser scanning of the Solomon Islands war canoe in the British Museum store; 3D image of geometry, with reconstructed attached prows; isolated ribs of the canoe; combining photogrammetry for a 3D colour reconstruction of the outer hull; details of the colour reconstruction, with complete decoration of the prow and stern.*

The project also raised a number of important anthropological issues. These derive from the process of digital repatriation. Key issues centre on access, authenticity and knowledge.

Access

Digital heritage technologies often promise to offer enhanced access to cultural objects stored in museums; this project intended to test this, in the context of a remote island in the Pacific. The political rhetoric of digital repatriation purports to offer an experiential engagement with cultural objects, mediated through realistic 3D digital images. Many indigenous communities do not have regular access to internet connections, unless a mobile computer and data set are provided, so this raises issues of 'access for whom?' This is especially important in the Pacific, where most people live in rural communities. However, the Solomon Islands were chosen, because rural communities now have access to laptop computers through a United Nations Educational, Scientific and Cultural Organization (UNESCO) scheme, as well as a VSAT internet broadband network. This means that people can access their own cultural heritage online, when provided through local school and governmental institutions. In the context of the digital repatriation of the 3D digital model of the canoe, the Vella Lavella community were able to view the canoe through an easily (downloadable) installable plug-in of the 3D display software. This meant that people could

explore the interior of the canoe – its hull and the shell inlay – mediated through the computer keyboard, mouse and screen. This practice of moving across the surface of the image and examining specific features was termed 'torching' by the local people. It suggests how, in moving the mouse, one is able to focus on the surface of the canoe, as though pointing a torch.

Authenticity

The project raised questions about the relation between the real canoe and its digital copy. If a cultural object is reproduced as a 3D digital image, how do people relate to its (digital, intangible) derivative? For example, for some religious adherents in India, images of Hindu deities are worshipped and revered, as they are deemed to be manifestations of gods. Recent research suggests that such beliefs extend to the realm of digital reproductions of secret/sacred objects (Brown, 2007). From an engineering standpoint, authenticity is embedded in the scientific method and the metric qualities of the documentation. Such attributes enable quantitative recording and reconstruction, whereby accurate, highly detailed dimensional information can be obtained. Such data is suited to both comparison between objects of similar types and accurate physical reconstruction. Adherence to metric requirements must be considered as an integral part of the overall process, otherwise it will significantly increase project costs.

Knowledge

Responses by the local community in the Solomon Islands to the 3D digital canoe were mixed, although no ritual protocols were established to view the canoe. The initial repatriated scan – although enthusiastically received by local people – still lacked colour in its virtual reconstruction. Some people were unable to identify the canoe as one of their own. They explained that this was because the canoe was undecorated: there were no cowry shells, red twill and feathers, so they did not recognize the digital canoe as a particular class of war canoe from Vella Lavella. They were unable to relate the 3D digital image of the canoe to what they imagined the canoe to be in the past. As a consequence, they claimed the digital image was dead, lifeless and even broken. This was rectified later, when a second, more detailed full colour 3D image with decorations was presented to the Vella Lavella community in 2010. If, as Svetlana Alpers states, the museum effect is about an informed process of seeing (Alpers, 1991), then how do we look at objects mediated through digital technologies? In this sense,

does the software interface through which the war canoe is viewed allow for a spectator to examine and focus in on certain features of an object, as though passing one's eye over the surface of a thing in an analytical way (Were, 2008)? Or does looking invoke wonder, awe (Greenblatt, 1991) or even a form of play?

Summary

These three points emphasize, through a critical approach to digital heritage technologies, that issues of access, authenticity and knowledge are crucial factors that are situated within specific cultural frameworks and understandings that require sensitive handling. Indeed, the success of this cross-disciplinary project is that it focused on the needs of the local community. In turn, in delivering a technological solution to the restitution of cultural knowledge, it led to new understandings about the technical construction of the war canoe, which was shared between Solomon Islanders, museums and anthropologists. Since digital heritage technologies offer the only feasible way that many indigenous communities will get to access their own cultural heritage held in Western museums, this project underlines the importance of designing technology in consultation with source communities. ■

Conclusion and future opportunities

As was the case in the early days of photography, there are multiple interests from the humanities, science and engineering fields driving forward cultural 3D imaging projects, from standpoints ranging from casual interest in 3D visualization to highly specified scientific analysis of coloured surface change. The case studies included here provide examples of the diversity of disciplines and interest that such work can attract and highlight some of the community considerations, but they must be viewed from the standpoint of the sweeping technological change in our society, being brought about by mobile computing devices.

Key to future adoption in the museum sector is the cost, set against fitness for purpose, of the 3D data produced. The demand for technologies to capture, display, reproduce and interact with objects is driven by the mass market expectations of mobile phones, computer gaming and 3D TV. If there is to be a sustainable future for the use of 3D content in museums, the sector will need to be proactive. It is important to understand the emerging markets for 3D models of cultural and heritage material; to understand who the users are and how they will wish to interact; the model quality required

for different applications; and the ways in which these data can form an integral part of the new media museum portfolio. Skills training and development of best practice within the sector are essential to ensure that 3D models are fit for multiple purposes and that, after a one-time capture, their source data can be reworked, if required, for scientific analysis, as well as simple display.

From a technology standpoint, whilst there are rapid advances and an increasing range of technologies being developed and repurposed for 3D recording in museums, no part of the 3D model chain is completely understood, particularly where capture and reproduction for scientific purposes is concerned. From a collection recording standpoint, the most significant challenge is the effective capture of a wide variety of materials, most notably, transparent objects, specimens in liquids, the highly glossy, the very large and the very small. Yet, this is an exciting moment, when daily advances in sectors as widely separated as communications and manufacturing are able to directly contribute, in highly unexpected ways, to the way we understand, access and use museum objects.

Bibliography

Alpers, S. (1991) The Museum as a Way of Seeing. In Karp, I. and Lavine, S. D. (eds), *Exhibiting Cultures: the poetics and politics of museum display*, Smithsonian Institution Press.

Armstrong, J. (2006) Depiction and the Sense of Reality, *Contemporary Aesthetics*, **4** (38), www.contempaesthetics.org/index.html.

Atkinson, K. B. (1968) The Recording of Some Prehistoric Carvings at Stonehenge, *The Photogrammetric Record*, **6** (31), 24–31.

Benjamin, W. ([1935] 1970) The Work of Art in the Age of Mechanical Reproduction, *Illuminations: essays and reflections*, Zohn, H. (trans.), Jonathan Cape.

Beentjes, T. and van der Molen, R. (2012, forthcoming) An Innovative Treatment of a Severely Damaged Bronze, the Thinker by Rodin. In Saunders, D., Strlic, M., Korenberg, C., Birholzer, K. and Luxford, N. (eds) *Proceedings of Lacona IX Conference*, 7–10 September 2011, London, organized by the British Museum, Archetype.

Blais, F., Beraldin, J.-A., El-Hakim, S. and Godin, G. (2003) New Development in 3D Laser Scanners: from static to dynamic multi-modal systems. In Gruen, A. and Kahmen, H. (eds), *Proceedings of the 6th Conference on Optical 3-D Measurement Techniques held on 22–25 September 2003,* Department of Applied and Engineering Geodesy, Vienna Institute of Technology.

Brown, D. (2007) Te Ahu Hiko: digital heritage and indigenous objects, people, and environments. In Cameron, F. and Kenderdine, S. (eds), *Theorizing Digital Culture Heritage: a critical discourse*, The MIT Press.

Brown, M. (2005) Heritage Trouble: recent work on the protection of intangible cultural property, *International Journal of Cultural Property*, **12** (1), 40–61.

Cameron, F. (2007) Beyond the Cult of the Replicant – museums and historical digital objects: traditional concerns, new discourses. In Cameron, F. and Kenderdine, S. (eds), *Theorizing Digital Cultural Heritage*, The MIT Press.

Davidowitz, T., van der Molen, R. and Beentjes, T. (2011) Recreating Patina: the filling and retouching of Rodin's 'The Thinker'. In Seymour, K. and van Haaften, C. (eds), *Symposium Proceedings of SRAL Symposium Filling and Retouching: paintings and painted surfaces held on 23 May 2011, Maastricht,* www.sral.nl/symposia.html.

Desmond, L. G. and Bryan, P. G. (2003) Recording Architecture at the Archaeological Site of Uxmal, Mexico: a historical and contemporary view, *The Photogrammetric Record*, **18** (102), 105–30.

Earl, G., Martinez, K. and Malzbender, T. (2010) Archaeological Applications of Polynomial Texture Mapping: analysis, conservation and representation, *Journal of Archaeological Science*, **37** (8), 2040–50.

E-Curator Team (2009) E-Curator: a 3D web-based archive for conservators and curators, *Ariadne Online Magazine for Information Professionals in Archives, Libraries and Museums in all Sectors*, (60), www.ariadne.ac.uk/issue60/hess-et-al.

Foucault, M. (1971) *The Order of Things: an archaeology of the human sciences,* Pantheon Books.

Graham, D. and Eddie, T. (1985) *X-Ray Techniques in Art Galleries and Museums*, Adam Hilger Ltd.

Greenblatt, S. (1991) Resonance and Wonder. In Karp, I. and Lavine, S. D. (eds), *Exhibiting Cultures: the poetics and politics of museum display*, Smithsonian Institution Press.

Hawkey, R. (1999) Learning from Objects Online: virtue and reality, *British Journal of Educational Technology*, **30** (1), 73–7.

Hein, G. (1998) *Learning in the Museum*, Routledge.

Hess, M., MacDonald, S., Brown, I., Simon Millar, F., Were, G. and Robson, S. (2011) Well Connected to your Digital Object? E-Curator: a web-based e-science platform for museum artefacts, *Literary and Linguistic Computing*, **26** (2), 193–215.

Hess, M., Robson, S., Were, G., Simon Millar, F., Hviding, E. and Berg, C. A. (2009) Niabara – the Western Solomon Islands war canoe at the British Museum. 3D Documentation, Virtual Reconstruction and Digital Repatriation. In Sablatnig, R. (ed.), *Proceedings of the 15th International Conference on Virtual Systems and*

Multimedia VSMM. 'Vision or Reality? Computer Technology and Science in Art, Cultural Heritage, Entertainment and Education', 9–12 September 2009, Vienna, Austria.

Huntley J. M. and Coggrave C. R. (2002) High Speed Measurement of Discontinuous Surface Profiles, *Solid Mechanics and Its Applications*, **82** (2), 161–8.

Jones, T. W. and Pappa, R. S. (2002) Dot Projection Photogrammetric Technique for Shape Measurements of Aerospace Test Articles, AIAA Paper 2002-0532, *Proceedings of the 40th AIAA Aerospace Sciences Conference*, 14–17 January 2002, Reno, NV, The American Institute of Aeronautics and Astronautics.

Luhmann, T., Robson, S., Kyle, S. and Harley, I. (2006) *Close Range Photogrammetry: principles, techniques and applications*, Whittles.

MacDonald, L. and Robson, S. (2010) Polynomial Texture Mapping and 3D Representations, *International Archives of Photogrammetry Remote Sensing and Spatial Information Sciences*, **38** (5), 422–7.

Malzbender, T., Gelb, D. and Wolters, H. (2001) Polynomial Texture Maps. In *SIGGRAPH '01: The 28th International Conference on Computer Graphics and Interactive Techniques*, Los Angeles, CA, USA, August 12–17, 2001.

Parry, R. (2008) *Recoding the Museum: digital heritage and the technologies of change*, Routledge.

Pitzalis, D., Cord, M. and Niccolucci, F. (2011) Using LIDO to Handle 3D Cultural Heritage Documentation Data Provenance. In Martínez, J.M. (ed.), *9th IEEE International Workshop on Content-Based Multimedia Indexing*, 13–15 Jun 2011, Madrid, Spain, Universidad Autónoma de Madrid, IEEE.

Remondino, F. and El-Hakim, S. (2006) Image-Based 3D Modelling: a review, *The Photogrammetric Record*, **21** (115), 269–91.

Remondino, F. and Menna, F. (2008) Image-Based Surface Measurement for Close-Range Heritage Documentation, *International Archives of the Photogrammetry, Remote Sensing and Spatial Information Sciences*, **37** (B5), 199–206.

Robson, S., Brown, I., Hess, M., MacDonald, S., Ong, Y.-H. and Simon Millar, F. (2008) E-Curator: 3D colour scans for object assessment. In Delivorrias, A. (ed.) *CIDOC 2008 Conference in Athens Dedicated to the Digital Curation of Cultural Heritage*, 15–18 September, 2008, Athens, Greece, International Documentation Committee of the International Council of Museums, www.cidoc2008.gr/cidoc/.

Robson, S., Brown, I., Hess, M., MacDonald, S., Ong, Y-H. and Simon Millar, F. (2008) Traceable Storage and Transmission of Colour Laser Scan Datasets. In Ioannides, M., Addison, A., Georgopoulos, A. and Kalisperis, L. (eds), *Proceedings of the 14th International Conference on Virtual Systems and Multimedia (full papers)*, 20–25 October 2008, Limassol, Cyprus, CIPA, the International ICOMOS Committee on Heritage Documentation and the Cyprus Institute.

Serrell, B. (1997) Paying Attention: the duration and allocation of visitors' time in museum exhibitions, *Curator*, **40** (2), 108–25.

Were, G. (2008) Out of Touch? Digital Technologies, Ethnographic Objects and Sensory Orders. In Chatterjee, H. (ed.), *Touch in Museums*, Berg.

Notes

1 www.photomodeler.com.

2 http://photosynth.net.

3 www.123dapp.com/catch.

4 www.david-laserscanner.com/.

5 www.konicaminolta.eu/measuring-instruments/products/3d-measurement/non-contact-3d-digitizer/konica-minolta-range7/introduction.html.

6 www.faro.com/content.aspx?ct=uk&content=pro&item=1.

7 www.nikonmetrology.com/handheld_scanners/.

8 www.arius3d.com.

9 www.4ddynamics.com/.

10 www.geodetic.com/products/accessories/pro-spot-2784.aspx.

11 www.gom.com/metrology-systems/3d-scanner.html.

12 www.breuckmann.com/en/arts-culture/products.html.

13 It is worth noting that there are two paradigms for processing the resulting data from 3D recording: those that rely on point processing only and those that convert the point data into a connected mesh or triangular network. The paradigm selected will have a key influence on the types of output that can be readily generated. For example, the dense data collection capability of an Arius3D system lends itself to point based processing, since the line-by-line capture process produces a highly structured array of coloured points, with sufficient spatial resolution to represent fine detail. Conversely, data captured with a pattern projection system will often map colour information from a high resolution camera image onto a less dense set of meshed surface data, in order that the comparatively large number of image pixels contributing to each mesh surface facet will improve the perception of fine detail.

14 www.innovmetric.com/polyworks/3D-scanners/home.aspx?lang=en.

15 www.geomagic.com/en/.

16 http://meshlab.sourceforge.net/.

17 www.gom.com/3d-software/gom-inspect.html.

18 www.danielgm.net/cc/.

19 www.rhinocad.co.uk/.

20 https://www.khronos.org/registry/webgl/specs/1.0/.

21 www.ucl.ac.uk/dh-blog/2010/03/10/digital-excursion-1-petrie-museum/.

22 www.ucl.ac.uk/news/news-articles/0803/08030604.

23 Potential printing processes involve making sure that the model is in the form of a hole-free mesh and then passing that data through a proprietary printer driver into output devices that commonly build up a model, layer by layer. Available materials include gypsum (www.zcorp.com/en/Products/3D-Printers/spage.aspx), nylon (www.3dprototype.com/3D-printing.html) and rubber (www.economist.com/node/18114221), metals and, even, chocolate (www.theengineer.co.uk/news/research-group-develops-3d-chocolate-printing-technology/1009276.article).

24 www.britishmuseum.org/pdf/Mummy%20the%20inside%20story.pdf.

25 http://standards-catalogue.ukoln.ac.uk/index/SPECTRUM.

26 www.britishmuseum.org/research/search_the_collection_database.aspx.

27 www.ahessc.ac.uk/Francesca-Simon-Millar.

28 http://echo.mpiwg-berlin.mpg.de/home.

29 http://pro.europeana.eu/web/guest/thoughtlab/new-ways-of-searching-and-browsing and http://www.slideshare.net/DavidHaskiya/sw-6043681.

CHAPTER 6

Text encoding and scholarly digital editions

Julianne Nyhan

Introduction

 The first stage of any digitization project involves the process of creating a digital representation of, for example, a text, image, sound or material object (see Chapter 3 on digitization). The second stage of a digitization project, carried out by digital humanists, usually involves the application of an additional layer of metadata (or information about information), so as to make features of the object machine readable. The Text Encoding Initiative (TEI) specifies metadata that can be used to make information *in* and *about* digital objects machine readable.

Text encoding (the act of applying metadata to a text) and the creation of scholarly, digital editions has been a core research area of digital humanities since its very beginnings and continues to be one of the most central areas of digital humanities. Special emphasis is placed here on TEI, because it is the '*de facto* standard for literary computing' (Jannidis, 2009, 258) and is endorsed by agencies such as the National Endowment for the Humanities (NEH), Arts and Humanities Research Council (AHRC) and the EU's Expert Advisory Group for Language Engineering. Its reach has extended beyond the humanities, and it has had a formative influence on the development of XML – the *lingua franca* of global data-interchange (www.tei-c.org/). This chapter reflects on how a digital text, created using digital humanities methodologies and techniques, tends to differ from other kinds of digital texts; it asks what TEI is, how it can be used and gives an overview of the advantages and disadvantages of TEI. Current practice is evidenced by the inclusion of two case studies: the Webbs on the Web Project and the DALF Project. The chapter closes by pointing to key resources for the teaching and learning of TEI.

What is a scholarly digital text?

John Unsworth has discussed how the mere use of a computer in humanities research does not automatically situate that research within the field of digital humanities:

> One of the many things you can do with computers is something that I would call humanities computing, in which the computer is used as tool for modelling humanities data and our understanding of it, and that activity is entirely distinct from using the computer when it models the typewriter, or the telephone, or the phonograph, or any of the many other things it can be.
>
> (Unsworth, 2002)

From this, we can make the analogy that the act of digitizing a text does not necessarily make it a digital humanities text, by which I mean a digital text that supports research and/or is the result of research.

This is an important distinction, because there are so many kinds of digital text available online; for an overview of these, see Perry Willett (2004). Each has their own merits, but not all are necessarily useful for research in the humanities or beyond. Here, the example of Project Gutenberg will suffice. Founded by Michael Hart in 1971, the aim of the site is '[t]o encourage the creation and distribution of eBooks'[1] and, in terms of computing, it is an early example of crowdsourcing. A fascinating and important project in its own right, the books it distributes tend to be less useful for research, because, for example, accuracy standards cannot be guaranteed: 'we do not provide standards of accuracy above those as recommended by institutions such as the US Library of Congress at the level of 99.95%',[2] and detailed bibliographical information about editions, whence the digital texts are derived, is sometimes missing. Already, by 1994, Stephen Sperberg-McQueen outlined the requirements that must be met in digital scholarly editions and concluded: 'As a consequence, we must reject out of hand proposals to create electronic scholarly editions in the style of Project Gutenberg, which objects in principle to the provision of apparatus, and almost never indicates the sources, let alone the principles which have governed the transcription, of its texts' (Sperberg-McQueen, 1994). Since Sperberg-McQueen's paper, many other groups[3] have discussed the hallmarks and desiderata of a digital scholarly edition. We can see from these recommendations that it is widely agreed that, to be useful for research, a digital scholarly text should, *inter alia*:

- provide the essential data that the scholar needs, such as bibliographical data about the base text
- describe editorial decisions and workflow, for example, whether spellings were normalized or not
- use non-proprietary and Open Source technologies and software, so that digital editions will not become obsolete, due to software or platform updates; so they can be transformed into other formats; and so they are accessible by as many people as possible.

We can also add that a digital humanities text is usually expected to do the following:

1 It should explicitly declare the editorial theory or interpretation that underpinned the edition and how this has been expressed in the design of the digital text. In the literature of the field, this is usually called modelling. It has been written about most extensively by Willard McCarty (see, for example, McCarty, 2005). While discussing another issue, Vanhoutte (2010) has succinctly expressed both the aims of modelling and the borderlines that exist between a scholarly electronic edition and a text that is merely published electronically: 'The electronic edition would … be … a publication tool demonstrating a fixed set of options rather than a modelling tool for exploring the text and generating meaning within it' (2010, 120). Of the many layers to a digital edition, project limitations of space mean that two of the most essential ones will be examined here: mark-up and preservation.

2 It should demonstrate, or enable, research that cannot be done otherwise, for example, by allowing old questions to be explored in new ways or allowing new questions to be asked.

3 It should be able to interact with other digital texts and digital ecosystems, such as research infrastructures.

One of the reasons that TEI has become so influential is that it enables (and, in regard to specifying bibliographical sources, requires) projects to make machine readable and explicit the ways that each of the criteria listed above have been met. Concrete examples of each criterion are given below, after a brief overview of TEI.

An overview of TEI and its origins

As Hockey has made clear: 'the use of markup goes back to the beginnings of electronic text technology' (Hockey, 2000, 24). By the mid-1980s, a number of humanities computing projects were reasonably well established. However, no particular markup language was commonly used by these projects. This had a number of disadvantages, for example, interoperability between projects was severely hampered, to say nothing of the time and energy that went into developing new, project-specific markup languages.

In 1987, 32 humanities computing scholars gathered at Vassar College in Poughkeepsie, New York, at a meeting funded, in part, by the National Endowment for the Humanities. The main outcome of the meeting was a statement of the intellectual principles of TEI – which became known as the *Poughkeepsie Principles* – later, more comprehensively formulated in a document entitled 'Design Principles for Text Encoding Guidelines, TEI ED P1', published on 14 December 1988 and revised 9 January 1990. The primary goal of the Text Encoding Initiative was described as providing 'explicit guidelines which define a text format suitable for data interchange and data analysis; the format should be hardware and software independent, rigorous in its definition of textual objects, easy to use, and compatible with existing standards' (Sperberg-McQueen and Burnard, 1988). The fifth, and most recent, edition of the Guidelines – P5 – was released in November 2007.

At the time of writing, TEI has developed into a not-for-profit consortium, with members from all over the world. It is led by a Board of Directors, and the intellectual and technical work on the guidelines is carried out by the Technical Council, with input from the TEI community as a whole, through, for example, their participation in special interest groups and working groups. TEI has an active community of users and maintains a number of resources to support that community. The TEI-L[4] mailing list, for example, provides a platform for discussion of all issues related to the guidelines and their implementation; an Open Source, peer-reviewed TEI journal[5] has recently been founded, and the TEI website provides links to resources, such as a Wiki[6] on tools related to TEI.

The TEI guidelines

The TEI P5 Guidelines 'specify encoding methods for machine-readable texts, chiefly in the humanities, social sciences and linguistics' (www.tei-c. org/index.xml). It enables researchers to insert tags into their text in order to make such texts machine readable. A computer has no innate intelligence, so,

to take a simple example, when an object such as a letter is digitized, without further intervention, it is not possible for a computer to recognize that the words 'Dear Sadhbh' are not just a series of 0 and 1, but also a salutation, written in English, and that 'Sadhbh' is a personal name. At present, a common way for those who implement digital editions to make such information machine readable is with markup, or by inserting codes into a text that describe it in some way. The following is an example of an old Irish poem that has been marked up in TEI. You may not understand the content of the poem, but the tags that have been applied to it should make clear to you that the following is a verse of four numbered lines. The beginning and ending of each line and the verse itself is also clearly indicated.

```
<verse>
<lb n="1">In esser dam to á?</lb>
<lb n="2">Tó, mani má mo á </lb>
<lb n="3">Ara tairi mo á mó?</lb>
<lb n="4">Mani má to á, tó</lb>
<verse>
```

Considering the apparent simplicity of this intervention, its consequences are startling. Before discussing such consequences, with reference to the basic hallmarks of digital, scholarly editions discussed above, I will begin with some necessary, preliminary considerations about markup.

Markup: essential preliminary considerations

Markup has been defined 'as any means of making explicit an interpretation of a text' (TEI, P5). Knowledge of markup is often described as a core competence of digital humanities (Terras, 2011). In terms of teaching the subject, it has been suggested that text encoding (including TEI) should be a central plank of what, at that time, was referred to as a humanities computing curriculum (Ore et al., 1999, 88) and, furthermore, that 'text encoding seems to create the foundation for almost any use of computers in the humanities' (De Smedt, 2002, 95). Humanists were among the first computer users to devise markup systems (Schmidt, 2010, 338), and an overview of the history of the development of markup in the humanities, from character encoding to present-day embedded markup, has been given by Vanhoutte and Van den Branden (2010); an overview of its development, in terms of markup languages themselves, has been given by Schmidt (2010, 338–9).

The term 'markup' is thought to come from publishing, where a writer would mark details, such as corrections or formatting instructions, on proofs in preparation for printing (Renear, 2004, 219). Coombs, Renear and DeRose (1987) have argued that is it impossible to write a text, without marking it up in some way – for example, by inserting space breaks to signal the beginnings and ending of words – a position echoed by Sperberg-McQueen (1991). McGann also argues that, whether implicit or not, conscious or not:

> There is no such thing as an unmarked text, and the mark-up system laid upon documents to facilitate computerised analyses are marking orders laid upon already marked up material. (Thus all texts implicitly record a cultural history of the artifactuality). (2004, 138)

Schmidt, on the other hand, emphasizes the embedded nature of markup and views positions, such as that of Coombes, within the context of historical necessity:

> In the early 90s humanists may have preferred a more expanded definition of markup because they needed to overcome their colleagues' resistance to it use, by arguing that it was only a variation on something they already used, such as punctuation, and spaces, or word processors. (Schmidt, 2010, 338)

Markup applied to electronic texts is frequently categorized as presentational, procedural and descriptive (such delineations are far from uncontested, and, in practice, markup languages do not always fall into such neat categories – see, for example, Renear, 2000, and Piez, 2001). Presentational markup is applied to a text, in order to specify some aspect of its appearance. HTML, for example, contains many presentational tags that can be used to indicate that a portion of text should be formatted in a certain way. Presentational instructions are sometimes indicated with procedural markup, which software acts upon in order to implement such instructions. Descriptive markup intentionally separates information about the form and content of a document and aims to describe its content only; its goal is to label what a unit of a document 'is', e.g. a noun, a place name or a glyph. Such markup is often referred to as semantic or declarative (meaning that the logical elements of a document are described), though the accuracy of these labels has been challenged. Antoniou and van Harmelen (2008) argue that:

> XML does not provide any means of talking about the *semantics* (meaning) of
> data. For example, there is no intended meaning associated with the nesting of
> tags; it is up to each application to interpret the nesting. (2008, 65)

Discussion of this has also been taking place within the digital humanities
community; see, for example, Sperberg-McQueen et al. (2000), Renear et al.
(2002) and relevant Balisage papers.[7]

The advantages of descriptive markup have been known and written
about for some time. Building on the work of Goldfarb (1981) and Reid
(1981), among others, in 1987, Coombs, Renear and DeRose published an
influential article evaluating the pros and cons of each of these approaches
to markup, in the context of scholarly publishing. Descriptive markup was
demonstrated to offer numerous advantages over that of presentational and
procedural.

The application of markup, with emphasis on TEI

Descriptive markup can be applied to any kind or genre of text; indeed, any
information that can be consistently represented using a symbol of some
kind and then digitized can be marked up. So markup can be used to make
not only, *inter alia*, dictionaries, novels, manuscripts, collections of poetry,
calendars and naval logs machine readable, but also inscriptions on stone,
musical notation, mathematical equations, digitized statues and images.
Researchers who mark up texts, in line with TEI, derive a number of benefits
from doing so.

Providing the essential data required by humans and machines

As the name suggests, the TEI guidelines are not a series of prescriptive
statements about how markup can be applied to a text. Rather, it offers
advice and examples of ways to encode a given textual feature.
Consequently, the guidelines can be used by a wide range of projects, some
of which make only minimal use of TEI and some of which make complex
and sophisticated use of it. Projects are also able to extend TEI, according to
certain criteria, if necessary.

For a text to be TEI conformant, the only obligatory elements that it must
contain are the TEI header, followed by a single text or facsimile tag (or
both). The guidelines describe the header as 'suppl[ying] the descriptive and
declarative information [that makes] up an electronic title page prefixed to

every TEI-conformant text' (TEI Guidelines, 2.1.1). Information that must be included in the header includes the texts that the electronic edition has been compiled from and the transcription and editorial strategy that underpinned the digital edition text. This information is then recoverable by both humans and machines. So, for example, texts published in a digital humanities project can be automatically included in the library catalogue of their own and international institutions.[8] The researcher using the text can identify which edition it has been derived from and, for example, whether the spelling mistakes of the author have been corrected or not.

The excerpts below are taken from The Fragmentary Annals of Ireland, published by the *Corpus of Electronic Texts (CELT) Project,* and demonstrates the kinds of information that can be included in the TEI header.

In this extract from the TEI header, the source of the digital edition is described:

```
<listBibl><head>The edition used in the digital edition</head>
<biblFull><titleStmt><title level="m">Fragmentary Annals of
Ireland</title>
<editor id="JR">Joan Newlon Radner</editor>
</titleStmt>
<editionStmt><edition>first edition</edition></editionStmt>
<extent>xxxvii + 241 pages</extent>
<publicationStmt>
<publisher>Dublin Institute for Advanced Studies</publisher>
<pubPlace>Dublin</pubPlace> <date>1978</date>
</publicationStmt></biblFull></listBibl>
```

In this extract from the TEI header, the workflow and treatment of particular textual features is described:

```
<editorialDecl>
<correction status="medium"><p>Text has been proof-read twice and
parsed using NSGMLS.</p>
<p>Radner's chronology refers to the revised dating in the Annals of
Ulster. Where her dates are tentative (marked by a ?) they are tagged
<emph>sup resp="JR"</emph>, otherwise as date values. Her dates have
been supplemented with <name id="DMC">Dr Daniel Mc
Carthy</name>'s chronologies (available at
www.cs.tcd.ie/Dan.McCarthy/). Date values supplied by him are tagged
```

```
<emph>date value="nnnDMC"</emph>.</p>
</correction>
<normalization><p>The electronic text represents the edited
text.</p></normalization>
<quotation><p>Direct speech is rendered
<emph>q</emph>.</p></quotation>
<hyphenation><p>Soft hyphens are silently
removed.</p></hyphenation>
<segmentation><p><emph>div0</emph>=the body of annals;
<emph>div1</emph> represents the individual extract made by the
compiler from the original MS which is now lost. <emph>div2</emph>
represents the individual annalistic entry of the edition. Passages of
verse occurring within paragraphs are treated as embedded texts;
stanzas and metrical lines are marked. Page-breaks are marked
<emph>pb n=""</emph>.</p>
</segmentation>
<interpretation><p>Names of persons (given names), and places are not
tagged. Terms for
cultural and social roles are not tagged. Dates are
tagged.</p></interpretation>
</editorialDecl>
```

In this extract from the TEI header, revisions that were made to the text are
described:

```
<revisionDesc>
<change>
<date>2008-09-05</date>
<respStmt>
<name>Beatrix F&auml;rber</name>
<resp>ed.</resp>
</respStmt>
<item>Keywords added, file validated; new wordcount made.</item>
</change>
<change>
<date>2008-07-27</date>
<respStmt>
<name>Beatrix F&auml;rber</name>
<resp>ed.</resp>
```

```
</respStmt>
<item>Value of div0 "type" attribute modified, title elements
streamlined, content of 'langUsage' revised; minor modifications made
to header.</item>
</change>
<change>
<date>2005-08-25</date>
<respStmt>
<name>Julianne Nyhan</name>
<resp>ed.</resp>
</respStmt>
<item>Normalised language codes and edited langUsage for XML
conversion</item>
```

From a technical perspective, the markup of the examples above uses an older scheme than that of the current P5 guidelines, though, in terms of the information supplied in the header, little is different in the current P5 header. For an excellent introduction to the Text Encoding Initiative (TEI) Header, see the TEI by Example Project (http://tbe.kantl.be/TBE/modules/TBED02v00.htm).

Opening new ways to question and explore

One of the most obvious benefits of applying markup to research objects – let us here consider texts – is the possibilities it opens up to allow text to be searched, read and interacted with, in ways that are otherwise impossible. For example, the digital edition of the Van Gogh letters[9] enables users to search the letters, according to criteria such as 'sketch' and 'person', and to combine such criteria in sophisticated ways that are either impossible or very difficult to pursue using the index to the printed work only. This is possible, due, in large part, to the TEI markup applied to the letters (see, especially, Ciula, 2010). The possibility of searching any text in this way is helpful and of much practical value. Though mostly outside the scope of this article, it is important to note that the new ways of understanding and interpreting texts that such digital editions can lead to is considered important in digital humanities too.

Interoperability and integration with existing infrastructure

To take another example, the Metadata Offer New Knowledge Project (MONK, http://monkpublic.library.illinois.edu/monkmiddleware/public/index.html) enables multiple texts to be simultaneously searched for internal features – for example, for particular words – or for object-level information – for example, bibliographical information – so that new patterns can be uncovered, often in multiple texts. Another example is the TextGrid Project (www.textgrid.de/) – a Virtual Research Environment, where data, services and tools are brought together in one integrated environment capable of supporting collaborative scholarly research. For example, a number of historical encyclopedia and specialized dictionaries encoded in TEI are available through its library (www.textgrid.de/digitale-bibliothek.html), and it is possible to perform structured searches across such works simultaneously. On the TEI website, the wide range of texts that use TEI are listed (www.tei-c.org/Activities/Projects/).

Over the past 25 years, numerous articles have also been published in journals, such as *Computers and the Humanities* and *Literary and Linguistic Computing*, on how TEI has been used adapted and extended in humanities' projects. Much less common, though, are studies that are based on an analysis of TEI – for example, how the application of TEI to a text reflects the tacit assumptions and disciplinary concerns of an encoder or by theorizing about patterns in genres of text, by analysing the markup that has been applied to numerous such texts. It seems clear that a great deal of interesting and productive research remains to be done, in this regard.

..

CASE STUDY The Webbs on the Web Project
(http://digital.library.lse.ac.uk/collections/webb#images)
..

Ed Fay, Digital Library Manager, London School of Economics (LSE)
The manuscript and printed works of Sidney and Beatrice Webb are among the founding collections of the library at LSE. To this day, their works are regularly requested by researchers, and Beatrice Webb's extensive diary is a key resource for research into a wider range of subjects, which includes politics in the late 19th and early 20th century, industrial relations, the role of women in society and family relationships.

The diaries were chosen as the launch collection for the new LSE digital library, with funding from the Webb Memorial Trust. LSE is one of the first academic libraries to provide a digital library – a service which is becoming more and more

necessary, due to the requirement to collect, preserve and provide access to digital material. This is compounded by the popularity of social media today and its importance as a historical record, particularly to an institution like LSE. The Webbs on the Web Project provides a single gateway to the works (published and unpublished) of Beatrice and Sidney Webb. It provides:

- online access to a bibliography of published works, with links to digital versions, where they are available
- digitization, transcription and online access to the typescript and manuscript versions of Beatrice Webb's diary, with search browsing capability
- an online gallery of images of Beatrice and Sidney Webb.

All 9000 pages of the actual manuscript, as well as 8000 pages of a transcribed version that is cross-referenced with the date fields indexed from the manuscript version, were made available. Both versions can now be viewed side-by-side for comparison. The incorporation of TEI into the LSE digital library technology stack allowed it to be augmented with specific functionality for textual comparison. This has allowed the LSE digital library to not only make digital content available, but to make that content richer and capable of meeting research needs. The general approach was to use an instance of the institutional repository (E-Prints) for the online bibliography, holding bibliographic metadata (DC) and full-text (PDF) publications, where available in digital form already. The digital library (Fedora) holds the scanned diaries (TIFF) and transcribed and marked-up text (TEI/XML), supporting their indexing and availability for online presentation, via a custom website/application. External suppliers were procured for digitization and transcription of the manuscript and typescript diaries. ■

Non-proprietary software and technology

TEI is based on open technologies, and, at present, its abstract conceptual model is expressed in XML (previously, this was expressed in SGML, and future iterations of the guidelines are not necessarily tied to XML). Today, one of the most common means of implementing descriptive markup is with XML – the eXtensible markup language. This is a set of guidelines, as outlined in the XML 1.0 specification (www.w3.org/TR/REC-xml/), which can be used to identify information, both within and about texts.

The hypertext markup language, HTML, consists of a fixed corpus of tags that can be applied to a document, in order to reflect three different types of information that have been categorized by Flynn (1995) as structural, content

descriptive and visual. Thus, HTML can be used to label some aspects of the structure of a document, for example, its headings, paragraphs and lists. Content descriptive tags are also available, for example, the use of 'strong' to indicate that information is, in some way, noteworthy (though this is less than desirable from an accessibility perspective). Formatting tags can also be used to indicate that a portion of text should be rendered in bold type or Times New Roman font, etc. In contrast to HTML, XML is not a language in itself, but, rather, a meta-markup language or set of instructions that can be combined, in order to create specialized markup languages. A project using XML, rather than HTML, as a format to encode its primary documents is not limited to the number of tags that are set out in the HTML specification, but, rather, can create a specialized markup language to reflect the unique requirements of that project. Other widely agreed upon advantages of XML is that it is vendor and platform independent; using the declarative transformation language XSLT (which is also written in XML), it can be output in formats such as pdf, HTML, TEI-XML and XHTML.[10] Formatting and transformations of structure are applied to a document in a separate file, and, thus, the information can be processed in numerous different ways, without ever changing the data contained in the master file. Jon Bosak, who chaired the W3C's XML Working Group, has stated:

> XML derives from a philosophy that data belongs to its creators and that content providers are best served by a data format that does not bind them to particular script languages, authoring tools, and delivery engines but provides a standardized, vendor-independent, level playing field upon which different authoring and delivery tools may freely compete. (Bosak, 1997)

From the humanities perspective, key disadvantages of XML can include its tree-model, which is hierarchical and does not allow overlapping hierarchies. This means that pieces of markup must nest correctly within one another. Where units of a text overlap with one another, e.g. a paragraph that spans a page break, encoders must find 'work arounds' (see TEI P5, Chapter 20, for an overview of commonly used approaches). The potential verbosity of XML documents can be another disadvantage. Binary XML, a compact representation of XML, is seen, by some, as a potential solution to this.

A closer look at the P5 guidelines

The TEI guidelines allow a wide range of textual features to be made

machine readable in texts such as dictionaries (Chapter 9), primary sources (Chapter 11) and on names, dates, people and places (Chapter 13). At present, P5 comprises some 504 tags, having grown from 163 in the first edition of the Guidelines published in 1990 (Jannidis, 2009, 258). Yet, as Jannidis notes, based on his overview of 'grouping elements by function, drawn from the P5 guidelines ... A look at these categories in the P1 version of the Guidelines shows that early on the TEI had more ambitious goals' (2009, 259). Furthermore, he goes on to note that, 'still, after twenty years of the TEI [there exists] no letters and no tag set for the physical description of books' (2009, 260). Notwithstanding this, TEI P5 heralded many changes. These included, *inter alia*, enhanced support for the integration of graphics and text. Previously, such projects had been marked up using other technologies, such as SVG (see Wittern, Ciula and Tuohy (2009) for a detailed discussion and examples). Due to the inclusion of XML schema languages, P5 also delivered enhanced support that allows users to reference other XML languages from within a TEI document or embed a TEI document within other kinds of XML documents, such as METS and MODS. This is useful, for example, for projects that deal with mixed content, such as text and musical notation (see, for example, www.tei-c.org/SIG/Music/twm/). Nevertheless, there remains much to be done. After 20 years of TEI, no dedicated tag set for correspondence exists, and users mostly design their own or draw on the Digital Archive of Letters in Flanders (DALF) tag set.

..
CASE STUDY DALF: Digital Archive of Letters in Flanders
..

Ron Van den Branden and Bert Van Raemdonck, Centre for Scholarly Editing and Document Studies, Royal Academy of Dutch Language and Literature
In 2003, the Centre for Scholarly Editing and Document Studies (of the Royal Academy of Dutch Language and Literature) launched the DALF project. DALF (Digital Archive of Letters in Flanders) was envisioned as a growing textbase of letters, generating different products for both academia and a wider audience, thus providing a tool for diverse research disciplines. The input of the textbase was provided through several separate edition projects.

In order to ensure maximum flexibility and (re)usability of each of the digital DALF editions, a formal framework was required. Aiming at adherence to international standards for digital text encoding, DALF used XML to define the structure of a letter as a 'Document Type Definition' (DTD). Moreover, to align with international efforts to define markup schemes, DALF took into

consideration the insights that had been presented in projects like TEI (Text Encoding Initiative), MASTER (Manuscript Access through Standards for Electronic Records) and MEP (Model Editions Partnership).

At the time, the Text Encoding Initiative had just published the fourth proposal (P4) of its *Guidelines for Electronic Text Encoding and Interchange*. These guidelines provided an excellent starting point for many of the features we wanted to encode in letters. Yet, some letter-specific features still required some additional means to be properly encoded. Since the TEI scheme could (and can) be extended, this was the approach we took for the development of the DALF DTD.

A selection of several subsets of standard TEI elements was made, to which some new elements and attributes have been added. Most of the new features, e.g. an identifying description of the letter (<letIdentifier>), a description of the most salient communicative parameters (<letHeading>), the description of physical characteristics (<physDesc>), and the presence of an envelope (<envOcc/>) found their place in <letDesc> – a letter-specific section in the DALF header. Some letter-specific structural text elements were added for postscripts (<ps>), envelopes <envelope> and calculations (<calc>). The modifications of the TEI P4 guidelines included the redefinition of <add>, <note> and <seg> as global elements.

The most important digital edition of letters that has been published through the DALF framework so far is the edition of 1500 letters dealing with the Flemish literary journal *Van Nu en Straks* (1893–1901). This edition has a fully eXist-driven web interface and allows users to browse, search, view and export the encoded letters or custom selections of letters in XHTML, XML or PDF. The letters can be visualized as reading text, diplomatic transcription or XML source view, and facsimiles are offered where available. Most of the 1500 letters are in Dutch; 180 are in French.

As DALF has been defined as an extension to the TEI P4 guidelines, it does not comply to the most recent version of those guidelines. When the TEI published the fifth proposal of its guidelines (P5) in November 2007, five years of ongoing support for projects using TEI P4 had been guaranteed. Therefore, the Centre for Scholarly Editing and Document Studies is planning a DALF update before November 2012. Since some of the sources of inspiration for the original DALF DTD have been incorporated in the TEI P5 encoding scheme (see, for example, the <tei:msDescription> section), a mere redefinition of DALF, in terms of TEI P5, could result in semantic and structural overlap. Moreover, updating to TEI P5 would be a good occasion for evaluating how DALF might be optimized to better meet the needs of scholarly editors, who want to encode correspondence

sources. Therefore, a thorough analysis of how DALF 2.0 should be designed is necessary. This analysis is ongoing. For the actual design of DALF 2.0, the Centre for Scholarly Editing and Document Studies will also take the remarks and suggestions made by the TEI's Special Interest Group for correspondence into consideration (see the DALF Guidelines: www.kantl.be/ctb/project/dalf/dalfdoc/; Van Nu en Straks, *The Letters*: www.vnsbrieven.org/VNS/). ▪

Disadvantages and perceived limitations of TEI

Both the act of text encoding and the TEI guidelines have been criticized by numerous researchers from a range of perspectives. As Renear has put it, text encoding '... has proven to be an exciting and theoretically productive area of analysis and research. Text encoding in the humanities has also produced a considerable amount of interesting debate ...' (2004, 218). One of the longest-standing debates refers to the problems of overlapping hierarchies and the theoretical position that text is an 'ordered hierarchy of content objects' (OHCO) (De Rose et al., 1990). According to Caton, this observation 'underpins all the major mark-up schemes for written text, like the TEI's Guidelines for Text Encoding and Interchange, the Davenport Group's DocBook and the ISO 12083 DTD (document type definition)' (Caton, 2001, 2.3; see his article, too, for a summary of OHCO and developments).

Renear (1997) has classified and discussed the three theories of textuality (Platonic, pluralist and anti-Realist) that emerged among the members of the text encoding community, in response to content-based text processing (and the OHCO theory). Revisions to the theory resulted in OHCO-2 and OHCO-3 (Renear et al., 1996). Ultimately, the authors were forced to concede that not all texts could be described in terms of ordered hierarchies, but that nevertheless the OHCO model is a theoretically productive area. Many other scholars have criticized the theory on other grounds, for example, Caton (2001) and McGann (2004, 139–41) have argued that the focus of OHCO (and, thus, TEI) is too narrow and that the 'performative' intention of a text (when the scope or meaning of a text changes, due to interpretative interventions of its readers or performers, etc.) must be given adequate consideration. Scholars such as Huitfeldt (1994) have developed encoding schemes which allow overlapping hierarchies. In addition to such theoretical criticisms, aspects of TEI, such as the complexity of the guidelines and perceived limitations of the abstract model itself, have been criticized (e.g. Olsen, 1996; Usdin, 2009). Numerous papers have been written on the

difficulties of using TEI, or encoding in general, to encode particular types of data, for example, Nyhan (2008). Most recently, Schmidt (2010) argued that 'not only HTML, but generalized markup as a whole, evolved from a printed format structure' (2010, 340) and argued that embedded markup is inadequate for cultural heritage texts:

> the embedding of markup codes into texts that never had them when written leads to a number of further difficulties: the inclusion of potentially obsolescent technical and subjective information into texts that are supposed to be available for the long term, the manual encoding of information that could be better computed automatically, and the obscuring of the text by highly complex technical data. (2010, 337)

Traditionally, in TEI, a fundamental distinction has been made between a text and a document. In the guidelines, the document is mostly seen merely as a vehicle for text, the focus of TEI being the text itself and how it can be made machine readable. However, the encoding model that has been devised by the Workgroup on Genetic Editions has the potential to alter this situation, should it be approved by the TEI Technical Council, by making markup available, so that it can be used to encode the documentary level:

> … [F]or genetic editions a focus on the document is crucial. In many cases, the only way to reconstruct the process of writing and re-writing which leads to a new text is to examine a specific document. We therefore propose to complement the existing text-focused approach with a new encoding scheme focused instead on the document

(see http://users.ox.ac.uk/~lou/wip/geneticTEI.doc.html, section 1.2). Much interesting work can also be done in this area in the coming years.

Looking to the future, it seems likely that the scalability and interoperability of TEI will become an issue of the utmost importance. For example, the TextGrid Project (discussed above) aims to allow TEI encoded texts from different projects (those who may have applied TEI to their texts in very different ways) to be absorbed into TextGrid and then be made searchable, via a common interface and search mechanism. Therefore, it has developed a base line encoding strategy (TextGrid, 2009), which does not replace specialized markup that is applied to individual projects in the first instance. Rather, it is an additional representation of the encoded work that contains a regularized subset of the encoding that has been applied to it and,

thus, supports structured and comparable searches across digital objects. Similar approaches have been pursued by projects such as MONK. Notwithstanding the advances that can be achieved through such reductionist approaches, they do, nonetheless, bring the application of deep and bespoke TEI encoding into question, as, given the current state of research, such encoding inevitably becomes redundant beyond the level of the individual text, once it is absorbed into a given Virtual Research Environment or eScience infrastructure.

Conclusion

This chapter has given an overview of TEI and demonstrated examples of how it is used in digital humanities' projects; its advantages and disadvantages have also been discussed, and pointers to further resources are given below. Given the centrality of text encoding and TEI to digital humanities, it is important for all digital humanities' practitioners to stay informed about the main developments in this area.

Guidelines and further reading

In addition to articles cited in the bibliography below, the following books, articles, tutorials and resources are recommended:

TEI resources

1 The best introduction to XML is the second chapter of the TEI Guidelines – A Gentle Introduction to XML, www.tei-c.org/P4X/SG.html.
2 All of the tutorials and exercises in TEI by Example, http://tbe.kantl.be/TBE/.
3 Getting started with P5 ODD tutorial, www.tei-c.org/Guidelines/Customization/odds.xml.
4 Materials of the Digital.Humanities@Oxford Summer School, http://digital.humanities.ox.ac.uk/dhoxss/2011/.
5 Brown Women Writers Project seminar materials on scholarly text encoding, www.wwp.brown.edu/outreach/seminars/seminar_list.html.

Bibliography

Antoniou, G. and van Harmelen, F. (2008) *A Semantic Web Primer*, MIT Press.

Bosak, Jon (1997) *XML, Java, and the Future of the Web*, www.ibiblio.org/pub/sun-info/standards/xml/why/xmlapps.htm.

Caton, P. (2001) Markup's Current Imbalance, *Markup Languages: theory and practice*, **3** (1), 1–13.

Ciula, A. (2010) The New Edition of the Letters of Vincent van Gogh on the Web, *Digital Humanities Quarterly*, **4** (2).

Coombs, J. H., Renear, A. H. and DeRose, S. J. (1987) Markup Systems and the Future of Scholarly Text Processing, *Communications of the Association for Computing Machinery*, **30** (11), 933–47.

de Smedt, K. (2002) Some Reflections on Studies in Humanities Computing, *Literary and Linguistic Computing*, **17** (1), 89–101.

DeRose, S. J., Durand, D. G., Mylonas, E. and Renear, A. H. (1990) What is Text, Really?, *Journal of Computing in Higher Education*, **1** (2), 3–26.

Flynn, P. (1995) Making More Use of Markup, *SGML '95*, Boston, MA, http://imbalc.ucc.ie/pflynn/articles/moreuse.html.

Goldfarb, C. F. (1981) A Generalized Approach to Document Markup. In *Proceedings of the ACM (SIGPLAN- SIGOA) Symposium on Text Manipulation*, ACM.

Hockey, S. M. (2000) *Electronic Texts in the Humanities*, Oxford University Press.

Huitfeldt, C. (1994) Multi-Dimensional Texts in a One-Dimensional Medium, *Computers and the Humanities*, **28** (4/5), 235–41.

Jannidis, F. (2009) TEI in a Crystal Ball, *Literary and Linguistic Computing*, **24** (3), 253–65.

McCarty, W. (2005) *Humanities Computing*, Palgrave Macmillan.

McGann, J. (2004) *Radiant Textuality: literature after the world wide web*, Palgrave.

Nyhan, J. (2008) The Problem of Date and Context in Electronic Editions of Irish Historical Dictionaries. In Mooijaart, M. and van der Wal, M. (eds), *Yesterday's Words: contemporary, current and future lexicography*, Cambridge Scholar's Publishing, 319–32.

Olsen, M. (1996) *Text Theory and Coding Practice: assessing the TEI*, http://gandalf.aksis.uib.no/allc-ach96/Panels/Giordano/molsen.html.

Ore, E., Short, H., Ballam, A., Broady, D., Burnard, L., Burr, E., Lee, S., Opas, L. L. and Rommel, T. (1999) European Studies on Textual Scholarship and Humanities Computing. In De Smedt, K., Gardiner, H., Ore, E., Orlandi, T., Short, H., Souillot, J. and Vaughan, W. (eds), *Computing in Humanities Education: a European perspective*, University of Bergen.

Piez, W. (2001) Beyond the 'Descriptive vs. Procedural' Distinction, *Markup Languages: theory and practice*, **3** (2), 141–72.

Reid, B. K. (1981) *Scribe: a document specification language and its compiler (PhD thesis)*, Carnegie-Mellon University.

Renear, A. (1997) Out of Praxis: three (meta)theories of textuality. In Sutherland, K. (ed.), *Electronic Text: investigations in method and theory*, Oxford University Press, 107–26.

Renear, A. (2000) The Descriptive/Procedural Distinction is Flawed, *Markup Languages: theory and practice*, **2** (4), 411–20.

Renear, A. (2004) Text Encoding. In Schreibman, S., Siemens, R. and Unsworth, J. (eds), *A Companion to Digital Humanities*, Wiley-Blackwell, 218–39.

Renear, A., Dubin, D., Sperberg-McQueen, C. M. and Huitfeldt, C. (2002) Towards a Semantics for XML Markup. In Furuta, R., Maletic, J. I. and Munson, E. (eds), *Proceedings of the 2002 ACM Symposium on Document Engineering*, New York, ACM, 119-26.

Renear, A., Mylonas, E. and Durand, D. (1996) Redefining Our Notion Of What Text Really Is: the problem of overlapping hierarchies, In Ide, N. and Hockey, S. (eds), *Research in Humanities Computing*, **8**, Oxford University Press, 263–80, www.stg.brown.edu/resources/stg/monographs/ohco.html.

Schmidt, D. (2010) The Inadequacy of Embedded Markup for Cultural Heritage Texts, *Literary and Linguistic Computing*, **25** (3), 337–56.

Smyth, A. (2004) Preservation. In Schreibman, S., Siemens, R. and Unsworth, J. (eds), *A Companion to Digital Humanities*, Wiley-Blackwell, 576–91.

Sperberg-McQueen, C. M. (1991) Text in the Electronic Age: textual study and text encoding, with examples from medieval texts, *Literary and Lingusitic Computing*, **6** (1), 34–46.

Sperberg-McQueen, C. M. (1994) *Textual Criticism and the Text Encoding Institute. Annual Convention of the Modern Language Association*, www.tei-c.org/Vault/XX/mla94.html. Reprinted in Finneran, R. J. (ed.) (1996) *The Literary Text in the Digital Age*, Editorial Theory and Literary Criticism, University of Michigan Press, 37–61.

Sperberg-McQueen, C. M. and Burnard, L. (1988) *Design Principles for Text Encoding Guidelines*, www.tei-c.org.uk/Vault/ED/edp01.xml.

Sperberg-McQueen, C. M., Huitfeldt, C. and Renear, A. (2000) Meaning and Interpretation of Markup, *Markup Languages: theory and practice*, **2** (3), 215–34, www.w3c.org/People/cmsmcq/2000/mim.html.

TEI Consortium (n.d.) *TEI: history*, www.tei-c.org/About/history.xml?style=printable.

TEI Consortium (2007) *Guidelines for Electronic Text Encoding and Interchange: TEI P5*, www.tei-c.org/release/doc/tei-p5-doc/en/html/index.html.

Terras, M. (2011) *Peering Inside the Big Tent: digital humanities and the oasis of inclusion*, Plenary Talk at Interface 2011, 27 July, UCL, http://melissaterras.blogsot.com.

Unsworth, J. (2002) What is Humanities Computing, and What is it Not? In

Braungart, G., Eibl, K. and Jannidis, F. (eds), *Jahrbuch für Computerphilologie*, **4**, 71–84, http://computerphilologie.uni-muenchen.de/jg02/unsworth.html.

Usdin, B. T. (2009) Standards Considered Harmful, *Proceedings of Balisage: the Markup Conference 2009*, Balisage Series on Markup Technologies, Vol. 3, www.balisage.net/Proceedings/vol13/html/Usdin01/BalisageVol.3-Usdin01.html.

Vanhoutte, E. (2010) Defining Electronic Editions: a historical and functional perspective. In McCarty, W. (ed.), *Text and Genre in Reconstruction: effects of digitalization [sic] on ideas, behaviours, products and institutions*, OpenBook Publishers, 119–43.

Vanhoutte, E. and Van den Branden, R. (2010) Text Encoding Initiative (TEI). In Bates, M. J. and Maack, M. N. (eds), *Encyclopedia of Library and Information Sciences*, 3rd edn, Taylor & Francis.

Willett, P. (2004) Electronic Texts: audiences and purposes. In Schreibman, S., Siemens, R. and Unsworth, J. (eds), *A Companion to Digital Humanities*, Wiley-Blackwell, 240–53.

Wittern, C., Ciula, A. and Tuohy, C. (2009) The Making of TEI P5, *Literary and Linguistic Computing*, **24** (3), 281–96.

Notes

1 www.gutenberg.org/wiki/Gutenberg:Project_Gutenberg_Mission_Statement_by_Michael_Hart.

2 Ibid.

3 See, for example, the *MLA Guidelines for Editors of Scholarly Editions*, www.mla.org/cse_guidelines accessed 16/03/2012.

4 See http://listserv.brown.edu/archives/cgi-bin/wa?A0=TEI-L.

5 *Journal of the Text Encoding Initiative*, http://journal.tei-c.org/journal/index

6 See http://wiki.tei-c.org/index.php/Main_Page.

7 See www.balisage.net/Proceedings/topics/Semantics.html.

8 See, for example, the Oxford Digital Library, www.odl.ox.ac.uk/metadata.htm.

9 See http://vangoghletters.org/vg/.

10 Many excellent tutorials on HTML, XHTML and XML, etc., are available via the W3C Schools website, www.w3schools.com/.

Historical bibliography in the digital world

Anne Welsh

Introduction

 Bibliography has been described as 'the discipline that studies texts as recorded forms, and the processes of their transmission, including their production and reception' (McKenzie, 1999, 12). Its scope is wide-ranging: in his seminal work, Gaskell has asserted:

> All documents, manuscript and printed, are the bibliographer's province; and it may be added that the aims and procedures of bibliography apply not only to written and printed books, but also to any document, disc, tape or film where reproduction is involved and variant versions may result. (Gaskell, 1995, 1)

In the modern world of websites in constant beta, it is hard not to recognize the digital within this. Corpus linguistics grew from a branch of textual bibliography, while, taking a step back to the production stages of digital content, some knowledge of the physical nature of the items being digitized is necessary. As Melissa Terras has pointed out in Chapter 3 (page 54): 'Digitization programmes aim to create consistent images of documents and artefacts which are fundamentally individual and inconsistent', and it is clear that an understanding of the material object is required for best results or, indeed, to make the high-level decisions on an item's suitability for digitization.

This chapter explores the use of computing within the academic discipline of historical bibliography and the professional career of rare books librarianship. It considers why we still need the physical book and what digital research adds to its history.[1] It highlights certain projects that have made use of computing to document and investigate printed books. Finally, it considers the similarities and differences between the roles of

bibliographers, librarians and digital humanists and finds areas of convergence and synergy between the disciplines. It concludes with suggestions for further study on the part of digital humanists, with an interest in rare books.

Books as technology

In his book, *The Shock of the Old*, David Edgerton argues that we have a tendency to view only the newest and most innovative advances as 'technology' and that this understanding undermines a fuller, more accurate picture of scientific progress. He advocates a 'history of technology-in-use', which considers processes, not only at their invention and early diffusion, but throughout their lifetime (Edgerton, 2008).

Within digital humanities, it has been argued that electronic text has impacted on our perception of the book, so that:

> We find ourselves, for the first time in centuries, able to see the book as unnatural, as a near-miraculous technological innovation and not as something intrinsically and inevitably human. We have, to use Derridean terms, decentered the book. We find ourselves in the position, in other words, of perceiving the book *as technology*.
> <div align="right">(Landow, 2006, 46)</div>

For historical bibliographers, familiarity with the book has never resulted in our forgetting that it is a technological innovation, and although we might avoid the hyperbole of 'near-miraculous,' as a discipline, we have published hundreds of accounts of the book as technology and the technologies that had to develop, in order to facilitate the 'invention' of the book. In fact, the story of the printed book is one that unites several key innovations from different technologies, synthesizing them, to form the everyday object with which we are now familiar in the 21st century.

Michael W. Haslam has written that:

> The parchment codex in fact represents the fusion of two separate media, and proceeds more from the re-application of pre-existing technologies than from the invention of new ones.
> <div align="right">(2005, 158)</div>

He goes on to discuss the codex made from wooden boards and the development of parchment from animal skins. Although parchment scrolls did exist, he argues that 'the Roman evidence suggests that parchment did

not come into regular use for (non-biblical) literary texts until the new codex form had established itself (2005, 159).

Moreover, the codex did not become the dominant form for written communication overnight. As Cornelia Roemer points out:

> Papyrus was the writing material *par excellence* for texts meant to be read time and again and for those whose continuing preservation has a legal force ...
> Thucydides, Plato, and Cicero all wrote on papyrus; their works, both in classical and Hellenistic Athens and in the Roman Empire, were published in rolls.
>
> (Roemer, 2009, 85)

There were many factors for the codex's rise in popularity, but chief amongst them were durability, capacity and ease of access. Codices are more robust and easier to store than scrolls, and they do not break as easily as clay tablets. They can accommodate far longer texts: Haslam describes how, before the codex, for multi-volume works:

> the text ha[d] to be parceled out over more than a single carrier object. That makes for practical problems of continuity and sequentiality, and may have less obvious effects on poems' stability and identity. (Haslam, 2005, 144)

Finally, and most obviously, the codex allows the reader to refer to passages anywhere in the text, simply by opening the book at the appropriate point, whereas the scroll's structure is entirely linear, requiring the reader to roll from one end to the other.

In use since at least the start of the Common Era (Howell, 1980), the codex is still the most popular book format, over 2000 years later. Its use-based history is just as full as its significance, as the new technology favoured by the poet Martial and the Christian Apostles to publish their bestselling works.

The coming of the new

The invention of the printing press was, similarly, a consolidation of other technologies, including ink-making, block printing, metallurgy and the adaptation of olive and wine presses to be used with paper and type (Febvre and Martin, 1997). As Carter has put it:

The fact is that most of the skilled trades involved in [printing and typefounding] were already well developed by the time that letterpress printing was thought of. Punches with letters and symbols cut in relief on the ends were used by coin and seal engravers and goldsmiths, the mechanical precisions necessary for making matrices and moulds was also needed to make arms and armour or clocks and watches, pewterers made complicated carvings in soft metal alloys. These skills were concentrated in large cities by the middle of the fifteenth century. (Carter, 1969, 13)

Early printers were proud of their role in advancing new technology, so, for example, we see England's first printer, William Caxton, announcing, in *The Recuyell of the Histories of Troy* (1473), 'This said book … is not wreton with penne and ynke as other bokes ben to thende that every man may have them attones'. However, by the 16th century, we can observe a backlash against the printed book as mass-produced object. As personal libraries became affordable to more people, because the printed book was more plentiful than its manuscript predecessor, the popularity of luxury manuscripts soared amongst those who could afford them. Type founders began to design fonts not for clarity and ease of reading, but to be as ornate as possible, competing with the splendour of the manuscript. As Lotte Hellinga puts it:

In the balance between the very general, so easily accepted by the eye that it becomes 'invisible', and the very particular, the typeface that deliberately intrudes into the awareness of the reader, is comprised the whole long history of typography. (Hellinga, 2009, 211)

In this history, we can also observe the balance between the old and familiar, with the new and exciting. Commentators, such as those mentioned above, like to point out the design debt that the printed book owed to the manuscript codex. The transition from one carrier of book content to another is repeated throughout history – from the scroll to the codex; from manuscript to print; and, in the early 21st century, from print to electronic.

Even early adopters of new technology often show a preference for analogies and imagery drawn from the previous physical object. So when we look at hugely successful initiatives, like the British Library's Turning the Pages (www.bl.uk/onlinegallery/ttp/ttpbooks.html), we can see that the analogy of 'turning the pages' has been preserved – we point to the side of the page we wish to turn and watch as the digital image of the book transitions to its next 'page'. As Christian Vandendorpe has put it:

As soon as the text mass exceeds the dimensions of a single screen, the author has to choose the dominant metaphor for the mode of reading: moving from page to page horizontally, as in the codex, or scrolling vertically, as in the medieval *rotulus*, which was unrolled from top to bottom for public proclamations ... The advantage of the horizontal scroll window is that the text is displayed in a fixed window, whose content readers refresh by clicking on the 'next page' arrow. This is the model that is naturally chosen for books that have already been printed and are being offered in e-book format.

(Vandendorpe, 2009, 138–9)

The proportions of the page layout in such online offerings, in fact, draw on proportions devised for the printed book. As Jan Tschichold has put it:

Methods and rules ... have been developed for centuries. To produce perfect books these rule have to be brought to life and applied.

(Tschichold, 1992, 8)

In 1946, J. A. van de Graaf published the 'secret canon of design', in his book *Nieuwe Berekening Voor de Vormgeving*. His aim was to reconstruct how Gutenberg and other early printers may have arrived at the margin proportions commonly seen in early printed texts (a ratio of width:height 2:3) (Tschichold, 1992). Other designers, including Tschichold himself, have arrived at similar proportions, although they have found a range used by early printers, which they have related to the golden ratio (Man, 2005) and the golden section (Tschichold, 1992; Hendel, 1999), both proportions which were known to artists and craftsmen of the early modern era, but which, as Tschichold has pointed out, were subject to variation before the decimal system:

Book pages come in many proportions, i.e. relationships between width and height. Everybody knows, at least from hearsay, the proportion of the Golden Section, exactly 1:1.618. A ratio of 5:8 is no more than an approximation of the Golden Section. It would be difficult to maintain the same opinion about a ratio of 2:3.

(Tschichold, 1992, 37)

In the work of these 20th century book designers and historians, we can see the effects of looking back at older techniques on the practices of the present day. While the debate was, in one sense, historical – attempting to recreate how 15th century printers (and, before them, manuscript scribes) set out

their pages – Tschichold's and Hendel's works are set texts for book designers today.

As a result, it is possible to lay Van de Graaf's canon over most (although not all) printed books and see that the textblock has been positioned within the grid, marking out the proportion 2:3. In teaching, the Kelmscott *Golden Legend* (de Voragine, 1892) is an ideal exemplar, with its heavily illustrated borders lining up perfectly. With his obsession with traditional crafts and design, it is hardly surprising that William Morris should have chosen such proportions for his work.

What does surprise some students is the applicability of the old canons to computer-based design. Clearly, e-books do not *require* this type of margin. Printed books need a wide gutter (inside margin) to allow space for them to be bound – depending on the style of binding and the thickness of the volume, anything from 1 to 2.5 centimetres may be lost to the binding. Similarly, margins are needed at the foredge, head and tail of the page, to allow for damage caused as the pages are turned – even clean fingers carry acidic sebum that will cause dirt to form over time, and the risk of tears is omnipresent.

The e-reader presents none of these physical dangers. Text can be displayed across the full screen of the device, without fear of damage. However, damage limitation is not the only reason for designing books with margins. Christian Vandendorpe expresses strong views on the importance of the margin in e-formats:

> The white margins surrounding the text are not useless space to be dispensed with; this space delimits the text and allows the eye to rest from the tension caused by reading. A page without margins is an aberration that forces readers to constantly resize their browser window according to the sites they visit.
>
> (Vandendorpe, 2009, 141)

Of course, the rise of the handheld e-reader has made the reading of e-publications a more immediately physical act again. As well as bringing the text physically closer to us than the desk based computer screen, this means that our hands need a place to rest round the edges. On purpose-designed machines, like the Kobo and Kindle, we see that a border (often in 2:3 proportions) runs around the screen, and the text runs edge to edge.

As Vandendorpe has pointed out, the analogy of the page is one that, so far, cannot be dispensed with. How much of this is due to what we might call 'systems requirements'? How much is because of our learned human expectations of how it *feels* to read is something that requires further study

(*cf* the Implementing New Knowledge Environments, or INKE Project – www.inke.ca/ – which is investigating how academics read within new knowledge environments)?

The page is, however, an inconvenient unit of measurement:

> Displaying the text in a page of fixed length may, however, impose limitations on the experience of reading …. This is especially true because on the screen, the visual disappearance of each page when the reader goes on to the next one creates a feeling of loss that readers must learn to deal with.
>
> (Vandendorpe, 2009, 139)

This argument is stated in emotional terms, derived from Laufer and Scavetta (1992). This may seem somewhat strong, until we think about specific forms in which page breaks can cause confusion or interruption, whether in physical or digital formats. So we see that, in music publishing, pages have been engraved or block-printed with breaks to facilitate the turning of the page during play, without an interruption in the performance (Krummel and Sadie, 1990). Page breaks can also interfere with the understanding of mathematical formulae (*cf* Krantz, 2005) and even poetry. In her recent book on Victorian illustrated gift books, Lorraine Janzen Kooistra provides a clear example of a poem that has been typeset over a page-break (2011, 373–4) in the Moxon Tennyson (1859), famous for its Pre-Raphaelite illustrations:

> [Clarkson Stanfield's] headpiece [illustration] for 'Break, break, break' divides the four-stanza poem over recto and verso, necessitating a page turn that formally breaks the poetic wish 'that my tongue could utter / The thoughts that arise in me' from its subsequent expression over the remaining twelve lines.
>
> (Kooistra, 2011, 56)

Related to poetry, but with theological significance to believers, religious expressions, such as prayer, can cause challenges for page layout. Paul Luna has given an account of the typesetting of *Common Worship* in Quark Xpress:

> It was decided that page breaks should fall so that no prayers were broken across pages: the longest single prayer was identified, and decisions on type size and page size based on that.　　　　(Luna, 2009, 392)

Page breaks and line breaks have been a concern of designers and typesetters since the early modern period, in which the compositor in the

printing house 'composed' the pages of books line-by-line and letter-by-letter from movable type (Gaskell, 1995). Joseph Moxon, credited with publishing the first manual of printing in 1683–4, discussed the importance of white space and of the forethought that the compositor should employ in his work, to allow for appropriate line and page breaks that would not distract the reader (Moxon, 1962, 246).

In the work of digital humanists to understand the design of the computer-based book, we can see the inheritance of the concerns of these early printers and publishers. While the computer frees us from the physical limitations of the page, current human expectations ensure its continuance as a useful and accessible design metaphor.

Versioning and its challenges

An understanding of early print history can also assist us in a deeper understanding of versioning. Conceptually, this is an ongoing concern of the field of historical bibliography, and much time and energy has been spent in discovering variant states of the different impressions of editions of significant works (Bowers, 2005). Often, variations result from compositor or other printer error. That is to say, we can *identify* some variant states of works, because we can identify differences in page layout, which indicates material printed at different times.

Some variant states can be amusing, as well as significant, such as Barker and Lucas's 'Wicked Bible' of 1631, in which the omission of the word 'not' in Exodus 20:14 resulted in the commandment 'Thou shalt commit adultery'. For the printers, this resulted in a fine of £300 – a vast sum of money in the early 17th century – and the withdrawal of their license (Eisenstein, 2005, 81). The copies of the Bible containing the mistake were recalled and destroyed, although a few have survived to the present day (Pollard and Redgrave, 1976–1991).

Most mistakes are not so dramatic, but the errors of printers have been helpful to enumerative bibliographers over the years, in proving that a particular book exists in a different state – and, therefore, was printed at a different time from other versions of the same book. This is important work, since the survival rates of materials from the early modern period are so low that it is difficult to determine how numerous books were in the 15th to 18th centuries. The existence of different states of a book can be indicative of the number of print runs, which, in turn, can indicate that the book was printed in greater quantities than was previously known. So the discovery of a new

impression of a book in a library in 2011 may indicate the existence of 100–300 copies of that impression of that book at its original printing in the 15th century.

Of course, the estimated size of print-runs in the early modern period retains a mythical and mystical aura. Survival rates of incunabula (books printed before 1501) are so low, and evidence for the size of print-run so scant, that figures remain indicative. As Joseph A. Dane has put it, in his methodological treatise on the subject, such figures are:

> illusory, since one cannot correlate 'likelihood of survival' with 'size of print run in any meaningful way. No one, to my knowledge, has come up with a mathematical or even a convincing bibliographical model of how such figures might be computed any conclusions will inevitably beg the question, and the logic will run as follows: *given* 18 million incunables; *given* 27,000 known editions; *given* an average print run of 300 per edition, how many lost editions are there? (Dane, 2003, 43)

There are many permutations in which a book might be reprinted from the same set of type, reset without corrections or amendments (in which the only variants would be generated by the compositor during the typesetting), or reworked as a new edition (Bowers, 2005). One of the real difficulties can be detecting variants due not to an entire reprinting or new edition of a text, but to a new printing of only part of the book. David McKitterick has studied and theorized in depth about such circumstances (2003). One straightforward example is that of *corrigenda* (corrections sheets), which might be produced as the book was coming off the press or at a later date and which may or may not be inserted:

> When lists of corrigenda were printed, they might appear in some copies but not in others; and when they were printed to be pasted in it was inevitable that copies escaped without this further attention. Even lists of corrigenda provided opportunities for differences, some offering more corrections than those in other copies of the same edition. (McKitterick, 2003, 123)

Corrigenda, and other partial versions of books, indicate a difficulty in counting *extant* versions of a text. Counting, and accounting for, the number of versions that existed when a text was printed in the early modern period is complicated even further. For example, if we find a few pages of a book in our collection, can we discover the other pages of the same copy in someone else's

collection? Not unless there is very clear physical evidence – such as exactly matching damage or annotations in an identical hand running throughout both our pages and the other one. They may have been part of the same book or they may not. Counting, therefore, is problematic (McKitterick, 2003).

Nevertheless, the printed book is a mass-produced item, and the more different versions we *can* identify, the closer we are to obtaining some idea of scale (Febvre and Martin, 1997). The latest article attempting to account for incunables combines statistical predictions with the work that has been carried out identifying actual surviving copies (Green, McIntyre and Needham, 2011), and digital humanists may find interesting scope for work, building on these foundations.

Of course, versioning has wider implications beyond the printed book, and an understanding of historical bibliography methods can provide a firm conceptual foundation, on which digital humanists can build, when they work on the challenges of websites in constant beta. Examples of partial reprintings can provide a physical analogy for some of the challenges we face in conceptualizing linked data.

Electronic catalogues and electronic books

The interest in being able to obtain quantitative data about print production in the early modern period can be seen to have acted as a driver towards bibliographers engaging with new technology, and, in turn, it is the creation of online databases that has allowed late 20th and early 21st century scholars to come closer to approximating the number of books produced in the early years of printing.

Librarians, too, have been motivated towards making catalogue information available on the internet. In practical terms, the online catalogue provides an inventory of the library's holdings and is useful for preventative preservation, since an accurate catalogue record can act as a surrogate for the item it represents, so that the library user can correctly identify the item they require, without having to consult and, therefore, to handle alternative items that appear alike at first glance.

National and international efforts to document early printed books have supplemented, and been supplemented by, the work of individual scholars. Important pre-electronic works include Pollard and Redgrave, covering 1475–1640; Wing, covering 1641–1700; and the many and varied short title catalogues of the British Museum (e.g. BM STC Italian covers, Italian publications 1465–1600).

In the pre-electronic era, these were weighty volumes that took some time to consult and often resulted in the cataloguer or bibliographer flicking back and forth between entries for similar impressions, trying to establish the item they held in their own hands. It was natural, therefore, that online versions of these short title catalogues be created. Students are sometimes surprised, though, by the early date given for the start of the move online:

> An ESTC [English Short Title Catalogue] team was established at the British Library in 1977, under the direction of Robin Alston, and began work on the Library's extensive holdings of in-scope material. By 1978, when Robin Alston and Mervyn Jannetta published *Bibliography, Machine-Readable Cataloguing and the ESTC*, there were already more than fifty contributors to the file including Göttingen State & University Library (Germany).
> (www.bl.uk/reshelp/findhelprestype/catblhold/estchistory/estchistory.html)

Today, the ESTC is hosted on the British Library website and freely available for anyone to use, so that it would almost be possible to take for granted our ability to search its contents.

Along with the Incunabula Short Title Catalogue (ISTC, www.bl.uk/catalogues/istc/index.html), which covers books published before 1501, the ESTC provides one of the major, internationally recognized means of identifying the various extant states of the early printed book.

Some digital humanists might argue that the creation of online catalogues – even catalogues containing such a high degree of scholarship – does not qualify as digital humanities. Cataloguing is a function of librarianship – in this case, because we are dealing with early printed books, it falls within the purview of rare books librarianship.

The relationship between the academic disciplines of librarianship (knowledge organization) and digital humanities remains, as yet, unexplored. At UCL, although it includes academics involved in digital research across the university, the Centre for Digital Humanities is part of the Department of Information Studies, itself founded as the School of Librarianship, in 1919. As a discipline and a profession, librarianship has been an early adopter of new technology, with evidence of mainframe computing being adapted for library use from the 1950s (Tedd, 1993; McCrank, 2002). Similarly, both the Library of Congress and the British National Bibliography conducted studies that would bear fruit as the Machine Readable Cataloguing project in 1966, sending catalogue data out by tape to 16 US libraries and, ultimately, in the creation of the MARC

(Machine Readable Cataloguing) format used worldwide, from 1968 to the present day (McCrank, 2002; Chan, 2007).

There is no doubt, then, that the use of technology is a preoccupation of the academic discipline of librarianship and information studies. The question is whether the discipline falls within the humanities. Organizationally, different universities have answered this question in different ways. At UCL, the Department of Information Studies is part of the Faculty of Arts & Humanities, whereas the equivalent department at the University of Sheffield, branded as the iSchool, is part of the Faculty of Social Sciences. Both departments work closely with the departments of Computer Science at their institutions.

The common interests and goals of iSchools and digital humanities centres have been recognized in a project established by the University of Maryland, College of Information Studies; the University of Michigan, School of Information; the University of Texas Austin, School of Information; the Maryland Institute for Technology in the Humanities (MITH); the Center for Digital Research in the Humanities (CDRH); and MATRIX. iSchools & the digital humanities (www.ischooldh.org) provides internships in digital curation and scholarship, in order to further four of the aims of the American Council of Learned Societies Commission on Cyber-Infrastructure for the humanities and social sciences' *Our Cultural Commonwealth* report (2006). It is noteworthy that both iSchools and digital humanities centres felt it desirable to collaborate, to provide their students with opportunities in (1) leadership in support of cyber-infrastructure; (2) digital scholarship; (3) maintenance of open standards; and (4) the creation of extensible and reusable digital collections. This project clearly locates itself in an interdisciplinary setting – between digital humanities and information studies.

Other projects exist, however, that locate themselves very firmly within the humanities. One such project is the *Catalogue of English Literary Manuscripts* (CELM), described in the inset case study, by H. R. Woudhuysen.

..

CASE STUDY The Catalogue of English Literary Manuscripts, 1450–1700 (CELM)

..

H. R., Woudhuysen FBA, Professor, Department of English Literature, University College London

In 1966, Peter Beal, a graduate of the University of Leeds, started work on the *Index of English Literary Manuscripts, 1450–1700* (IELM). The first volume, of what was originally meant to be a one-year project, appeared in 1980. Its two parts covered the years 1450 to 1625 and were followed, in 1987 and 1993, by a further volume in two parts, taking the coverage up to 1700. For the first time, English Renaissance scholars had a full catalogue of the manuscripts – autograph and scribal – of the major authors of the period. The *Index* included writings in verse, prose, dramatic and miscellaneous works, including letters, documents, books owned, presented, annotated by the authors and related items. In 23,000 entries, Peter Beal covered the works of 128 authors – of these, two were women: his choice was determined by a decision to base the whole project (further volumes covered the 18th and 19th centuries) on authors with entries in *The Concise Cambridge Bibliography of English Literature* (1974). Each author's entry begins with a valuable introduction, giving an overall survey of the surviving material.

Beyond the valuable study of authorial autograph manuscripts, the project initiated a series of investigations into what has come to be known as 'scribal publication'. This phenomenon, in itself, has contributed an important element to the study of the history of the book in Britain. Following the *Catalogue*'s publication, Peter Beal continued to collect material, relating to the authors whose manuscripts he had already described, and, by the early years of the new century, he was ready to find a way of updating the *Index*. A proposal in 2004 to the Arts and Humanities Research Board (later Council) for a five-year project to create an enhanced digital version of the *Index* was successful, and, the following year, work began on *The Catalogue of English Literary Manuscripts, 1450–1700* (CELM). Since then, Peter Beal has continued his research, assisted by John Lavagnino of King's College London's Department of Digital Humanities, who has acted as the project's technical advisor, while I have acted as its general overseer, along with a distinguished international advisory panel (see http://ies.sas.ac.uk/cmps/Projects/CELM/index.htm).

CELM covers the work of around 200 authors (60 of them women) in some 40,000 entries. The author entries range in length, from having no items (Emilia Lanier and Isabella Whitney), to having only one (Thomas Deloney and Sir Thomas Elyot), to having around 4500 (John Donne). A conference relating to the project was held at King's in the summer of 2009, when the database was shown to a number of scholars and a version of the *Catalogue* was launched online as an open-access resource at a larger event in July 2011.

Work on CELM began with keyboarding all the entries in IELM, turning the contents of the four published volumes into a database. In many ways, CELM is recognisable as a digital version of IELM. However, whereas IELM was solely

based around authors, CELM has a repository view, as well as an author view – both are available in longer and shorter forms. The repository view allows the user to see what is available – manuscript by manuscript, leaf by leaf – in some 500 locations, from Aberdeen University Library to the Zentralbibliothek, Zürich, Switzerland, by way of numerous private owners and untraced items. Even though the repository view only contains descriptions of items by CELM's authors, it is a major step towards producing what is, in effect, a short-title catalogue of English manuscripts of the period.

Much thought was given to the question of tagging material and to the possibilities of full-text searching. For example, it would be relatively easy to find some specific literary genres, such as verse letters or epigrams, by full-text searching, but other 'hidden' categories, such as women, scribes, compilers, owners, collectors, composers, dealers, bindings and binders, would have remained elusive, unless tagged. The project still has enormous scope for further development. It might, for example, supply links to library home pages and their catalogues and to related digital projects, such as *ODNB*, Perdita and the Electronic Enlightenment. Most importantly of all, there are several areas where CELM offers a valuable starting point for further research: for example, into paper and book bindings, auction and booksellers' catalogues, the history of scribal publication, literary genres, authorship, and collecting. One obvious development would be to link entries to images of the material that is being described. In time, it is hoped that full descriptions of each manuscript referred to can be created – that is, by cataloguing material by non-CELM authors. There is scope for more work on, as yet, unvisited repositories, as well as for including more authors and literary types, especially anonymous works. Consideration continues to be given as to how to maintain the resource and how to signal the addition of new material to users.

What began as a simple one-year survey of, what was thought to be, quite a limited field has grown, through Peter Beal's extraordinary labours, into a vast project that is now essential to the work of all scholars of the period. Its size has meant that it is inconceivable that the results of such an undertaking would be published again in paper form. A digital database was essential if the materials' complexity and extent were to be accommodated; a project of this kind that could not be searched efficiently would have limited usefulness. New material, new discoveries about manuscripts and changes of ownership can be introduced, so that the resource is constantly updated. In effect, CELM is the place from which all researchers working on the literature and culture of the 16th and 17th centuries, the history of manuscripts and on the development of libraries and collecting will begin. It is in the process of creating digital scholarship of this

kind, that fields of inquiry are rethought and redefined: these kinds of digital resources will increasingly become not just the vehicles for the advancement of knowledge, but the agents for it. ■

Bibliography is a rightful focus of study for English scholars, and CELM is fairly typical in drawing on this tradition of scholarship. It is also typical in starting out as a traditional index (in 1966) and graduating to something more suitable for the online research environment. The Bibliographical Society presents a list of electronic publications (www.bibsoc.org.uk/electronic-publications.htm), which range from pdfs that make no use of the affordances of digital formats, through to projects like BPI1700: British Printed Images to 1700 (www.bpi1700.org.uk/), which provides a searchable database, alongside useful resources covering the historiography, genres and techniques of illustrations from the early modern period.

Possibly the most widely used online resource is Early English Books Online (EEBO) (http://eebo.chadwyck.com), which presents 'more than 125,000 titles listed in Pollard and Redgrave's *Short-Title Catalogue (1475–1640)* and Wing's *Short-Title Catalogue (1641–1700)* and their revised editions, as well as the *Thomason Tracts (1640–1661)* collection and the *Early English Books Tract Supplement*.

Again, it is notable that this online project is based on research started in the pre-digital era. In this case, we are presented with digital images of the University of Michigan's Early English Books microfilm project, first released in 1938 and still ongoing (estimated for completion in five years' time). The creation of fully searchable, TEI-compliant SGML/XML text is being carried out in two tranches by the Text Creation Partnership (originally ProQuest, University of Michigan and Oxford University, but now expanded to include a large number of research libraries) – the first 25,000 were completed from 1999–2008 and the second tranche of 44,000 begun in 2008.

If scanned images of microfilm are not adequate for your research purposes, it is now possible to access Early European Books: printed sources to 1700 (http://eeb.chadwyck.com/). It 'offers full-colour, high-resolution (400 ppi) facsimile images scanned directly from the original printed sources … complete with its binding, edges, endpapers, blank pages, and any loose inserts, providing … information about the physical characteristics and provenance histories of the original artefacts' (http://eeb.chadwyck.com/). As a project started in the online age, it comes with ready-made 'detailed descriptive bibliographic metadata … to support browsing and searching' (http://eeb.chadwyck.com/).

With projects like EEBO and EEB, we see the shift from digitizing information *about* the resource to digitizing the resource itself.

Google Books

How do the efforts of the historical bibliography community relate to the efforts of Google Books? Apart from the involvement of several world-leading rare books' collections (*cf* http://books.google.co.uk/googlebooks/partners.html, for a full list of partners) and their associated librarians and curators in Google's Library Project, we might observe that Google is drawing on library concepts to provide analogies for its work – Google Books Library Project – an enhanced card catalogue of the world's books (http://books.google.co.uk/googlebooks/library.html).

As such, the Google Books Library Project sits alongside initiatives to make library data more visible and accessible on the internet, including WorldCat (www.worldcat.org/), the World Digital Library (www.wdl.org/) and the Open Library (http://openlibrary.org/).

There are two clear advantages that Google Books Library Project possesses:

- the positioning of library data (bibliographic data, with some contextual information and, what Google terms, 'snippets') alongside Google Books, which provides copyright cleared search access to the full-text of some books and search and display access to some books
- Google's search algorithms.

From the perspective of historical bibliography, one potentially interesting feature of Google Books is its interest in counting the number of books to which it has access (Taycher, 2010). At first glance, this may seem similar to the aims of historical bibliographers, in distinguishing all the variant states of early printed books and documenting them, discussed above.

Taycher's blog article, *Books of the World, Stand Up and be Counted!* (2010) asserts that Google is having to redefine the book as object, in order to provide a definition of the items it is counting within Google Books. At first glance, Taycher seems to be drawing on sound bibliographic foundations. He describes why the cataloguing concept of the 'work' as 'a distinct intellectual or artistic creation' (IFLA, 2009, 13) is not helpful in encap-sulating the objects Google is counting:

> It makes sense to consider all editions of 'Hamlet' separately, as we would like to distinguish between – and scan – books containing, for example, different forewords and commentaries. (Taycher, 2010)

That is to say, Google is interested in counting different *editions* of works, as the historical bibliographer would understand the concept of the edition.

Taycher points out the comparatively short history of the use of the International Standard Book Number (ISBN) and its assignment to objects that Google does not wish to include in its book count. He cites T-shirts, but a quick glance through *The ISBN Users' Manual*'s list of eligible and ineligible items, to which ISBNs may be allocated (International ISBN Agency, 1996), gives a wider flavour of the issues faced. It is clear that even many of the eligible items (e.g. text-based computer programs, educational videos, flat-form film) would only be misleading as part of the Google Book count.

Finally, he discusses other widely used control numbers employed by online library catalogues, specifically Library of Congress Control Numbers (LCCN) and OCLC Accession Numbers. He correctly identifies that these may correctly be assigned to more than one physical object – as in the case of a serial.

When we think about long runs of journals or even certain series of books, it is not always the case that there is a one-to-one relationship between the bibliographic record and the physical objects described. For example, the *Journal of Internet Cataloging* ran from 1997–2007, then, in 2008, its title changed to the *Journal of Library Metadata* (Taylor & Francis Online, 2011). Libraries that hold every issue and catalogue, under the international standard *The Anglo American Cataloguing Rules* (2nd edn) (AACR2), will commonly have two bibliographic records on their system – one serial record, covering the *Journal of Internet Cataloging*, with the date field closed (1997–2007) and a second serial record, covering the *Journal of Library Metadata*, with an open date field (2008–). The records will usually be linked, so that a search for one title will retrieve both records.

Of course, these two records cover far more than two physical objects. As they cover a quarterly publication (Taylor & Francis Online, 2011), the record for the *Journal of Internet Cataloging* may be representing 44 physical objects; and the record for the *Journal of Library Metadata* may be representing 16 physical objects and rising. If the library has bound all its issues annually, these numbers may be reduced to 11 and 4 and rising. Some libraries may have bound some issues annually and not others (e.g. if their budget for

binding has been reduced), so these two records are doing a lot of work bibliographically.

A similar issue exists for Taycher's example of *Lecture Notes in Mathematics* – a series of academic monographs established in 1969 (Springer, 2011a), whose volume, 2043, *The Dirichlet Problem for Elliptic-Hyperbolic Equations of Keldysh Type* by Thomas H. Otway, is advertised for publication on 31 December 2011 (Springer, 2011b). Some libraries will catalogue each member of the series as a monograph (one record per physical object), while others will create serial records of the kind just described for the *Journal of Internet Cataloging* and the *Journal of Library Metadata* (one record for thousands of objects).

Taycher also discusses difficulties in counting, where pamphlets, or other slim publications, have been bound together, forming, arguably, one bigger physical object. The answer to 'how many books are Google counting?' is, therefore, complicated by the fundamental question: 'what is the physical unit Google is counting?'

This certainly sounds, at first, like the same question bibliographers are asking, when they ask how many books there are. Brian Lavoie and his colleagues have framed similar questions in recent articles. They argue that:

> Print collections will likely undergo significant transformation as libraries continue to reshape themselves in the networked digital age. Some transformations will occur at the local level …. However, it is likely that many more transformations will take place within a system-wide context – not individual library collections as isolated units, but rather as units of the aggregate library collection …. the system can be defined at various levels of aggregation: by state, by region, nationwide, or even all libraries everywhere …. the key point is that decisions regarding local collections will eventually and inevitably be taken with system-wide implications in mind.
>
> (Lavoie and Schonfield, 2006)

Lavoie and his colleagues have focused on WorldCat, as 'a data source that supplies a uniquely broad perspective on digital materials in library collections' (Lavoie et al., 2006, 107). They acknowledge, though, that, '[u]nfortunately, no reliable estimate of the proportion of digital materials cataloged exists' (Lavoie et al., 2006, 107).

Herein lies the difficulty faced by Google, in making its book count. Taycher attempts to enter into bibliographic theory, by defining a new unit in which to count books:

One definition of a book we find helpful inside Google when handling book metadata is a 'tome,' an idealized bound volume. A tome can have millions of copies (e.g. a particular edition of *Angels and Demons* by Dan Brown) or can exist in just one or two copies (such as an obscure master's thesis languishing in a university library). (Taycher, 2010)

He goes on to list several drawbacks, but the real philosophical and practical issue is summed up in his phrase 'when handling book metadata.' Whereas historical bibliographers (and librarians more generally) start with physical objects that they are holding in their collections and their hands, Google starts with metadata. Its interest in the 'tome' is as a way to handle de-duplication issues:

We collect metadata from many providers (more than 150 and counting) that include libraries, WorldCat, national union catalogs and commercial providers. At the moment we have close to a billion unique raw records. We then further analyze these records to reduce the level of duplication within each provider When evaluating record similarity, not all attributes are created equal. For example, when two records contain the same ISBN this is a very strong (but not absolute) signal that they describe the same book, but if they contain different ISBNs, then they definitely describe different books. We trust OCLC and LCCN number similarity slightly less, both because of the inconsistencies noted above and because these numbers do not have checksums, so catalogers have a tendency to mistype them We put even less trust in the 'free-form' attributes such as titles, author names and publisher names

(Taycher, 2010)

So, at this point, Google is not claiming to count the number of different books in existence – only, really, the number of library and publisher catalogue records that exist after an extremely intelligent deduplication process:

Counting only things that are printed and bound, we arrive at about 146 million. This is our best answer today. It will change as we get more data and become more adept at interpreting what we already have.

(Taycher, 2010)

Where, then, will Google 'get more data'? Presumably from the thousands of new catalogue records that are created by libraries and publishing houses

every year. How much new data will there be? The formula for this is easier to write, than to discover in numeric terms. We might express it as:

> Number of new books published + number of old books published and retained but as yet uncatalogued by publishers, libraries or bibliographers.

So, as things stand, the historical bibliography community cannot rely on Google to provide answers to the questions about how many books were published in a particular period. As we have just seen, Google is disambiguating only as far as edition level – not different impressions and states – and, in any case, is reliant on data produced by bibliographers and cataloguers.

That is not to say that Google Books has nothing to offer historical bibliography. Conceptually, it might be the case that, were Google able to ingest the ISTC, ESTC and enough library catalogue records from international collections, its programmers could devise algorithms to cope with a level of versioning and deduplicating that would, in turn, be of use to historical bibliography as a discipline. Even a list of potential duplicates, based on a comparison of the world's catalogue records, could provide useful loci for research.

In the meantime, we may hope for a rise in the demand for our data, driven partly by WorldCat, partly by Google and partly by the research projects that depend on them.

The debt of history

We have seen how different cataloguing standards have impacted on the Google Books Project. Arguably, one of the interesting aspects of digital projects in historical bibliography is how each of them handles legacy data. The other case study in this chapter presents a brief overview of how four online projects recording watermarks have handled changes in technology.

CASE STUDY Watermarks in paper: four related online projects

Marieke van Delft, Curator of Early Printed Collections, Koninklijke Bibliotheek, The Hague

One of the characteristics of early paper is the watermark. This is a visible mark, formed during the manufacturing of the paper using a sieve. The sign is

attached to the sieve, with the result that the paper is thinner at that point on the sheet. These figurative elements in paper served as national brands and quality assurances. Watermarks have intrigued researchers for a long time, resulting in the compilation of catalogues, the most important being those of C. M. Briquet (1968) and Gerhard Piccard (1961–1997). They show a wide variety in forms of watermarks, including anthropomorphic figures, animals, fabulous creatures, floral motives, mountains, luminaries and everyday items, like tools or tableware, symbols, geometrical figures, coats of arms and letters. Briquet's and Piccard's catalogues were of great importance, but digitization and databases have offered amazing new possibilities, as will be shown in the following.

First of all, the technique of reproducing the watermarks has greatly improved. Briquet and Piccard collected images by tracing the watermark. This can be done without any special equipment, but the result is not very precise. A more accurate image can be gained through a rubbing. All one needs is a pencil and a thin piece of paper. The thin piece of paper is placed on the leaf with the watermark and a plate of Perspex below it to form a stable base. An image appears on the thin piece of paper when rubbing it with a soft pencil. However, the best images nowadays are gained through electron radiography – a very expensive method. One could use a backlight and photograph the watermark with a digital camera. This introduces a problem that needs to be solved: the printed type. With tracing, rubbing and electron radiography, one does not see the printed type. But with digital photography, one does. Digital editing of the images can solve this issue.

The works of Briquet and Piccard are linear, arranged by motifs. Online databases offer more possibilities. In the early 90s, Gerard van Thienen – curator at the Koninklijke Bibliotheek, the National Library of the Netherlands – started his work on watermarks in incunabula – books printed between 1450 and 1500 – in the Low Countries. Some 2200 editions have been printed in this area in the second half of the 15th century, around 2000 of these on paper. Van Thienen examined c. 1800 copies, resulting in 16,000 images of watermarks (12,000 rubbings and 4000 electron radiographs). All images were scanned and described in a MS Access database that was published on the web as Watermarks in Incunabula printed in the Low Countries (WILC) (www.kb.nl/watermark).

Each watermark is recorded by a description of the motif and specific elements, such as height, width, distance of the chain lines and position on the sieve. From the incunable from which the watermark was taken, the following elements are provided: a reference to the institution where the copy is kept, the number of leaves and folios of the copy and production details (city, printer and date). For traditional descriptive elements, such as author and title, a link is

made to the Incunabula Short Title Catalogue (ISTC) at The British Library (www.bl.uk/catalogues/istc).

One other important feature has to be mentioned. Whereas Piccard and Briquet only register unique watermarks, in WILC, identical watermarks can be found. If a watermark appears several times in the same book, only one image is inserted in WILC. If, on the other hand, the same watermark appears again in another incunable, it is recorded once again. These identical watermarks are brought together in so-called Equivalent Groups (EG). Such an EG can be used to identify when and where the same sort of paper was used and turns out to be an important feature to date books or ascribe anonymously printed books to a certain printer.

Only 800 of the 2200 printed incunabula printed in the Low Countries contain a date. Since paper was very expensive in those days, one may assume that printers did not keep it for a very long time. So when an undated book is printed on the same paper as a dated one – as can be seen using Equivalent Groups – it is printed around the same time (within a range of five years). In WILC, almost 3300 watermarks have been dated by this method. In the same way, one can ascribe books to certain printers.

For example, in 1487, *Flores poetarum de virtutibus et vitiis, sive Sententiae* (ISTC if00221500) was printed in Delft, by either Christiaan Snellaert or J. J. van der Meer. The book contains 13 watermarks: flower, four-petalled; hand, thumb left, quatrefoil; letter p, quatrefoil, small dash, to right; letter p, quatrefoil, to left; letter p, quatrefoil, to right. Five of the Equivalent Groups contain watermarks that also appear in books that have been printed by Van der Meer, and none of the watermarks appear in books of Snellaert. Therefore, one may assume that Van der Meer printed this book.

WILC started as an isolated database. Meanwhile, the Piccard Collection at the Landesarchiv Baden-Württemberg in Stuttgart has been digitized and is published on the web (www.Piccard-online.de). Besides that, at the Österreichische Akademie der Wissenschaften in Vienna, another important database of watermarks was built: Wasserzeichen des Mittelalters (WZMA) (www.ksbm.oeaw.ac.at/wz/wzma.php). From September 2006 to February 2009, an international group of paper researchers and IT-specialists joined in the Bernstein project, co-funded by the European Commission, eContentplus program. They integrated these three major databases (and a smaller one of Florence), now represented at the Memory of Paper website (www.memoryofpaper.eu). They also developed new tools for paper research, such as an online international bibliography of paper studies, an atlas of paper and a toolkit to start new paper databases.

Much information about this project can be read at the Bernstein Twiki (www.bernstein.oeaw.ac.at/twiki/bin/view/Main/WebHome) and in the various editions of the Exhibition Catalogue (Rückert et al., 2009). The catalogues have developed into a handbook of modern paper research, with articles about watermarks and their reproduction techniques, watermark researchers, the databases, paper history and a description of the Bernstein Project.

After WILC, the Koninklijke Bibliotheek at The Hague has continued watermark research and provided facilities to describe the Watermarks in Incunabula printed in España (WIES), also collected by Gerard van Thienen. At the moment, he leads another project as well: Watermarks in Incunabula printed in Great Britain (WIGB). In this project, the watermarks that Paul Needham of Princeton brought together are described. Both projects are funded by the Bibliographical Society in London and will be published on the web and eventually be included in Bernstein.

Concluding, one can say that the field of watermark research is proceeding rapidly, as a result of new methods and technologies. Books and prints can be dated, falsifications can be established and trade routes can be researched, all using these databases and new technologies. They have opened new worlds for paper historians, book historians, economic historians, antiquarians, art historians, art dealers and forensic investigators. ■

As Marieke Van Delft concludes, in her case study above, this is a field of study that:

> is proceeding rapidly as a result of new methods and technologies. Books and prints can be dated, falsifications can be established and trade routes can be researched, using these databases and new technologies. They have opened new worlds for paper historians, book historians, economic historians, antiquarians, art dealers and forensic investigators.

One final question that we can and, perhaps, should consider is the extent to which these researchers from traditional disciplines can be classified as belonging to the digital humanities. Related to this is the awareness of the digital humanities as an academic field within these more traditional professional groups.

> The Consortium of European Research Libraries (CERL) was formed in 1992 with a primary objective … to record all books printed in Europe during the hand-press period, c.1450–c.1830, in a machine-readable catalogue called the

Heritage of the Printed Book Database …. Two other significant initiatives are the development of the CERL Thesaurus and the CERL Portal.

(www.cerl.org/web/en/about/main)

CERL runs workshops throughout Europe and provides webinar training. In recent years, it has supported the establishment of provenance databases, drawing on the life's work of academic Paul Needham, and has ventured into improvements to the searchability of the Incunabula Short Title Catalogue (ISTC), through the creation of its Material Evidence in Incunabula (MEI) initiative. CERL's workshops attract attendees from across the historical bibliography community, both its leading lights and new scholars. Do these people see themselves as digital humanists? Largely not, it seems. There are a few who attend digital humanities conferences, as well as those for rare books. Are they scholars who are using technology to answer humanities research questions in new ways? Most definitely so. Perhaps, then, in considering *Digital Humanities in Practice* within the discipline of historical bibliography, we are considering a practice that is not identified by bibliographers as digital humanities at all. Viewed in a more optimistic light, though, perhaps we can observe that historical bibliography is a discipline that recognizes that digital skills, and those who possess them, really are indispensable – to echo Melissa Terras' DH2010 plenary, in which she calls on digital humanists to prove their skills just as necessary to the humanities as a whole (Terras, 2011).

Conclusion

This book chapter has set out some of the fundamental concepts of bibliography that may aid the digital humanist in their study of the book in the 'brave new digital world'. We have seen that the book is a concept that covers both content and container and that both these aspects continue into the digital environment. We have discussed the book as an analogy for design in the presentation of texts and have seen how both scrolling and paging are concepts derived from the book's physical embodiment in the past. We have considered bibliographic projects begun in the pre-digital era and given new and increased possibilities through the power of the computer. Finally, in considering large projects, such as Google Books, we have seen parallels between digital humanities and bibliography, as well as with rare books librarianship.

Bibliography

Bowers, F. (2005) *Principles of Bibliographic Description*, Oak Knolle Press.

Briquet, C. M. (1968) *Les Filigranes. The New Briquet-Jubilee Edition*, Stevenson, Allan (ed.), Paper Publications Society.

British Museum (1958) *Short-Title Catalogue of Books Printed in Italy and of Italian Books in Other Countries from 1465 to 1600 now in the British Museum*, British Museum.

Carter, H. (1969) *A View of Early Typography up to about 1600: the Lyell Lectures, 1968*, Clarendon Press.

Chan, L. M. (2007) *Cataloging and Classification: an introduction*, 3rd edn, Scarecrow Press.

Dane, J. A. (2003) Twenty Million Incunables Can't be Wrong. In *The Myth of Print Culture: essays on evidence, textuality, and bibliographical method*, University of Toronto Press.

De Voragine, J. (1892) *The Golden Legend of Master William Caxton, Done Anew*, Kelmscott Press.

Edgerton, D. (2008) *The Shock of the Old: technology and global history since 1900*, Profile.

Eisenstein, E. L. (2005) *The Printing Revolution in Early Modern Europe*, 2nd edn, Cambridge University Press.

Febvre, L. and Martin, H. (1997) *The Coming of the Book: the impact of printing 1450–1800*, Verso.

Gaskell, P. (1995) *A New Introduction to Bibliography*, St Paul's.

Green, J., McIntyre, F. and Needham, P. (2011) The Shape of Incunable Survival and Statistical Estimation of Lost Editions, *Papers of the Bibliographical Society of America*, **105** (2), 141–75.

Haslam, M. W. (2005) The Physical Media: tablet, scroll, codex. In Foley, J. M. (ed.), *A Companion to Ancient Epic*, Wiley-Blackwell.

Hellinga, L. (2009) The Gutenberg Revolutions. In Eliot, S. and Rose, J. (eds), *A Companion to the History of the Book*, Wiley-Blackwell.

Hendel, R. (1999) *On Book Design*, Yale University Press.

Howell, P. (1980) *A Commentary on Book One of the Epigrams of Martial*, Athlone.

International Federation of Library Associations (IFLA) (2009) *Functional Requirements for Bibliographic Records. Final Report*, www.ifla.org/files/cataloguing/frbr/frbr_2008.pdf.

International ISBN Agency (1996) Notes on the Allocation of ISBNs to Non-Printed Books. In *The ISBN Users' Manual*, www.isbn.org/standards/home/isbn/international/html/usmnote.htm.

Kooistra, L. J. (2011) *Poetry, Pictures, and Popular Publishing: the illustrated gift book*

and Victorian visual culture, 1855–1875, Ohio University Press.

Krantz, S. G. (2005) *Mathematical Publishing: a guidebook*, American Mathematical Society.

Krummel, D. W. and Sadie, S. (eds) (1990) *Music Printing and Publishing*, Macmillan.

Landow, G. P. (2006) *Hypertext 3.0: critical theory and new media in an age of globalization*, The John Hopkins University Press.

Laufer, R. and Scavetta, D. (1992) *Texte, Hypertexte, Hypermedia*, Presses universitaires de France.

Lavoie, B. F. and Schonfeld, R. C. (2006) Books Without Boundaries: a brief tour of the system-wide print book collection, *Journal of Electronic Publishing*, **9** (2), http://dx.doi.org/10.3998/3336451.0009.208.

Lavoie, B. F. et al. (2006) Mapping WorldCat's Digital Landscape, *Library Resources and Technical Services*, **51** (2), 106–15.

Luna, P. (2009) Books and Bits: texts and technology 1970–2000. In Eliot, S. and Rose, J. (eds), *A Companion to the History of the Book*, Wiley-Blackwell.

McCrank, L. J. (2002) *Historical Information Science: an emerging unidiscipline*, Information Today.

McKenzie, D. F. (1999) *Bibliography and the Sociology of Texts*, Cambridge University Press.

McKitterick, D. (2003) *Print, Manuscript and the Search for Order, 1450–1830*, Cambridge University Press.

Man, J. (2005) *Gutenberg: how one man remade the world with words*, Wiley.

Moxon, J. (1962) *Mechanick Exercises on the Whole Art of Printing, 1683–4*, Davis, H. and Carter, H. (eds), Oxford University Press.

Piccard, G. (1961–1997) *Die Wasserzeichenkartei Piccard im Hauptstaatsarchiv Stuttgart. Findbuch I–XVII*, Kohlhammer.

Pollard, A. W. and Redgrave, G. R. (eds) (1976–1991) *A Short-Title Catalogue of Books Printed in England, Scotland, & Ireland, and of English Books Printed Abroad, 1475–1640, 2nd edn*, revised by Jackson, W. A., Ferguson, F. S. and Pantzer, K. F., Bibliographical Society.

Roemer, C. (2009) The Papyrus Roll in Egypt, Greece, and Rome. In Eliot, S. and Rose, J. (eds), *A Companion to the History of the Book*, Wiley-Blackwell.

Rückert, P. et al. (2009) *Bull's Head and Mermaid*, Landesarchiv Baden-Württemberg/Austrian Academy of Sciences.

Springer (2011a) *Lecture Notes in Mathematics*, www.springer.com/mathematics/lecture+notes+in+mathematics?SGWID =0-168502-0-0-0.

Springer (2011b) *Mathematics. Dynamical Systems and Differential Equations. The Dirichlet Problem for Elliptic-Hyperbolic Equations of Keldysh Type*,

www.springer.com/mathematics/dynamical+systems/book/978-3-642-24414-8.

Taycher, L. (2010). 'Books of the World: stand up and be counted', *Google Books Search*, 5 August,
http://booksearch.blogspot.co.uk/2010/08/books-of-world-stand-up-and-be-counted.html.

Taylor & Francis Online (2011) *Journal of Library Metadata. Publication History*,
www.tandfonline.com/action/aboutThisJournal?journalCode=wjlm20.

Tedd, L. A. (1993) *An Introduction to Computer-Based Library Systems*, Wiley.

Tennyson, A. (1859) *Poems, 2nd edn*, Moxon.

Terras, M. (2011) Present, Not Voting: digital humanities in the Panopticon: closing plenary speech, digital humanitis 2010, *Literary and Linguistic Computing*, **26** (3), 257–69.

Tschichold, J. (1992) *The Form of the Book: essays on the morality of good design*, Lund Humphries.

UCL Department of Information Studies (2009–2011) *Module INSTG012: historical bibliography*, www.ucl.ac.uk/infostudies/teaching/modules/instg012.

Vandendorpe, C. (2009) *From Papyrus to Hypertext: toward the universal digital library*, University of Illinois Press.

Welsh, A. (2011) *A Painless Introduction to Paper in the Brave New Digital World: why we still need the physical book and what digital research adds to its history*, unpublished, www.ucl.ac.uk/infostudies/anne-welsh/outreach/PainlessIntro.ppt.

Wing, D. G. (ed.) (1994) *Short-Title Catalogue of Books Printed in England, Scotland, Ireland, Wales, and British America, and of English Books Printed in other Countries, 1641–1700, 2nd edn*, Modern Language Association of America.

Note

1 This chapter is an extension of the paper given as the UCL Centre for Digital Humanities paper: Painless Introduction to Paper in the Brave New Digital World: why we still need the physical book and what digital research adds to its history. Slides are available at Welsh (2011). As such, it encapsulates many of the core concepts that underpin the module in historical bibliography, which is offered to students on UCL's MA in Archives and Records Management, MA in Library and Information Studies and the newly established MA/MSc in Digital Humanities (UCL Department of Information Studies, 2009–2011).

Open access and online teaching materials for digital humanities

Simon Mahony, Ulrich Tiedau and Irish Sirmons

Introduction

Education for all has taken on a new meaning in the digital age. A cultural change is taking place in universities, with academics using the internet to share their research (Open Access) and teaching and learning resources (OER: Open Educational Resources) online, for free. This spirit of collaborative working is on the increase and, potentially, opens up higher education to a mass global market, giving students and teachers greater access and flexibility, at little cost.

The appeal of the open agenda is summed up quite succinctly by the Public Library of Science, saying:

> Open access stands for unrestricted access and unrestricted reuse. Paying for access to content makes sense in the world of print publishing, where providing content to each new reader requires the production of an additional copy, but online it makes much less sense to charge for content when it is possible to provide access to all readers anywhere in the world.
>
> (www.plos.org/about/open-access)[1]

With OER, similar principles apply: academics create, share and allow their teaching resources not only to be re-used, but also to be amended, improved and transformed. It is the philosophy of OER, and the way in which the internet has radically changed access to information, that has led to the development and success of projects such as MIT's OpenCourseWare (http://ocw.mit.edu), which makes virtually all MIT course materials available online for free, or corporate platforms, such as iTunes U (www.apple.com/education/itunes-u) or YouTube EDU (www.youtube.com/education), that

distribute educational content, via social media channels. In the UK, the Open University has had great success with their OpenLearn programme (http://openlearn.open.ac.uk), and HEFCE is funding a large and internationally regarded UKOER programme, led by JISC and the Higher Education Academy (2009–2012), that involves more than 70 UK higher education (HE) and further education (FE) institutions, as well as publishers, companies, charities and other stakeholders outside of academia, and, at the time of writing, has just entered its third phase (www.jisc.ac.uk/oer; www.heacademy.ac.uk/oer).

The term *Open Educational Resources* (OER) was first introduced at a UNESCO conference in 2000 and promoted in the context of providing free access to educational resources on a global scale. At the heart of the OER movement, lies 'the simple and powerful idea that the world's knowledge is a public good and that technology in general and the World Wide Web in particular provide an extraordinary opportunity for everyone to share, use, and reuse that knowledge' (Smith and Casserly, 2006, 10). While, on first sight, it may seem a counter-intuitive for academics or institutions to make their teaching resources available openly, there is plenty of evidence for the reputational and economic benefits to be gained from this step. By allowing students to preview high-quality learning and teaching resources via OpenLearn, the Open University, for example, gained 'at least 4,400 people by April 2008 (growing to over 7,000 by November 2008)' in the first two years of the programme's existence, proven by their simultaneous enrolment in the free OpenLearn and the OU's regular courses, and this is continuing at an accelerating rate (McAndrew et al., 2009, 9).

The potential of OER is also realized by governments all over the world, even in times of public scarcity. In January 2011, the US government announced a new federal education fund, making available $2 billion to create OER resources, with a view to achieving the goal of having the highest proportion of college graduates in the world by 2020 (http://creativecommons.org/weblog/entry/26100). It also looks as though the benefits of Open Access (OA) in higher education could go beyond teaching and research. In October 2011, JISC published a report that showed that the private sector also benefits from Open Access in higher education. The report, commissioned by the UK Open Access Implementation Group, suggests that 'for at least two-thirds of these businesses, OA has the great benefit of saving organisations time in searching for published material through non-OA sources' (Parsons, Willis and Holland, 2011, 23).

But beyond all arguments along these economic lines, the true rationale of

openness is one of reclaiming original academic practice and collaboration. Rather than reinventing the wheel, lecturers can potentially take a 'pick and mix' approach to the resources – reusing or remoulding course reading lists, essay questions, lecture notes, slides or seminar discussion topics for their own purposes, and focus on providing a great learning experience to their students. Students can use OER to study autonomously or to amend their learning in class. Consequently, the move towards openness extends beyond resources and includes, increasingly, also, Open Educational Practices (OEP) or just Open Education (OE).[2]

As the humanities, in general, and the digital humanities, in particular, are becoming more and more collaborative, the nature of modern research practice makes it clear that future humanities scholars need to be trained in the collaborative process and to understand the importance of critical reflection. In this chapter, we will argue that this is necessary for those who stay in the academy, but it must be remembered that this is equally true for the success of students whose future careers will be in business and commerce. No longer can a single person, whether in the academy or in business, have all the skills necessary to succeed in a digital project. They now need to work with other practitioners and have the necessary abilities to do just that. These skills must be taught alongside traditional writing and communication ones; many of these are, in fact, new communication skills, and it is successful communication that leads to successful collaboration.[3] These are the type of abilities that are taught in digital humanities programmes.

The global OER movement

The global OER movement can trace its origins back to the Massachusetts Institute of Technology's announcement in 2001 that it would make all its teaching material available in a repository as OpenCourseWare (OCW), freely available to the public, with an initial 50 courses developed by their faculty (MIT OCW, 2011). The term OER itself was introduced by a UNESCO conference in the following year, originally in the context of higher education in developing countries. By 2005, OCW had expanded into a consortium of hundreds of universities and organizations, with many funded by the William and Flora Hewlett Foundation (MIT OCW, 2011). In 2009, MIT's OCW site had over one million visits per month, and, today, boasts '122 million visits by 87 million unique visitors from virtually every country' (MITOpenCourseware Dashboard Report, 2009). The Open

University, with its OpenLearn repository, was the first British university to join the OCW Consortium. What is pertinent here is that within the first two years of the release of their content, the Open University saw a positive impact on their enrolment figures, with a definite and discernible link between OpenLearn and registrations (see above, McAndrew et al., 2009, 9). Direct links to an increase in student enrolment and parallel funding by the Hewlett Foundation helped to make OpenLearn a sustainable long-term project.

However, despite these high figures, OERs still continue to be relatively unused in most education programmes (Andrade et al., 2011, 8). It is also difficult to determine whether this lack of uptake is due to a general lack of awareness of OERs, especially at more traditional higher education institutions, an unwillingness to use other people's material for teaching or that by releasing the material and making it freely available, there is, in some way, a loss of ownership. To address some of these issues, in 2009, the UK's Joint Information Systems Committee (JISC) and the Higher Education Academy (HEA) supported a UK initiative to encourage the incorporation of OERs into all government-sponsored education programmes. The initial programme was broken down into two phases. The pilot phase ran from 2009–2010 and focused on demonstrating the 'sustainability of long-term open resources release' (JISC, 2010). It resulted in the publication of a comprehensive synthesis and evaluation report (https://oersynth.pbworks. com/w/page/29595671/OER-Synthesis-and-Evaluation-Project) and an accessible and practical OER infokit (https://openeducationalresources. pbworks.com/w/page/24836480/Home). The stability achieved by long-term OER release would allow educators to make OER inclusion a normal part of their curriculum preparation and development.[4]

The second phase ran from 2010–2011, with the following objectives (JISC, 2011):

- to extend the range of materials openly available
- to document the benefits offered by OER to those involved in the learning process
- to enhance the discoverability and use of OER materials.

OERs created during both phases were to be added to the JISC-funded repository, Jorum, originally called JorumOpen, which has been designated to become the UK's national OER repository (www.jorum.ac.uk). There are other relevant repositories as well; in the context of the humanities, we would like to point out HumBox (www.humbox.ac.uk) and the related

Languagebox (www.languagebox.ac.uk). But in line with the general OER idea, OERs are more commonly distributed via regular social networks and cloud services, like YouTube, SlideShare or Flickr, discoverable without accessing centralized repositories, by regular internet searches, RSS feeds or OER-specialized search engines, like Xpert (www.nottingham.ac.uk/xpert).

This chapter makes use of the experiences that the authors gathered in the preparation and delivery of two UKOER projects: Open Learning Environment for Early Modern Low Countries History (OLE Dutch history, www.ucl.ac.uk/alternative-languages/OER/) and OER Digital Humanities (DHOER, http://ucl.ac.uk/dhoer), in the pilot phase and phase 2, respectively.

Communities of practice and learning communities

Despite the seemingly obvious benefits of OERs, producing resources and releasing them as OERs is not enough. It is necessary for us to develop communities of both practice and learning. What are needed are new approaches and new ways of thinking, and this, it is important to remember, is a consideration not only for the students, but also the educators. The use of re-usable learning objects and materials, along with the ongoing practice of developing new ones to contribute to the wealth of such resources, needs to become part of the training of teachers at all levels. In all UK higher education institutions, probationary teachers and lecturers are required to attend and participate in training. This is where the creation, release, use and re-use of teaching materials can be instilled in up-and-coming educators. When these methodologies become more commonplace in the teaching of educators and the development of their research practice, they will become commonplace in the arsenal of teaching tools employed by course tutors. This then creates the 'knock-on' effect, where the more they are used, the more they will become used.[5]

Re-using and sharing the teaching material of departmental colleagues is often standard academic practice, as is adapting and updating them; the difference here is that OERs are externally sourced and then, if adapted and updated, put back into the wider community and not kept just within the department. If these initiatives are to become self-sustaining, the routine updating of content (downloading, updating and re-uploading modified OERs) needs to become part of the educators' workflow. In the UK, we have a flourishing community, evidenced by the growth of a major annual conference (OER10 in Cambridge; OER11 in Manchester; OER12, held

together with the global OpenCourseWare Consortium's conference OCWC12, again in Cambridge), and what is needed is that we develop a culture of collaboration and participation; to create and sustain what the Dearing Report one-and-a-half decades ago envisaged to be 'a learning society'.[6]

This move to openness and collaborative working has a wider importance. More mechanisms for getting people to work together are needed for students, as well as practitioners. Because of the modular system, for many students, study has become an individual, rather than community-based activity. Although, as we know, the humanities and, particularly, the digital humanities are highly collaborative, our students often risk becoming trained as solitary learners, running the risk of them losing the collaborative skills they may already have, skills which are valuable both in the academy and the workplace and that are at the heart of the majority of digital humanities' research projects. In the UK school system, students are encouraged to work together in groups and produce collaborative work. When they come to university, they are warned about the dangers of plagiarism and are reminded constantly that the work they submit must be their own. This lean to solitary study becomes especially noticeable as students start to progress in the academy as graduate students, to their PhD and beyond; there is a tendency for research students to become more and more isolated as they progress towards greater specialism. Although the focus on individual output is necessary for academic examination, a tension exists between the goals of advanced study and the collaborative skills that are needed in the job market and, indeed, the type of collaborative research projects undertaken by digital humanists.

The way forward

In the UK, a third phase in the JISC & HEA OER programme has started in September 2011 and is focusing on 'Embedding and Sustaining Change' (HEA/JISC, 2011):

> Based on the findings of the first two phases of work, we now conceptualize open educational resources as a component of a wider field of 'open academic practice', encompassing the many ways in which higher education is engaging and sharing with wider online culture.

Two point eight million pounds will be spread over four funding threads

from October 2011 to October 2012, with the overall aim of achieving OER self-sustainability by:

- the creation of a Postgraduate Certificate in OER development
- a continuation of the release of Open Materials for Accredited Courses (OMAC)
- embedding OER Practice in institutions and focusing on 'whole institutional change'.

Specific themes identified in Phases I and II for the growth of OER are:

- collaborating with institutions beyond higher education
- exploring publishing models for OER
- addressing identified sector challenges
- enhancing the student experience.

JISC and the Academy noted that no one-size-fits-all programme exists for the development and sustainability of OERs. One additional aspect which, perhaps, could be pressed further to support this would be the promotion of OERs to the general public. We argue that this, together with building a community of practice around the use and regeneration of OERs, is key to the long-term sustainability of the project.

Benefits to universities of OERs

In a survey of 570 higher education/adult education stakeholders taken by the Open Education Quality Initiative, over 80% of responders agreed that the use of OER-improved education and that their use '… lead to pedagogical changes and increases [in] the participation of learners in educational scenarios' (Andrade et al., 2011, 57). As universities face many challenges in order to compete for students and funding, they demand proof that OERs can improve their competitive edge amongst their peers (Organisation for Economic Co-operation and Development, 2007, 18). By creating a space where educators display their learning objects through OERs, universities offer prospective students and financial benefactors a window into their classrooms, demonstrating the university's value and culture.[7]

The next step is to change the academic culture and to encourage open educational practices, which requires much more than technological changes (Andrade et al., 2011, 12). It will require an understanding of the

challenges facing the educational community today and how OERs can help them achieve their goals in learning. This extends far beyond the confines of the UK or US education systems. Another challenge is providing access to OERs in the developing world, areas of poor and often expensive internet connectivity.[8] Making OERs accessible, free and online does not necessarily make them available to the people who would most benefit from using them. Although OERs, once released online, are open to the world, they are only open to the 'well connected' world, which is expansive, but not universal. Elsewhere, what are often needed are not materials that look good on the latest Smartphone or iPad, but ones that display effectively on low-cost mobile phones and incorporate simple, widely used technologies.

Sustaining OERs

One persistent challenge for institutions that champion OERs, just as for all net-based projects, is finding funding for the future sustainability of their initiatives. Independent funding sources from governments and private grants have stretched into the billions of pounds and dollars (US Department of Labor, 2011); MIT and the OCW Consortium have benefited from the William and Flora Hewlett Foundation (OCW Consortium, 2011). The UK government's JISC and HEA initiatives have enabled universities around the country to create OER repositories, such as those at Southampton and Leeds (JISC, 2010). The United States government established a grant worth $2 billion dollars over the next four years (US Department of Labor, 2011) which will establish a central repository for community college generated learning material (see the introduction to this chapter). However, all this investment in the creation of resources will be wasted if a relatively small amount is not set aside for sustaining and maintaining them. If institutions want to sustain their OER programmes, they will need to incorporate the production and use of open learning objects into their current business models, standard operating procedures and academic culture. Further, if re-use and repurposing of these resources is to be encouraged, then they must be released in a format that allows repurposing and editing, importantly, without the need for expensive proprietary software. The most widespread practice with text or graphic-based OERs is to release them as PDFs, as those represent a ubiquitous, user-friendly, open-in-your-browser format. However, their flattened form hardly encourages re-editing, as that would generally require the laborious task of rewriting the content, which defeats the purpose of having a repurposable resource. For sustainability and to

encourage re-use, OERs should, as they are in DHOER (see the case study in this chapter), be released in an open, future-proof, XML based format, such as the Open Document Format (ODT, ODS, ODP, etc.) or similar. Users can re-edit these in commonly used Office suites, like Microsoft Office (version 2007 SP2 or later), if they wish, but, importantly, they are also able to make use of freely downloadable Open Source alternatives, such as OpenOffice (www.openoffice.org), LibreOffice (www.libreoffice.org) or a variety of freely available ODT converters for proprietary word-processing packages. In addition, and to aid the less technically proficient, documentation about how this can be done, and which tools may be used, should also always be included and attached directly to the OER, along with licensing details and adequate metadata to ensure that the resource is found.

··

CASE STUDY OER and distance education in a lesser taught language community (OER Low Countries history: www.ucl.ac.uk/dutch/OER)

··

Simon Mahony, Ulrich Tiedau and Irish Sirmons, University College London

Modern Languages: strategically important and vulnerable subjects in higher education

Our first case study is about a lesser taught language subject community – Dutch studies. In the UK and the Anglophone world in general, Dutch is, undoubtedly, a minority subject,[9] despite being the language of two neighbouring countries, who also belong to the largest trading partners of Britain. Dutch, despite its guttural sound, is also the modern language most closely related to English, making it very easy to learn for native speakers of English.[10] Despite all this, student numbers in the UK have been modest and, if anything, have fallen in recent years. The general decline in interest in modern languages (Worton, 2009) is affecting all language programmes, but this is especially serious for less widely taught languages, such as Dutch.

While modern languages are recognized as 'strategically important and vulnerable subject areas' (www.hefce.ac.uk/whatwedo/kes/sis), provision of Dutch exists only at four UK higher education institutions: University College London (UCL) and the universities of Sheffield, Cambridge and Nottingham. Confronted with diminishing resources, these departments decided to co-operate and bundle their resources, and, in 2001, they formed the *VirtualDutch*

consortium, with UCL Dutch acting as the lead institution.[11] The main aims of this programme were to create shared electronic resources for teaching and learning and to develop ICT-supported forms of inter-institutional collaboration. Funding was provided from a range of sources: the University Council of Modern Languages (UCML), The Higher Education Funding Council for England (HEFCE), the Nederlandse Taalunie (Dutch Language Union – the joint Flemish-Dutch equivalent of the British Council) and the Royal Netherlands Embassy in London, as well as additional internal university funding. By sharing resources and expertise amongst the participating institutions, the initiative has also brought more breadth and depth to the curriculum. Using learning technologies as a main strategy to achieve this was a deliberate choice. *VirtualDutch* was partly born out of the belief that today's communication technology can no longer be ignored in an academic curriculum. Students encounter a wide range of learning environments, from classroom contact to multimedia language instruction in a Virtual Learning Environment and web based self-study. They also feel part of a larger Dutch studies community in the UK, especially when they collaborate in joint teaching projects.

A wide range of Open Educational Resources has been developed since the start of the programme in 2001, including self-access reading skills courses, learner's grammars, online reference works and some 30 multimedia study packs for autonomous learning, covering various aspects of Dutch and Flemish language, literature, history and society. These resources cater for various levels of linguistic competence, ranging from topics such as individual Dutch or Flemish authors, such as Multatuli or Louis Couperus, to the sociolinguistic situation of Brussels and the multicultural society in the Netherlands today.

These resources are openly available on the *VirtualDutch* teaching and learning portal that was launched in 2007 and is currently in redevelopment. The portal also provides access to external resources, such as the relevant quality-controlled web resources of the *Intute Arts and Humanities* subject gateway[12] and a directory of RSS feeds, audio and video podcasts from Dutch and Belgian newspapers, broadcasting stations and educational institutions. It also includes two bibliographical databases on Dutch literature in English translation and on Studies in English on Dutch history and literature, aimed at native English-speaking learners of Dutch *ab initio*. There is plenty of evidence of excellence for *VirtualDutch*. All individual sub-projects have been tested and evaluated. The *VirtualDutch* programme, as a whole, has been monitored by two external evaluators – one appointed by UCML, the other by the *Dutch Language Union*. Student response is fully documented and has been overwhelmingly positive (van Rossum, 2004, 163). *VirtualDutch* was also cited as an innovative

collaborative teaching project in the HEFCE Annual Review 2002/03, *Realising a Vision of Higher Education* (September 2003).[13]

Thus, *VirtualDutch* has been developing forms of collaboratively creating OERs since 2001, independently of the larger worldwide Open Educational Resources movement that started at around the same time. As some of the earlier resources of *VirtualDutch* had become outdated technologically; the idea behind taking part in the UKOER pilot phase was to build on the *VirtualDutch* experience and re-release a cluster of resources around a specific topic in a case study, drawing on the support and expertise of the JISC and HE Academy communities. As the writer is a historian, and a cluster of *VirtualDutch* OERs on early modern history (16th/17th century) existed, the choice of topic was an obvious one – an Open Learning Environment for Early Modern Low Countries history. Also, while *VirtualDutch* is well known and respected within the international Dutch Studies community (Hammond, Hermann and Mahmody, 2009), it was not otherwise very visible. Part of the rationale for taking part in the UKOER programme was also to embed the initiative into the wider OER community and to create resources that would appeal to a wider audience, including prospective students.

Open learning environment

The first major resource release was a timeline of Anglo-Dutch exchanges, from ancient times to the 19th century, based on a manuscript by Jaap Harskamp – former curator of the Dutch and Flemish collections at the British Library – in which, drawing on a huge variety of sources, he had compiled and annotated a comprehensive list of over 800 events relating to Anglo-Dutch relations throughout the centuries. The manuscript that he very generously made available to the project was turned into an interactive multimedia Web 2.0 timeline on Anglo-Dutch relations using MIT's Web 2.0 *Simile* technology (http://simile.mit.edu). The 16th and 17th century, the Dutch revolt and the subsequent Golden Age of the Netherlands, are also, traditionally, the area of Dutch history which attract most interest in the Anglophone world. Consequently, a special focus of the OER was put on relations between the Low Countries and the Anglophone world. The timeline has attracted much attention from the UKOER community, e.g.:

One of the reasons I love the OER Programme is that it turns up stuff like this. The VirtualDutch timeline of Anglo-Dutch relations. It's built using MITs Simile software and it's packed full of utterly fascinating detail. Amongst

more familiar historical events it includes such gems as the following: [...]. Brilliant! Of course this has completely derailed any 'real' work I was going to do this afternoon.[14]

As the scope of the project has been extended, a great number of *VirtualDutch* resources have been re-worked as OERs, licensed under suitable Creative Commons licences, allowing for re-use and repurposing the material worldwide, under acknowledgement of authorship, and deposited on Jorum, HumBox and Languagebox. These include: Try Dutch! – a Dutch language taster; Amsterdam Represented – a taster in Dutch cultural studies; and a study pack on Dutch poetry. The project also gave some scope for investigation of how best to balance integrity and granularity of resources. We moved away from the idea of producing one single transferable learning package – an integrated Open Learning Environment – because it would go against the principle of making the resources easily reusable and repurposeable. Rather, a series of OERs has been released as individual learning objects and been made available via the project's website – Jorum, HumBox and cloud channels, such as SlideShare.

Technologically, the project used existing software, mainly Moodle (http://moodle.org), Educommons, a content management system designed to support OpenCourseWare projects, (http://educommons.com) and MIT's SIMILE package (Semantic Interoperability of Metadata and Information in unLike Environments, http://simile.mit.edu), all of which are Open Source, and existing cloud computing services like SlideShare (www.slideshare.net), and Xtimelines – a web service that allows creating and exploring Simile timelines online (www.xtimeline.com).[15] No new technical developments were planned as part of the project.

In summary, a substantial amount of Open Educational Resources in the 'strategically important and vulnerable' subject area of Dutch studies have been released, directly benefiting staff and students of Dutch at UCL and the VirtualDutch partner institutions. They are also open for re-use and repurposing worldwide. Apart from Dutch departments, the material will be highly relevant for students of British or European history. Uptake of the OERs created in this community is tracked with the help of web statistics and feedback questionnaires.

Synergy effects existed between OER Dutch and the OER projects of the Subject Centre for Languages, Linguistics and Area Studies (LLAS). Being embedded into the *VirtualDutch* community, resources have been added to the infrastructure built after the project's lifespan, and outputs were also used in a postgraduate degree programme, Dutch Cultural Studies, by distance learning at UCL and Sheffield. ■

..

CASE STUDY OER and digital humanities (DHOER: www.ucl.ac.uk/dhoer)

..

Simon Mahony, Ulrich Tiedau and Irish Sirmons, University College London

DHOER (Digital Humanities Open Educational Resources) is a UKOER Phase II (www.jisc.ac.uk/oer) 'release' strand project, set up to create and release a comprehensive range of introductory materials on approaches, topics and methods in the digital humanities. These resources are based on modules taught at the UCL Centre for Digital Humanities and are released under non-restrictive licensing in several open formats.[16] As well as supporting the digital humanities, these resources are intended to benefit many cognate disciplines, including the whole spectrum of the arts and humanities, cultural heritage, information studies, library studies, computer science and engineering. The project has also been involved in awareness-raising of OER, by presenting at workshops, conferences and organizing several UKOER programme- and institution-wide events.

Turning these teaching and learning resources into OERs published on the internet, and making them freely available for anyone, has created an important teaching and learning resource for the emerging and strategically important subject area of digital humanities. These resources draw on the expertise of the UCL Centre for Digital Humanities (www.ucl.ac.uk/dh) and the Department of Information Studies (www.ucl.ac.uk/dis), as well as being informed by the experience of previously creating and releasing OERs and the changes that this process brings about for learning and teaching, gained by the earlier pilot phase project, *VirtualDutch* (the first case study in this chapter).

The original plan was to create a single large Open Educational Resource, integrating the materials within the Open Source Virtual Learning Environment (VLE) Moodle. However, as the UKOER programme progressed, issues of re-usability and repurposability became more prominent and, as with *VirtualDutch*, the issue of granularity, versus the integrity of OERs, emerged. The focus of the whole programme shifted towards the creation of smaller units of learning objects, and it became necessary to break down the larger resources into meaningful individual learning objects, in a way that they could easily be redistributed and repurposed. Striking the balance between granularity and integrity was one of the challenges encountered in the project. In addition to this problem of granularity, Moodle, while being Open Source and a proven platform for the delivery of OERs,[17] lacks full support for exporting resources in SCORM (Sharable Content Object Reference Model) and IMS Content Packaging[18] format. Licensing information is written into the cover page of the

resources where possible and included in the associated metadata, which follows the Dublin Core[19] and includes information on level, learning context and original intended audience.

The teaching materials used for DHOER come from existing modules taught within the Department of Information Studies. These had, as is usual in academic departments, been developed, updated and added to over several iterations, by successive module tutors. This is usual practice and, in fact, no different from the OER model, except that now the DHOER resources would be available for use outside of the department, faculty and institution. All tutors contacted were agreeable to having their content included, provided they were acknowledged and the resources released under suitable licensing (see above). Wider discussion did, however, throw up some anxieties. Academic publications are traditionally subject to peer review and rigorous editorial control, prior to publication; facts and citations are checked, typographical and other errors picked up along the way. They are then the result of a long process, starting with authoring and ending with the proofreading, before online or print publication. This does not happen with OERs, which do not have the benefit of 'many eyes' and editorial review before release. Consequently, some concerns were raised about work going out under the name of the author with errors uncorrected and the possible repercussions on their credibility. This, however, points to one of the strengths of the OER process that, when licensing for re-use, you are giving permission for the content to be adapted and re-published; errors and omissions can be corrected and re-uploaded by a user with the original author still acknowledged.

One of the modules chosen had many guest speakers, who had all previously made their presentations (suitably adapted by removing any copyrighted material they did not own the rights to) available for the module students, via the institutional intranet. Without exception, all the speakers that were invited agreed to have their material included, after a check to make sure that they did in fact 'own' the content and, again, provided they would be credited under an appropriate licence. More than one had already attached a Creative Commons licence before giving access to our students. An interesting comment from one guest speaker was that they were quite happy to have their presentation included, provided that if it was re-edited, they should be acknowledged, but also that it should be made clear who was making those changes and that it was not the original author. Here, perhaps, the anxiety was that errors might be introduced at a later stage and that they would incorrectly be attributed to the original author of the resource.

As well as authorship and acknowledgement, the issue of copyright can be

particularly problematic and needs a little comment here on how it relates to DHOER. Being aware of some of the issues from the experience of *VirtualDutch* and the JISC start-up briefing, the project hosted a Before You Start: OER, IPR and Licensing Workshop (www.ucl.ac.uk/dhoer/news/IPR_workshop) to address any potential problems from the outset. The workshop was led by two members of the OER IPR Support Project (www.web2rights.com/OERIPRSupport), specifically to help identify and manage intellectual property rights issues and to advise about the appropriate Creative Commons licences. It appears, from this, that the largest single problem, regarding copyright for OERs (and online teaching in general), occurs when dealing with legacy material with no clear provenance attached. With the exception of the presentations from guest speakers, all the DHOER source materials were created in-house. The text had been authored and edited by the module tutors and included in the project with their agreement. As part of the project workflow, all personal data and details were removed, and the images were checked for possible copyright infringement. Any images where the rights' ownership could not be confirmed were removed and, where possible, replaced with a free usable one from Wikimedia Commons (http://commons. wikimedia.org). All guest speakers were asked to confirm that they held the rights to materials in their presentation and confirm that they agreed to our release plan. Very few images had to be removed; again, this generally occurred because the speakers were unsure of the source.

Individual objects were released in the PDF-format that is usual for OER projects, as, simply opening in a browser, it can be handled by almost every platform and end-user, including those not comfortable with technology. However, as PDF is not open at all and, strictly speaking, contravenes the idea of openness and repurposability inherent in OER, each collection of resources comes bundled by module, with the original source files in Open Document Format to facilitate the reuse, editing and the extending of the original material (see above on sustaining OERs). Instructions, including how to download Open Source office suites, are provided in the information and directions for use that come with each resource.

Similarly, each resource comes with EPUB and DAISYReader formatted versions, all generated from the original Open Documents. The EPUB files can be easily uploaded into various e-reader and portable devices, including Android based ones, Apple iBooks (iPod/iPad), Amazon Kindle, etc., with the added benefit of including page and section navigation. The DAISYReader formatted files allow the visually impaired to listen to the textual content of a resource via Daisy 3 compliant applications, which also allow for voice enabled navigation (www.daisy.org).

The individual OERs can be used separately, in any order (they do not necessarily follow a fixed sequence), or put together as a complete module. They can be accessed individually, in any of the above formats, or downloaded as a compressed archive (using, for example, the Open Source 7-Zip application, www.7-zip.org), with a link to the Open Source 7-Zip tool, along with instructions for use and extraction of the zipped files, which is also included.

All the resources have been deposited into HumBox (www.humbox.ac.uk) and, from there, the metadata and URI (Uniform Resource Identifier) links to the objects are automatically harvested into the 'national' OER repository Jorum (www.jorum.ac.uk), as well as being listed in OER directories, such as Xpert (www.nottingham.ac.uk/xpert) and OER Commons (www.oercommons.org). The collections are linked via the HumBox URIs, so that a single version exists, but is accessible in several different ways (again, to aid accessibility and discovery).

Continuing the ground work set down by its predecessor, *VirtualDutch*, DHOER also continues to promote the idea of Open Educational Resources on a national and institutional level and advocates the introduction of a faculty- or institution-wide policy on OERs, which would complement UCL's advanced Open Access policy for research outputs.[20] In a first step, a new top-level website OER@UCL has been created (www.ucl.ac.uk/oer), in collaboration with the CPD4HE project (www.ucl.ac.uk/calt/cpd4he), at the UCL Centre for Advancement of Learning and Teaching, in a first step at pulling together information from all four OER projects, with UCL involvement.

The MA/MSc programme in digital humanities has just accepted its first cohort of students in the teaching session of 2011/12, where the project outputs are being tested with a user group of these students, tutors and practitioners. It is also hoped that by allowing students to access high-quality teaching and learning resources prior to applying for a degree programme, the project will benefit not only the home institution, in terms of (home and overseas) recruitment and academic reputation, but will also be instrumental in consolidating UCL's, and, indeed, the UK's, role as one of the leading research centres of culture in this field. The inherent paradox, here, is, of course, why students should pay fees to attend courses when they can get the basic materials online. However, the university experience is far more than just a collection of assembled teaching materials. There is the wider package of being part of an enlightened and enquiring community, engaging in thought-provoking discussion, the sharing of ideas, being challenged by new ones thrown into the mix by the tutor and, importantly, the accreditation. The evidence of the increased enrolment numbers at the Open University (see above) clearly points to this, without considering the added bonus of the increased social interaction

enjoyed on a campus-based programme. In addition, the US government's funding of OERs is specifically aimed at increasing the number of college graduates (see the introduction to this chapter).

Apart from digital humanities, information studies and computing departments in the UK and other English-speaking countries, the OERs released by DHOER will be relevant for students of any arts and humanities subject, both in the UK and abroad. In terms of platforms, file formats and standards, this lead us to look at the growing use of mobile, e-Book reader and tablet devices among the intended primary and secondary learner audiences for these resources and to release OERs in various EPUB formats.[21] An important issue when considering usability is that designers of teaching materials should be aware that they are producing materials that should be optimized for the lowest reasonably employable technology, rather than the highest, and should not assume that their users will necessarily have access to the same resources that they do. For example, the mobile phone is widely used for mobile education in Southern Africa and, there, considered to be the 'Southern African computer' (Foko, 2009, 2537), as well as in rural India and China.[22] In reality, it is not necessary to look that far, as there are many areas of the UK that lack adequate broadband connectivity and infrastructure. Here, also, even those from low socio-economic background, with no access to the internet, still have access to mobile phones: 'It is not technologies with inherent pedagogical qualities that triumph in distance education but technologies which are generally available to citizens' (Keegan, 2008, 4).

Putting together these resources will support teaching and the development of the teaching curricula more widely than the digital humanities community. On the whole, DHOER, moving beyond its original aims and purposes, has contributed considerably to the advancement of the OER idea and helped to start a movement to bring about the cultural change that the UKOER programme envisages. UCL adopted a very progressive Open Access policy for research outputs back in 2009 (www.ucl.ac.uk/media/library/OpenAccess), and this move to Open Access for research outputs has created a dynamic that, over time, can be expected to be extended to Open Educational Resources as the next logical and, hopefully, obvious step. ■

Conclusion

These two case studies raise further questions, as all projects do, and stimulate the need for further research. One major issue is the lack of context for an individual OER. The MIT OpenCourseWare delivers complete

modules pre-packaged, off the shelf and ready to go. However, the user of Jorum or HumBox is generally looking for a task, exercise or learning object to complement a class or lecture, something to aid the students' understanding. Firstly, then, the resource needs to be found: it must have adequate and relevant metadata attached, rich enough to fully describe the content, but, at the same time, the metadata needs to be sufficiently focused to prevent the user being overwhelmed with irrelevant results. The repositories use keyword searching, matched against the tags that the contributors add, and the results, like those from popular search engines, generally return far too many irrelevant hits that need to be sifted through. This is time consuming and laborious. Once found, the OER lacks context; where does it fit within a programme, module, teaching session or task-based learning exercise? This information also needs to be included at an object-based level: what is the assumed level of the students' competence? What is the learning context? Who is the intended audience?

If the teaching that uses the OER is credit-based, then there will be the need for assessment. This becomes a potential problem area, unless the OER package contains sound pedagogical material that is moving towards that assessment. This can, of course, be compensated for by the course tutor or otherwise incorporated into the evaluation process for that module.

Another consideration is resource discovery. Does the repository open itself to being indexed by Google and other web indexers? If not, then how would that impact on the reuse of the resource? Things that are known can be looked for and found, but, otherwise, and without indexing, the serendipity of the unexpected Google result (that we are sure we have all now come to welcome) would be lost. In the context of a library, and thanks to the DDC (the Dewey decimal classification system), when we find the resource we are looking for (here, a book), we look at the adjacent shelving for other relevant and pertinent items. OERs are assigned URIs generated by the repository to which they are deposited and, for the same to happen in their case, it would require a similar standard to be developed and applied. Although numeric and seemingly not human-readable, ISBN (International Standard Book Number) have blocks of numbers, such that denote language, publisher, format, etc., that are quite recognizable to the specialist. Some standard classification (yet to be worked-up) must be applied to OER; URIs would allow not only improved discovery, but also the potential for automated thematic grouping of related resources.

Further issues exist around applicability. Should the learning objects be discipline-specific or discipline-free and have the capacity to be modified,

depending on the use to which they are put? An example of a tool for creating discipline-free, re-usable learning objects might be the GLO Maker (Generative Learning Object Maker www.glomaker.org) or Xerte (www.nottingham.ac.uk/xerte).[23] If the OERs are discipline 'neutral' (such as, perhaps, for teaching digital literacy skills or citation and referencing), they would need to be made relevant and contextualized for each use, but would then have a far wider applicability. There is a trade-off here with time and work against the usability aspect.

Different cultures have different learning styles, attitudes to change, memory and aesthetic tastes (McLoughlin, 1999). This is another consideration and penetrates far more deeply than the need for translation when adapting learning materials for another global area. This is also equally true of areas where English has become the 'lingua franca', as the localization of content is still needed to compensate for cultural differences, particularly in the area of graphics, symbols, layout and other variants.

Once all this is taken care of, there still remains the often contentious question of ownership and the continuing relationship between the original author and the re-used and, perhaps, adapted OER. Under the terms of the licensing attached to the OERs (certainly, with most Creative Commons licences applied to the output of the case studies considered here),[24] attribution is one of the conditions, and so the original creator should always be acknowledged, with their name permanently attached to the resource. If the resource is taken, re-edited, updated and repurposed, then we would argue that the OER is being improved and having additional value added. It becomes a more useful resource. Moreover, this process is close to a 'rolling peer review', in that any errors or omissions in the original resource should be being picked up and corrected by those reusing and repurposing the OER. This model is nothing new and originates, arguably, from the Open Source movement, as, in some ways, does the Creative Commons itself. The difference here is that although the source should be acknowledged, there is no existing mechanism to prevent multiple variant versions being circulated at the same time. This is aggravated by some producers of OERs uploading copies of their resources on multiple sites (rather than a single source document for each resource and multiple links to that document, as do the two case studies), which will increase the likelihood of forked versions.

It would be helpful to include guidelines for repurposing and, perhaps, a guide to best practice that could be used as a reference and attached to each resource as well. There is considerable support for licensing and legal issues, arising from the creation and repurposing of OERs from the OER IPR Support

Project (www.web2rights.com/OERIPRSupport/) and the team at JISCLegal (www.jisclegal.ac.uk). At the time of writing, the best guide to best practice exists in the area of re-editing and repurposing of OERs (that these authors are aware of) and is the OER Infokit (https://openeducationalresources. pbworks.com).

Furthermore, although at the start of this chapter we noted the considerable funding that has gone into the creation of OERs and the efforts that now revolve around their sustainability, we do not yet have reliable metrics for the measurement of their use. We can gather download statistics simply enough, but just as we can record the download for journal articles and other academic resources, that is no indication of whether or not they have actually either been read or (in the case of OERs) used as a teaching resource.

The discussion around this whole area of the use and re-use (or not, as the case may be) of OERs does have one significant spin-off benefit and that is that it encourages us, as educators, to talk about and reflect on the teaching process. OERs are (or should be) pedagogically driven, and whether they are used or not, they have stimulated the discussion on, and research into, the learning process and our pedagogical aims. They have become the agent of change and objects to talk about, giving us the opportunity to reflect on what we do as educators.

We must develop a community around the creation, use and re-use of OERs and include them in the training of new educators: as a result, their use should become part of normal, everyday workflow and teaching preparation. Not only do we need to embed digital humanities' methodologies, thinking and the resources we take for granted in our teaching, but also make them available, openly and freely to all. Openness and collaboration are central to the digital humanities philosophy (as these authors understand it), and commitment to both these concepts should, we argue, be central to any digital humanities teaching programme. OERs will then become mainstream, rather than peripheral entities. The change in academic attitudes and practice will be slow, but we (in this fledgling community) are making a start now.

References

Andrade, A., Ehlers, U., Caine, A., Carneiro, R., Conole, G., Kairamo, A., Koskinen, T., Kretschmer, T., Moe-Pryce, N., Mundin, P., Nozes, J., Reinhardt, R., Richter, T., Silva, G., and Homberg, C. (2011) *Beyond OER: Shifting Focus to Open*

Educational Practices OPAL Report 2011, Open Educational Quality Initiative, http://duepublico.uni-duisburg-essen.de/servlets/DerivateServlet/Derivate-25907/OPALReport2011-Beyond-OER.pdf.

Anyangwe, E. (2011) *Exploring open access in higher education,* The Guardian Professional – Higher Education Network, www.guardian.co.uk/higher-education-network/blog/2011/oct/25/open-access-higher-education.

Centre for Excellence in Teaching and Learning (CETL) Open Educational Resources (2010) *Universities' Collaboration in eLearning (UCEL),* www.ucel.ac.uk/oer10.

Corbyn, Z. (2011) UCL Embraces Open Access with Institution-Wide Mandate, *Times Higher Education,* www.timeshighereducation.co.uk/story.asp?storycode=406832.

Dublin Core Metadata Initiative (2010) *DCMI Dublin Core Metadata Element Set, Version 1.1,* http://dublincore.org/documents/dces.

Foko, T. (2009) The Use of Mobile Technologies in Enhancing Learning in South Africa and the Challenges of Increasing Digital Divide. In Siemens, G. and Fulford, C. (eds), *Proceedings of World Conference on Educational Multimedia, Hypermedia and Telecommunications 2009,* 2535–40.

Hammond, L., Hermann, C., and Mahmody, S. (2009) Virtual Dutch: Kroniek Nederlandse Literatuur En Cultuur Op 't Web, *Internationale Vereniging van Neerlandici,* **4** (July), 6–9, www.ivnnl.com/library/2IVN_krant_juli_def_zwaar.pdf.

HEA/JISC OER Phase 2 (2011) *Open Educational Resources Programme – phase two,* www.jisc.ac.uk/oer.

HEA/JISC OER Phase 3 Call for Projects (2011) *HEA/JISC Grant Funding 10/11 – HEA/JISC Open Educational Resources (OER) Phase Three Programme: Embedding and Sustaining Change – Call for Projects,* www.jisc.ac.uk/media/documents/funding/2011/08/OERProgrammePhase3FINAL.pdf.

Higher Education Funding Council for England (HEFCE) (2003) *Realising a Vision for Higher Education,* www.hefce.ac.uk/pubs/hefce/2003/annrev.

JISC Phase 1 (2010) *Open Educational Resources Programme – phase one: JISC,* https://cms.jisc.ac.uk/whatwedo/programmes/elearning/oer.aspx.

Keegan, D. (2008) *How Successful Is Mobile Learning?,* www.ericsson.com/ericsson/corpinfo/programs/resource_documents/eclo_ericsson_keegan.pdf.

McAndrew, P., Santos, A., Lane, A., Godwin, S., Okada, A., Wilson, T., Connolly, T., Ferreira, G., Shum, B., Bretts, J. and Webb, R. (2009) *OpenLearn Research Report 2006–2008,* http://kn.open.ac.uk/public/getfile.cfm?documentfileid=15729.

McLoughlin, C. (1999) The Implications of the Research Literature on Learning Styles for the Design of Instructional Material, *Australian Journal of Educational Technology*, **15** (3), 222–41.

MIT OCW – Dashboard (2009) *MITOpenCourseWare Dashboard Report: January 2009*, http://ocw.mit.edu/about/site-statistics/monthly-reports/MITOCW_DB_ 2009_01.pdf.

MIT OCW – History (2011) *Our History, MIT OpenCourseWare*, http://ocw.mit.edu/about/our-history.

MIT OCW – Site Statistics (2011) *Site Statistics*, http://ocw.mit.edu/about/site-statistics.

National Committee of Inquiry into Higher Education (1997) *Report of the National Committee of Inquiry into Higher Education*, www.leeds.ac.uk/educol/ncihe.

OCW Consortium (2011) OCW Consortium – About the OCW Consortium, www.ocwconsortium.org/en/aboutus/abouttheocwc.

OKell, E., Ljubojevic, D. and MacMahon, C. (2010) Creating a Generative Learning Object: working in an ill-structured environment and teaching students to think. In Bodard, G. and Mahony, S. (eds), *Digital Research in the Study of Classical Antiquity*, Ashgate.

Open Educational Resources Infokit (2010) *Open Educational Resources*, https://openeducationalresources.pbworks.com.

Organisation for Economic Co-operation and Development: Centre for Educational Research and Innovation (2007) *Giving Knowledge for Free: the emergence of open educational resources*, Organisation for Economic Co-operation and Development Publications.

OTTER Team (2010) *CORRE: quality matters in OERS*, www2.le.ac.uk/departments/beyond-distance-research-alliance/projects/otter/ about-oers/Corre-web.pdf.

Parsons, D., Willis, D. and Holland, J. (2011) *Benefits to the Private Sector of Open Access to Higher Education and Scholarly Research: a research report to JISC from HOST policy research*, http://open-access.org.uk/wp-content/uploads/2011/10/OAIG_Benefits_ OA_PrivateSector.pdf.

Rossum, M. van (2004) Resources for a Virtual Department of Dutch: an evaluation of online study packs, *Dutch Crossing: journal of low countries studies*, **28** (1/2), 163–83.

Smith, M. and Casserly, C. (2006) The Promise of Open Educational Resources, *Change: The Magazine of Higher Learning*, **38** (5), 8–17.

Support Centre for Open Resources in Education (SCORE) Open Educational Resources (2011) *Universities' Collaboration in eLearning (UCEL)*, www.ucel.ac.uk/oer11/.

Terras, M. (2010) Disciplinary Focus and Interdisciplinary Vision. In Bodard, G. and Mahony, S. (eds), *Digital Research in the Study of Classical Antiquity*, Ashgate.

US Department of Labor – Employment and Training Administration (2011) *Notice of Availability of Funds and Solicitation for Grant Applications for Trade Adjustment Assistance Community College and Career Training Grants Program*, www.doleta.gov/grants/pdf/SGA-DFA-PY-10-03.pdf.

UCL Media Relations (2009) UCL to Implement Open Access Policy to All Research, *Press Releases*, www.ucl.ac.uk/media/library/OpenAccess.

University of London International Programmes Centre for Distance Education (2012) *Centre for Distance Education*, http://cdelondon.wordpress.com.

Worton, M. (2009) *Review of Modern Foreign Languages provision in higher education in England*, Higher Education Funding Council for England, **41**(2009), http://discovery.ucl.ac.uk/329251/2/hereview-worton.pdf.

Further reading

Attwood, R. (2009) Times Higher Education – get it out in the open, *Times Higher Education*, www.timeshighereducation.co.uk/story.asp?sectioncode=26&storycode=408300.

Curtis+Cartwright Consulting (2011) *Evaluation of HEFCE's Programme of Support for Strategically Important and Vulnerable Subjects*, Curtis+Cartwright Consulting Ltd.

Hermans, T. (2002) Up and Running: The Virtual Department of Dutch. *ALCS Newsletter*, **6** (1), 2–3.

Kraan, W. (2010) Meshing up a JISC e-Learning Project Timeline, or: it's linked data on the web, stupid, *Wilbert's Work Blog*, http://blogs.cetis.ac.uk/wilbert/2010/03/12/meshing-up-a-jisc-e-learning-project-timeline-or-its-linked-data-on-the-web-stupid.

Notes

1 Quoted after: Anjangwe, E. (ed.) (2011) Exploring Open Access in Higher Education, *Guardian Higher Education Network*, www.guardian.co.uk/higher-education-network/blog/2011/oct/25/open-access-higher-education.

2 In this context, we should mention the Open Educational Resources University (OERu) – a virtual collaboration of like-minded institutions committed to creating flexible pathways for OER learners to gain formal academic credit. It does not confer degrees, but works in partnership with accredited higher education institutions, who provide assessment on a fee-for-service basis, http://wikieducator.org/OER_university;

www.tonybates.ca/2011/10/05/introducing-the-oeru-and-some-questions.

3 For a full and detailed discussion on this, see Terras (2010).

4 For full details about this, see HE Academy Pilot Phase (2011) Open Educational Resources Programme – Pilot Phase, *The Higher Education Academy*, www.heacademy.ac.uk/resources/detail/oer/OER_pilot_phase.

5 The OMAC strand of UKOER2 (Open Materials for Accredited Courses) specifically tried to enable the release of high quality open educational resources, designed to support Academy accredited programmes or schemes of professional development that meet the UK Professional Standards Framework (UK PSF), www.jisc.ac.uk/whatwedo/programmes/elearning/oer2/OMAC.aspx. DHOER collaborated closely with one of the OMAC projects, www.ucl.ac.uk/calt/cpd4he. The OMAC strand is continued in UKOER, phase 3.

6 National Committee of Inquiry into Higher Education (UK) (1997) *Report Chapter*, Chapter 1, page 10: 'a society in which people in all walks of life recognise the need to continue in education and training throughout their working lives and who see learning as enhancing the quality of life throughout all its stages'.

7 iTunes U does so to an extent, but without the benefits of easy re-usability and repurposability. It is a rather one-directional form of OER, very useful and popular, indeed, but also stopping short of the full potential of OER.

8 See, for example, *OER Africa: building African education through openness*, www.oerafrica.org (an initiative of the Southern African Institute for Distance Education). Also, in 2010, a UNESCO Chair in Open Educational Resources was established at the Open University in the Netherlands, with the task to offer evidence and guidance to governments and other institutions for the exploration, introduction, implementation and exploitation of Open Educational Resources (OER) at all education levels and sectors and in a variety of societies, at the institutional, national and regional levels, in line with the United Nations Millennium Development Goals.

9 As opposed to large parts of central and Eastern Europe, where Dutch is a major subject in higher education.

10 One could argue that Frisian, spoken in the Dutch province of Friesland, would be even closer to English than Dutch.

11 Initially called *Virtual Department of Dutch*. From 2001–2004, the University of Hull also took part; Nottingham joined the initiative in 2007.

12 Although *Intute* closed in July 2011, the resource is still accessible, www.intute.ac.uk.

13 See, for example, HEFCE Annual Review (2002/2003) *Realising a Vision of Higher*

Education, www.hefce.ac.uk/pubs/hefce/2003/annrev/default.htm.

14 Lorna Campbell (JISC CETIS) on her blog on 26 February 2010.

15 Xtimelines: a website that allows you to create and explore timelines, www.xtimeline.com.

16 The DHOER resources are all released under the terms of the Creative Commons Attribution-NonCommercial-ShareAlike 3.0 Unported licence (CC BY-NC-SA 3.0, http://creativecommons.org/licenses/by-nc-sa/3.0).

17 Not least, the Open University's OpenLearn materials, which are presented via a heavily customized version of Moodle: http://openlearn.open.ac.uk.

18 An international standard for metadata to describe education-related resources.

19 The Dublin Core refers to a set of terms or elements defined by the Dublin Core Metadata Initiative and used to describe resources, in order to categorize them in various ways and, particularly, to aid their discovery, http://dublincore.org.

20 UCL, in June 2009, adopted a far-reaching and progressive Open Access policy, mandating the deposit of all research outputs into its institutional OA repository, *Discovery*. It did so as one of the first and most prestigious universities in the UK and, according to the Times Higher, only the 35th university in the world: *UCL Embraces Open Access with Institution-Wide Mandate*, www.timeshighereducation.co.uk/story.asp?storycode=406832.

21 With the announcement of its iBooks2/Author platform for the iPad, Apple, in January 2012, is likely to also become a major player in the open educational scene, www.apple.com/pr/library/2012/01/19Apple-Reinvents-Textbooks-with-iBooks-2-for-iPad.html.

22 For more discussion on the use of mobile learning, see the University of London Centre for Distance Education, http://cdelondon.wordpress.com.

23 For some general discussion on this, with early examples of development and use, see Okell, Ljubojevic and MacMahon (2010) Creating a Generative Learning Object. In Bodard and Mahony (eds).

24 Except the most radical and, therefore, seldom used CC-Zero licence, which puts material into the public domain without asking for attribution.

CHAPTER 9

Institutional models for digital humanities

Claire Warwick

Introduction

 In 2011, the first full academic department of digital humanities was established at King's College London (KCL) (www.kcl.ac.uk/artshums/depts/ddh/index. aspx), when what had been the Centre for Computing in the Humanities (CCH) changed its name and status to become part of the academic establishment. It is perhaps fitting that this should have taken place at KCL, since CCH was one of the longest established and most distinguished academic centres of digital humanities activity in the world. It is also, perhaps, significant that this should have happened in 2011; a year in which we saw an unprecedented growth in digital humanities internationally. The Modern Language Association (MLA) convention was awash with sessions on digital humanities;[1] several books, including this one, were commissioned and/or published;[2] new graduate programmes were announced;[3] new centres were opened, for example, a hugely ambitious project at Texas A&M (http://dh.tamu.edu/). The signs are that digital humanities is headed, increasingly, for the academic establishment, but how has it arrived at this point, and what can previous developments help us to learn for the future of the discipline? How is digital humanities organized? And what kind of institutional infrastructure will help it to thrive? It is these questions that this chapter will address.

Centernet (http://digitalhumanities.org/centernet/) – the international organization for digital humanities' centres – now lists over 200 members. It is impossible, therefore, to adequately characterize the detailed work patterns of all such centres and programmes, as McCarty and Kirschenbaum found possible, as recently as 2003 (McCarty and Kirschenbaum, 2003). The following chapter will, therefore, describe some common aspects of digital humanities

infrastructure, but generalizations are inevitable, and every centre or programme differs in its detailed, local context. Nevertheless, some themes can be discerned, in the way that digital humanities are organized in institutions.

Service or research

In 2004, I discussed the history of some pioneering centres, in what was then called humanities computing (Warwick, 2004), and, in 2007, we again discussed some issues of institutional context, as part of the research of the LAIRAH project (Warwick et al., 2007). On re-reading these publications, some of what we found seems impossibly archaic, and other elements show that academic culture is slower to change than we might hope. In 2004, humanities computing was still a minority area, still seen as unproven and lacking in acceptance by traditional humanities' disciplines. This was partly because digital humanities (as we now know it) had, in the case of most centres then in existence, emerged from a background of service computing, in other words, providing IT support to academics. In other cases, and arguably that of many of the newer digital humanities' centres, centres had emerged because different research projects had come together and formed a centre. In several places, such as CCH, or what is now The Brown University Center for Digital Scholarship (http://library.brown.edu/cds/pagestag/digital-humanities), both had happened. However, the sometimes contradictory demands of service and research form an important background to digital humanities centre development and, arguably, its acceptance as a serious academic discipline institutionally, and so it is important to discuss this dichotomy further.

Service computing

Many digital humanities' centres grew from a service function. The former Humanities Computing Unit at Oxford University, for example, was based in Computing Services (Burnard, n.d.); the Brown Women Writers project was heavily reliant on the work of Alan Renear, then based at Brown University's computing services, and this is true of several pioneering centres (www.wwp.brown.edu/about/history/). Many US based centres are either associated or physically based within the university library, for example, those at UVa (The University of Virginia) (www2.lib.virginia.edu/scholarslab/), Nebraska (http://cdrh.unl.edu/) and the University of Maryland (http://mith.umd.edu/).

This tended to come about because computing service personnel had the required expertise to support humanities scholars and might, as in the case of Lou Burnard at the HCU, be humanities graduates who had later moved into computing. They were able to comprehend the research that humanities scholars wished to do, but also had the expertise to help make it possible, in the days when computing hardware and applications were considerably less friendly to non-expert users, than they now are. Associations with libraries have come about partly because of the service-orientated culture of library services and because they were also relatively early in gaining expertise in the provision and support of digital resources for scholars of all kinds. There is a distinct advantage in such an association: librarians understand the demands and problems of data preservation, and it is often in the library or computing services (or both) that institutional repositories, supercomputing facilities and data archiving resources are based. Large, international, multi-agency projects, such as DARIAH (www.dariah.eu/), CLARIN (www.clarin.eu/) and Bamboo (www.projectbamboo.org/), have also adopted this service-based approach; seeking to identify researchers' needs, in terms of the provision of tools, services or data preservation.

Equality or subordination

This is admirable, in that it recognizes that humanities researchers may have specialist needs, in terms of computing support and facilities, and that these are vital if digital humanities research is to succeed. Nevertheless, there is a negative aspect to this, in terms of the cultures of prestige and non-monetary reward on which universities run. As Bethany Nowviskie has argued so convincingly (Nowviskie, 2011), roles in digital humanities, or, indeed, in any part of the university structure that are predicated on serving others or providing resources, tend to be regarded as less prestigious than academic ones. Libraries, archives and computing services are vital for universities to run adequately, yet they are often undervalued by the very academics that use them, because they do not generate research in themselves. They also cost the university money, whereas research, especially that funded by grants, generates it. I have argued elsewhere that, rightly or wrongly, academics do not gain credit simply for the provision or curation of data, but usually for activities that analyse or evaluate it (Warwick, 2011). Even academic editors suffer, because of this assumption. Digital humanities is still, in many ways, striving to define the difference between the provision of a digital resource and the definition of the scholarly activity that makes

such a resource possible (Madsen, 2010). Thus, if associated with a support unit, such as computing services or libraries, digital humanities may be assumed to be service, not research. Previous evidence suggests that this may make it vulnerable. The Humanities Computing Unit in Oxford was closed, partly because of this assumption: its research function was not sufficiently evident, and the cost of its support funding seemed too high to the university management (Warwick, 2004). The name of its successor – the Oxford e-Research Centre (www.oerc.ox.ac.uk/) – demonstrates the new hierarchy of esteem: humanities have been suppressed entirely, and service is now replaced by research. It, therefore, seems more generally applicable and more scholarly, as a result.

The other possible negative consequence of the service model is its unequal nature. It very clearly subordinates computing to humanities research. This may be appropriate if we assume that to create excellent research in the humanities, scholars may require technologies that are computationally relatively simple. This may have been so in the early days of digital humanities; concordancing software was, for example, ideal for the needs of most digital text research on corpora of what we now think of as relatively small sizes, yet support for such applications did not pose a challenge significant enough to require the skills of a researcher in computer science. However, this meant that it was, initially, relatively hard to interest computer scientists or engineers in digital humanities. Increasingly, however, this is not the case; the recent growth in interest in data mining of very large bodies of text, or in work in the area of authorship attribution, requires the full collaboration of computer scientists. Work at UCLDH in image-based computing and 3D scanning, discussed in Chapter 5 (www.ucl.ac.uk/museums/research/ecurator), or the 3D modelling of cultural artefacts undertaken at Ritsumeikan University in Japan (www.dh-jac.net/research.html) could not happen without advanced research in computer science and engineering. The UCL philosophy of digital humanities, therefore, stresses that new knowledge should be created in both computer science or engineering and the humanities part of the research and that challenges should be of interest to both. This requires equal partnership, rather than the subordination of computing to the humanities. If digital humanities continue to develop in such ways, it seems likely that a more equal approach will need to be adopted more widely in the future.

Centres or networks

It is perhaps not surprising that several of the more recently established centres for digital humanities have grown up around research, where several projects have joined together to achieve a sense of critical mass. This often seems to have been the case in European digital humanities: many digital humanities centres in continental Europe are focused on research of a particular kind, for example, linguistic or philological computing, such as the Kompetenzzentrum für elektronische Erschließungs- und Publikations-verfahren in den Geisteswissenschaften at the University of Trier, Germany (http://kompetenzzentrum.uni-trier.de/de); image computing, such as the Centre National pour la Numérisation de Sources Visuelles in France (www.cn2sv.cnrs.fr/); or new media at HUMlab in Umea, Sweden (www.humlab.umu.se/english/?languageId=1). These centres then provide a base for further projects and so the number of scholars associated with the centre grows, as has also been the case in Nebraska and the Scholars' Lab at UVa. As the name of the latter suggests, several such centres have physical labs attached, some of which are extremely lavish, as is the case at Umea (www.humlab.umu.se/english/about/). Such centres may follow the practice pioneered by the Institute of Advanced Technology in the Humanities (IATH) at UVa, where technical staff are based permanently in the Centre, and academic staff are Visiting Fellows on secondment from more conventional departments. This requires a considerable commitment of funding and, indeed, of space from the host university.

The following case study shows how one digital humanities centre has come into being, having started from a collection of different research projects.

..

CASE STUDY Creating the Center for Digital Research in the Humanities at the University of Nebraska–Lincoln

..

Richard Edwards, Professor of Economics, University of Nebraska–Lincoln, Kenneth M. Price, Hillegass University Professor of American Literature Co-director, Center for Digital Research in the Humanities, University of Nebraska–Lincoln and Katherine L. Walter, Co-director, Center for Digital Research in the Humanities, University of Nebraska–Lincoln.

The University of Nebraska-Lincoln (UNL) created the Center for Digital Research in the Humanities (CDRH, http://cdrh.unl.edu) to focus, provide support and enrich the quality of the growing array of digital humanities scholarship on

campus. CDRH first emerged as a natural outgrowth of the work of several individuals over nearly a decade, whose efforts resulted in this formally adopted and budgeted program. With CDRH officially designated a Center by the Board of Regents and the State in 2005, the University has committed to long-term sustenance of digital scholarship.

Goals and activities of the Center

CDRH – a partnership of the College of Arts & Sciences and the UNL libraries – serves to co-ordinate and rally a rapidly growing group of digital humanities scholars and their projects. It is led by co-directors Kenneth M. Price of the English Department and Katherine L. Walter of the University libraries.

From the beginning, CDRH's initiators saw digital scholarship as thriving best when pursued collaboratively. They consciously brought together scholars, publishers, librarians and archivists to work across dividing lines and to create interdisciplinary synergies. The Center fosters collaborative initiatives across disciplines and administrative units, by providing scholars with support, expertise, leadership and a congenial community of colleagues. Through scholarly activities and associations, such as the Nebraska Digital Workshop and centerNet, CDRH connects Nebraska's scholars with other digital humanities scholars around the country and the world. In short, the Center serves as a catalyst for digital humanities scholarship.

Currently, CDRH hosts over 50 scholarly projects, involving faculty, staff and students from humanities disciplines such as English, History, Modern Languages and Literature, Religion, Anthropology and Geography. Among other partners are the University of Nebraska Press and the Center for Great Plains Studies/Plains Humanities Alliance. The University's commitment includes funds and other support directed to CDRH itself, and departmental commitments include targeted new hires intended specifically to support digital scholarship at UNL.

Some examples of digital projects at Nebraska

Among digital humanities projects underway are digital, thematic research collections, including the *Walt Whitman Archive*, the *Willa Cather Archive* and *Omaha Indian Artifacts and Images*; tool development projects, such as *Abbot* – a schema harvesting tool that takes arbitrary XML-encoded text collections and transforms them in such a way as to make them inter-operable with one another; and geo-spatially oriented projects, such as *The Making of Modern America*, which explores the dynamic social changes that came between 1850

and 1900, with the development of new transportation and communication systems.

Establishing the Center

Despite the growing extent and (equally apparent) growing success of digital humanities scholars at Nebraska, it was by no means inevitable that the University would perceive, understand and act to take full advantage of the opportunities it now faced. Thus, the University's major commitment, as reflected in the establishment of CDRH and the hiring of several digital scholars, remains to be explained. A few key features or lessons can be identified.

First, neither the initial opportunities nor any subsequent successes would have existed, without the University having ambitious digital scholars themselves. This point may seem obvious (because it is), but it is central, nonetheless. And here there was a certain amount of serendipity. The late Professor Sue Rosowski, overseeing the print based Cather Scholarly Editions, was determined to create a *Cather Archive*. Professor Katherine Walter, who had led the Electronic Text Center since late 1998, was eager to put Nebraska among leading universities making use of new digital technologies. Professor Ken Price, invited to join the Nebraska faculty in 2000, primarily to contribute to the already substantial programme in 19th-century literature, was committed to developing the *Whitman Archive*.

These, and other scholars, were crucial to the success of the larger enterprise, both because they do digital scholarship and, more importantly, because the quality of their work demanded (and got) attention – from outside funding agencies, the wider scholarly community and even university administrators. The ability to 'sell' this new initiative within the University was directly dependent upon the accomplishments of the faculty participants.

These initial faculty members contributed further key ingredients. They had a vision and a commitment to a broader initiative in digital humanities scholarship – a vision that has now been realized in the formal establishment of CDRH and the allocation of several faculty hires to this area. Second, they provided skilful and consistent leadership in proposing and pressing for the University's commitment. And third, by their very presence, they provided the most powerful enticement to other scholars, whom Nebraska was attempting to recruit. In all of these ways, the digital humanities initiative at Nebraska would simply not have been possible, without the serendipitous coming together of a group of talented faculty.

Second, the University was (and is) seeking to invest in scholarly and scientific

areas, in which it has the opportunity to build programmes of true and recognized excellence. Nebraska is a mid-sized public research university, with significant teaching and service responsibilities; while it seeks to develop high quality programmes, it cannot realistically expect to attain national significance everywhere. Over time, the University decided upon a strategy of investing specially designated funds in a few carefully chosen areas, where the expectation to have the best programme, or a programme among the three or five best in the country, is realistic.

Digital scholarship in the humanities was designated as one of the University's elite 'Programmes of Excellence'. This implied that certain new monies (now about $400,000 per year) would become available. Of equal significance, however, this designation identified digital humanities scholarship within the University community as deserving of special attention and support; thus, administrators in charge of information technology, the research office, space allocation and other valuable campus facilities and services, were encouraged to undertake special efforts within their own operations and budgets to support this initiative. The University libraries, in particular, reallocated space to house CDRH.

Perhaps most importantly, the participating deans of Arts and Sciences and University libraries agreed to designate certain vacant faculty lines, or assign the time of current faculty members, to the work of digital scholarship and, in some cases, specifically to CDRH. Thus, the newly established Angle Chair in the Humanities was designated for digital scholarship, which attracted the distinguished scholar Dr William G. Thomas III from the Virginia Center for Digital History to Nebraska. Other outstanding new assistant professors were also hired. Third, the role of the external funding agencies has been critical. Although funding in the humanities is tiny by comparison with that in the sciences, the ability of universities – and, certainly, Nebraska, in particular – to develop innovative and daring programmes aspiring to excellence, depends heavily on support from external agencies.

Producing high-quality digital scholarship is not inexpensive. Considering the interdisciplinary teams and the technical infrastructure required to produce digital scholarship, funding needs are likely to out-run traditional university sources of support for humanities research. And while funding for start-up costs is important, obtaining external funding to sustain the initiative is crucial. Fortunately, Nebraska scholars have found that with vision, high-quality scholarship, clear articulation and persistence, such external support can be forthcoming.

Digital humanities scholarship offers excellent potential for attracting

significant support from private donors as well. Currently, the CDRH has a challenge grant from the National Endowment for the Humanities (NEH) to build a permanent endowment to support its ongoing work.

Future developments

By designating digital scholarship as a Programme of Excellence, the University sent a powerful, but implicit, message to the Faculty that a scholar can, and should, be tenured, promoted and receive merit raises, based on a file heavily weighted with electronic scholarship. Though initially the system of promotion and merit review was largely untested, the local results are, thus far, promising. The CDRH has developed guidelines for peer review of digital scholarship that have been adopted by the University.

CDRH has developed sufficiently so that it is no longer reliant solely on one or two faculty members. Excellence breeds further excellence, and as the programme continues to develop and achieve success, it has attracted increasing support, attention and, yes, more scholars. Now, the departure of any one key professor would not be fatal. ∎

Networks

The other institutional model is that of the research network. Some of these may be based around a research project on a specific issue and distributed among different universities, for example, the MONK (www.monkproject.org/) and INKE (www.inke.ca) projects. Others may be national networks, such as Centre Nationale pour la Numérisation des Sources Visuelles, discussed above. Yet, it is also possible to use this kind of model as a framework for institutional digital humanities activity, especially if the centre is relatively newly established, but aggregates research that has been ongoing for some time. When the idea for UCLDH was proposed, we held a meeting to gauge the level of interest, and around 100 people from every faculty in the university came. Many of them were already carrying out exciting digital research. We, therefore, felt that it was not appropriate for us to insist that such expert, established researchers should come to be part of a new centre. Thus, we conceived of UCLDH as a relatively small, central hub of a very large network, which encompasses both UCL itself and organizations beyond it, in the cultural heritage sector, including many of the museums, galleries, libraries and archives for which London is so famous.

Much of the initial activity of the Centre has been aimed at allowing researchers and practitioners, who would not otherwise have met, to discuss areas of mutual interest. In this context, it is especially important that UCLDH is based within the UCL Department of Information Studies (the iSchool), since this department has a long history of collaboration with information professionals and computer scientists, thus, it is an ideal setting for a digital humanities centre. Other UK digital humanities activity has also been organized on this network basis, for example, the University of Cambridge (www.crassh.cam.ac.uk/page/276/digital-humanities.htm) and the Australian National University (http://dhh.anu.edu.au/) both have relatively new digital humanities initiatives: both are attempting to find out what kind of research is already taking place and to organize activities such as talks, symposia and seminars that will bring distributed researchers together. It seems likely, therefore, that this may be a model that will be adopted in second phase digital humanities development, where the function of a centre is not so much to encourage researchers to undertake work in digital humanities, but to help facilitate new ideas, connections and the kinds of collaboration that are essential for the proper functioning of digital humanities research.

In some countries, digital humanities is only now beginning to develop as an organized activity, although individual researchers may have been working for some time on projects that might be described as digital humanities. The network model may prove more appropriate in such circumstances, since the major challenge is creating links between researchers and raising awareness of what is already being done, as well as fostering new activity. In the following case study, Isabel Galina discusses these issues, in relation to establishing digital humanities in Mexico.

..
CASE STUDY Digital humanities in Mexico
..

Isabel Galina Russell, Coordinación Red de Acervos Digitales, Instituto de Investigaciones Bibliográficas, UNAM
Although digital humanities is a well established field, with journals, scholarly conferences (Borgman, 2009), academic centres (Svensson, 2010; van den Huevel et al., 2010) and postgraduate courses (Clement, 2009), it could be argued that the full internationalization of the field has not been fully achieved. Countries such as the United States, the United Kingdom, Canada and, to some extent, Germany, France, Italy and Australia have dominated scholarly digital

humanities activity, with little or no participation from other regions of the world, such as Asia, Africa and Latin America. However, this does not necessarily mean that academics from these parts of the world are not involved in projects and activities that could be considered digital humanities related (Muller et al., 2010). These scholars have, instead, worked independently and without knowledge of digital humanities as a field of enquiry in itself. It is important that, in order to become a truly international field, the consolidated digital humanities community should find and promote the incorporation of scholars from around the world (Terras, 2010). At the National Autonomous University of Mexico (Universidad Nacional Autónoma de México – UNAM), we set out to investigate what types of digital humanities projects existed and what particular characteristics and challenges they presented for developers (Galina and Priani, 2011), in order to promote collaboration on both a national and international level.

A collection of digitized 17th century manuscripts from Mexico marked up in TEI on astrology and astronomy, an electronic corpus of a history of Mexican Spanish from the 16th to 19th century, the visualization of pre-Hispanic archeological sites in 3-D and a digitized archive of historical documents of the political trials of ex-president Francisco Madero from 1910 are just a few examples of the digital humanities projects that we have found in Mexico. These initiatives, however, were not easy to uncover, as there is no register or documentation of this information. Most of them were already known to us or were discovered by word of mouth. There are probably many other initiatives hidden on the web.

Although digital humanities was a relatively unknown field among the projects surveyed, we did find that they shared many of the characteristics of digital humanities projects in other countries. For example, most of them were small, personal initiatives that were not incorporated into a wider general framework of research and teaching. Although funding appeared to be readily available, this was not supported by a solid infrastructure for digital humanities projects, especially in terms of academic recognition, long-term sustainability and preservation. As one researcher said, 'university authorities have a notion that this is vaguely important', but, unfortunately, this does not go beyond small project funding (Galina and Priani, 2011). There is little registered digital humanities activity from Mexico in journals and a few attendees at digital humanities conferences. We found no centre, group, conference or meeting that Mexican digital humanities practitioners could gravitate towards. However, there is a core group of enthusiastic and committed digital humanities scholars, and a significant interest from the university community was shown when we

organized a few introductory events. Because of this we, decided to set up a network for digital humanities (Red de Humanidades Digitales, www.rad.unam.mx/ index.php/index), to address the numerous issues encountered and to promote digital humanities in Mexico and the wider Latin American region. We identified three key areas on which to focus our efforts:

- lobbying, promotion and dissemination of digital humanities
- training
- guidelines and aids for the evaluation of digital humanities projects.

Lobbying, promotion and dissemination of digital humanities

A key aspect is communicating the existence of digital humanities as a field and the research that has been done so far, by fellow digital humanities scholars around the world: the history of digital humanities activity is a valuable resource on which to base our work. As in other parts of the world, many humanities scholars are wary of accepting digital humanities as a valid field of enquiry. Technology is often promoted or used for its own sake, regardless of whether it addresses a particular field's needs. It is therefore important that digital humanities be presented within a valid epistemological framework and that we refer to the large body of previous work. It is important to base our dissemination and lobbying on the experience of other countries. However, it is also crucial that we research and contribute to digital humanities within our own particular academic, cultural, political and economic context. Research and documentation, particularly in Spanish, is, therefore, one of the key issues.

Training

As with other parts of the world, the formation of digital humanities scholars is an acute problem. Digital humanities project managers have to train project participants, as their research requires a particular combination of knowledge and skills not normally found in undergraduate and postgraduate curricula. An additional problem is that most participants are students, who remain part of projects for short periods, requiring constant training of new members. RedHD is actively looking for ways in which to incorporate digital humanities training into undergraduate and postgraduate humanities programmes, as well as offering seminars, workshops and other training events in general. In the long run, we would be interested in establishing a postgraduate degree in digital humanities.

Guidelines for digital humanities projects

Many Mexican digital humanities scholars found that evaluation and tenure committees tended to view their research simply as websites or databases and did not recognize the specialization, innovation and research that go into producing these types of materials. Nevertheless, the unfamiliarity of digital humanities means that the evaluators do not have access to the tools required for this evaluation. The RedHD will focus much of its attention on producing and enabling better evaluation systems for these types of research and teaching.

In our case study of digital humanities in Mexico, we found a small, but enthusiastic, group of scholars who immediately identified with, and were pleased to discover, the existence of digital humanities. Additionally, the subject has generated a great deal of interest (despite some skepticism and resistance) from the university community. Overall, however, there is fertile ground for digital humanities activity, and we aim to continue to work on a national level and, eventually, towards forming a digital humanities Latin American network. However, building a community requires more than good intentions, and we are working on strategies to strengthen and promote its growth. It is very important to articulate collaboration with the digital humanities international community, at the same time that we build on our own particular academic, political, cultural and economic reality. ■

Teams or individuals

Some of the researchers who are most often attracted to working in digital humanities are those in an early phase of their research career. This leads to questions of how research careers are supported and how digital scholarship is recognized and rewarded in an academic setting. In the Log Analysis of Internet Resources in the Arts and Humanities (LAIRAH) report (Warwick et al., 2007), we found that this was a significant concern in 2005–6 and remains so still. One of the factors which dictates whether digital humanities will thrive in a university is the question of whether those who work in the field are recognized for what they do (Moulin et al., 2011). This can be problematic, since, the type of publications that digital humanities scholars produce is not typical of those in traditional humanities fields: we tend to publish multi-authored articles and conference papers, rather than single-authored monographs (Spiro, 2009). This partially reflects the speed with which technology moves: a single-authored monograph may take several years to write, and, by the time it is published, there is a risk that the techniques and tools it discusses may be outmoded. Conferences are also

very important in digital humanities, because they allow us to find out as quickly as possible about new developments in the field. Thus, for a digital humanities scholar, it is vital to present at important conferences. Yet, in traditional humanities, where the single-authored monograph remains the gold standard, multiple-authored articles and conference papers are considered amongst the least prestigious forms of publication. Thus, it may be difficult for a digital humanities researcher to make a good case for tenure and promotion, when their CV and publication lists may look more like that of a scientist, than a humanities scholar (Nowviskie, 2011). As Sinclair (2011) points out, there is too often an assumption that an article with five authors is only a fifth as valuable as one with a single author. This is fundamentally to misunderstand the nature of interdisciplinary research.

It is also important to recognize the team-based nature of the research that is carried out in digital humanities (Siemens, 2009). Thus, the needs of digital humanities academics are different from colleagues, who may be in the same department. They require grant funding, the ability to meet and discuss projects with other potential team members and access to computational equipment and infrastructure. It may take some time, as a result, to construct new projects and agree on team roles. A single scholar simply needs time alone in a library, archive or at their desk to create and write up research. These different demands need to be understood by senior management, especially if digital humanities research is carried out in the context of a traditional humanities department, as is often the case, especially in North America.

The assumption that all humanities scholars must produce at least one monograph has also been seen to be a deterrent to early career scholars being involved in digital projects. For many years, it was common to hear stories of younger academics being discouraged from taking on digital projects, because it was a distraction from writing a book that would allow them to become tenured or be promoted (Fitzpatrick, 2011). Thus, we need not only to recognize the value of multiple authorship, but the scholarly value of digital resources themselves. This has long been a problem. However, there is a hopeful sign, in this regard. In the UK, the Research Excellence Framework will, for the first time, allow scholars to enter digital projects, not simply books or articles written about them, as one of their four outputs in all disciplines (until recently, this has been limited to more specialist technical disciplines) (Higher Education Funding Council for England, 2011). This should mean that there is no longer, at least in the UK, an argument that those early in their career should simply produce printed out-put (Moulin et al., 2011). This is very important for the future of digital

humanities as a discipline. When digital humanities is seen as prestigious, and scholars are valued, praised and promoted for such research, their colleagues are likely to join in; thus, the field will grow. If an institution regards digital humanities as a strange, marginal activity, it is unlikely that more scholars will want to take part in this kind of research; so, it is likely to remain peripheral (Warwick et al., 2008).

It is also wrong to assume that issues of prestige and career progression only affect academics in digital humanities faculty positions. There is a growing awareness of the value of what Bethany Nowviskie calls #alt-ac digital humanities scholars (Alternative Academic, http://mediacommons. futureofthebook.org/alt-ac/). These are scholars who are likely to be educated to higher degree level in a humanities discipline or in digital humanities and may also have a very high level of technical experience in digital humanities. They may manage digital humanities projects or centres, work in support services, such as libraries, or act as technical officers on funded digital humanities projects – writing code or building applications. Such people are vital for digital humanities as a discipline, yet they are often under-estimated and regarded, erroneously, as the person who mends the printer or puts things on the website. Academics may not give them publication or other types of credit for the work that they do, they may remain unappreciated by the management of departments and universities in which they work. Yet, is it vital that career progression should be taken seriously for those in these roles: they have very high levels of expertise, knowledge of the field and institutional practice that is invaluable. They often help to facilitate communication between technical specialists and humanities scholars and so are vital to the success of many digital humanities projects (Moulin et al., 2011). Yet, if their work is not appreciated, they may become discouraged and leave. This represents a huge cost to digital humanities projects in terms of expertise, if new members of the team have to be trained, and valuable knowledge is lost every few years.

Teaching or training

Another important decision that faces digital humanities centres is whether to undertake any teaching. Many digital humanities centres host training courses in the use of particular types of software or specialist tools, and this reflects a background in support services, such as libraries and computing services. However, there are still relatively few Masters programmes and no

full undergraduate programmes in digital humanities globally. At the time of writing, it is possible for undergraduates to take options in digital humanities at KCL and to study for a joint honours degree at the University of Glasgow in the UK, and, as of 2011, there were over a hundred discrete courses that were relevant to digital humanities, in numerous different academic disciplines and academic degree programmes (Spiro, 2011). Masters programmes already exist at the University of Alberta and Kings College London and have recently been launched at UCL, Loyola University (USA), Trinity College Dublin, the National University of Ireland at Maynooth and Ritsumeikan University in Japan. While there are over 200 centres listed on the Centernet website, it seems strange that so few of them offer degree programmes. John Unsworth (Unsworth, 2010) points out that many Masters' programmes in Information Studies offer options that are relevant to digital humanities, as we do at the UCL Department of Information Studies. Yet, there are very few full digital humanities programmes.

This may partly be as a result of the origin of some centres in support services: many of those who were full-time employees came from a support or development background and did not have experience of academic teaching or course development and, thus, might have been unlikely to develop teaching programmes. Or it might be that centres that begin as a collection of research projects are thought of by university management as purely research centres, and, thus, teaching is not regarded as important for their intellectual mission or income stream. Academics who take fellowships at digital humanities centres on a relatively short-term basis may already teach their own subject, such as History, English, etc., and have neither the time nor expertise to teach core digital humanities courses.

This is doubly unfortunate, in terms of the way that digital humanities is perceived by colleagues in other humanities disciplines, and there is a risk that it may be regarded as less prestigious as a result. Although many academics say publicly that they prefer research to teaching, and despite the tendency to promote individuals on the basis of research excellence, nevertheless, most professional academics regard teaching as important and key to the function of the university, as, indeed, does university management. Without a core teaching programme, digital humanities will always struggle to claim its status as a discipline. It is a frustratingly circular problem, but the lack of teaching programmes may be partially due to the fact that it has taken some time for digital humanities to be accepted as a legitimate discipline, as Terras argues (Terras, 2006). It has been hard to break out of this negative loop

until recently. This is why it is so important for our field that Centre for Computing in the Humanities (CCH) at KCL has become the Department of Digital Humanities (DDH): a centre has become a department. CCH has had a teaching programme for many years, and although it is, of course, a world-leading research centre, this factor will surely have been vital in its acceptance as a full department. If digital humanities academics teach, as well as carrying out research or development work, it means that they appear to be more 'normal', thus colleagues in more traditional fields should find it easier to comprehend and accept what we do in digital humanities. Where optional courses are shared between digital humanities and other humanities subjects or with Information Studies, other academics begin to see benefits for their students, in terms of additional options or the provision of transferable technical skills.

Teaching is important to digital humanities in many ways: it helps to train the next generation of digital humanities scholars and practitioners, of course, but it also gives the subject a sense of stability in institutional terms. Research funding is unreliable, especially in the arts and humanities, and, thus, it can be difficult to plan for the future of a centre. The centre either has something of an air of impermanence about it or permanent staff become a cost to the institution. Teaching programmes bring in income, in terms of student fees, and thus help to defray some of those costs. This makes it easier for digital humanities to demonstrate its financial value to an institution and makes centres less vulnerable.

Strategic mission

The question of whether digital humanities are perceived to be important or peripheral to universities, or, indeed, other cultural heritage organizations, is extremely important. As we have seen, in some universities, it has been difficult for digital humanities to establish itself as a core activity, partly because of its origins in service departments, or in research projects, whose techniques other academics struggled to understand. This may now have begun to change, since the levels of digital awareness, literacy and, indeed, immersion is now far higher than it was in the early days of digital humanities. Nevertheless, for digital humanities to thrive, it must be perceived to be central to the mission and activities of a university and not seen as a peripheral activity.

At Nebraska, the digital humanities initiative emerged from a consultation about the strengths of the university and ways it could

distinguish itself from similar institutions. At UCL, digital humanities were funded for its first two years by the Provost's Strategic Development fund – money which is distributed, as a result of decisions made by the Provost (President) himself. This reassures us that we have support at the highest level for our activities. The interdisciplinary nature of digital humanities also fits well with UCL's overall research strategy. At the time that UCLDH was being proposed, the university had just launched the Grand Challenges: five overarching themes, under which interdisciplinary research in the university is brought together to address important global problems (www.ucl.ac.uk/grand-challenges). Digital humanities is most relevant to Intercultural Interactions and Human Wellbeing, but its team-based and collaborative outlook means that it fits very well with the Grand Challenge approach. We are also fortunate in that the Deans of both Arts and Humanities and Engineering Science are enthusiastic supporters of the project, perhaps because one is the principal investigator of a digital humanities project and the other has a Master's degree in art, as well as a PhD in engineering. Thus, we are aware that our activities are supported and approved of by senior management, and this signal is also sent to colleagues in other disciplines. As I have argued, prestige and being seen to be valued for what we do is important to digital humanities' growth and such explicit signals are, therefore, very important.

As well as being Co-Director of UCLDH, I am also the Vice Dean (Associate Dean): Research for the Faculty of Arts and Humanities. This means that I am aware of current thinking and future strategy in research matters, both at UCL and beyond, and digital humanities benefits from this knowledge and from my links across the university.

Communication

Communication is another important aspect of digital humanities, and, not surprisingly, we have adopted web 2.0 applications, in particular, blogs and Twitter (@UCLDH), as a way to engage with our professional community. This may seem to be a somewhat trivial and ephemeral activity for scholars to be engaged in, but it has been adopted with enthusiasm in digital humanities as a serious channel of communication, as Claire Ross discusses in Chapter 2. There are also crowdsourcing resources specific to digital humanities: Digital Humanities Now (http://digitalhumanitiesnow.org/) is a service that aggregates tweets on trending digital humanities topics; and DH Questions and Answers (http://digitalhumanities.org/answers/) provides a

crowdsourced question-and-answer resource for numerous topics of interest in digital humanities, two of which I have cited in this article.

Twitter is important not only for individuals in digital humanities, however. Many digital humanities centres have a hashtag and numerous followers. My own twitter account is, for example, followed by these centres: @UCLDH, @Scholarslab (The Scholars Lab, UVa), @Westcenter (Bill Lane Center for the American West at Stanford University, http://west.stanford. edu/), @HaCCS (The Humanities and Critical Code Lab, http://haccslab.com), @CDRH_UNL (Center for Digital Research in the Humanities, at the University of Nebraska-Lincoln), @CUNYNewMediaLab (CUNY New Media Lab, www.newmedialab.cuny.edu/), @IATH_Virginia (Institute for Advanced Technologies in the Humanities, University of Virginia, www.iath.virginia. edu/), @chi_initiative (Michigan State University Cultural Heritage Informatics Initiative, http://chi.matrix.msu.edu/), @digitalWUSTL (digital collections at WUSTL, http://digital.wustl.edu/collections/), @knagasaki (International Institute for Digital Humanities, General Incorporated Foundation, Tokyo, Japan, www.dhii.jp/aboutus-e.html), @MATRIX_MSU (MATRIX: The Center for Humane Arts, Letters, and Social Sciences Online, www2.matrix.msu.edu/) and @KingsCeRch (Centre for e-Research KCL, www.kcl.ac.uk/innovation/groups/cerch/index.aspx).

This is not an exhaustive list, and, of course, other centres use Twitter, but do not follow me.[4] Nevertheless, it shows how many centres have understood the value of Twitter to disseminate corporate information for digital humanities. This kind of information is important, as an anecdote from UCLDH's own experience shows. Melissa Terras, Co-Director of UCLDH, created a set of posters designed to intrigue the viewer and encourage them to contact us. She mounted these on her blog (http://melissaterras.blogspot.com/ 2010/04/and-final-taster.html) and on UCLDH's Flickr account (www.flickr. com/photos/ucldh/sets/ 72157623996338026/) and tweeted about them. Brett Bobley, head of the NEH's Office for Digital Humanities (www.neh.gov/odh), saw them on the blog and was so impressed, he asked her to share the link to Flickr. UCLDH posters now hang in the ODH and advertise the discipline to US scholars and funders. They were also printed out by colleagues at the University of Victoria (Canada) and the University of Glasgow. As a result, we hope that more people in North America will be aware of what we do, than could possibly have happened if we had conducted a traditional marketing campaign, perhaps by sending out printed posters to universities. All this came about through the use of Twitter and shows how it can provide global awareness of the activities of individual digital humanities centres.

This is no accident on the part of UCLDH. As a result of Melissa's advice, in particular, we have paid careful attention to our digital identity; in other words, what our web pages, blog and twitter presence convey to others. Our logo, web pages and blog have been designed by a very talented PhD student – Rudolf Amman (@rkamman) – so that they create as positive an impression of us as possible. This may be dismissed as superficial marketing puff, but we feel that it is vital. If we study all things digital and social media, then our use of them must be exemplary and convey an accurate image of our work and beliefs about our field. It is also important, as I have argued above, that digital humanities are seen as central to the academic mission of a university and not just a bunch of geeks who do strange things with computers. Communication is crucial in this: the higher the profile of digital humanities activities, research and teaching within a university, the more it is likely to thrive. We must show why what we are doing is important and make our work understandable to others if we want to be valued by senior management, who, after all, control access to funding. It is also important that we communicate well with the world outside our institutions: in this context, the recent publicity that digital humanities has garnered in the *New York Times* and *Washington Post*, as well as the worldwide media attention afforded to the Google NGrams research, is extremely welcome. This does not, however, happen by accident, and researchers have to be willing to talk about their work to the press and to non-academic audiences if we want this level of global exposure: hence, the importance of effective communication as part of the digital humanities institutional presence.

Conclusion

As a recent blog entry in the *Chronicle of Higher Education* suggests, digital humanities is increasingly regarded as a vital element in graduate programmes in North America (Pannapacker, 2011), and universities across the world will, doubtless, be thinking about how, and whether, it may be incorporated into their activities. It is clear, therefore, that digital humanities is a growing, thriving discipline, very different from the one that we discussed even five years ago. Doing digital humanities now no longer means you exist at the fringes of several disciplines (Computer Science, Information Studies, and traditional humanities subjects, for example), but are increasingly seen as at the core of a new, exciting movement in research and teaching: one that may even solve the much-vaunted 'crisis of the humanities'. Digital humanities faculty and practitioners no longer feel

embattled and excluded from the mainstream, institutionally.

Nevertheless, we can still learn from the past of digital humanities, as a way to ensure our future. We need to be aware of the tensions between service, research and teaching. It is, of course, for each institution to make decisions about where digital humanities might sit in its infrastructure. However, we need to be aware that without a strong teaching presence, or, ideally, a full Masters programme, it may be difficult for digital humanities to establish itself fully as a 'proper' academic discipline. Teaching helps establish our credibility with academic colleagues in other disciplines, but also provides a firmer financial basis for the future than research income. Service and support are vital, but can be regarded as a financial drain by institutions and lead to some old-fashioned assumptions that technology is secondary to serious scholarship. We need, rather, to involve researchers from the digital side of digital humanities in projects that create real intellectual excitement for them, which may mean more of an emphasis on research as core to digital humanities, as opposed to serving the needs of others in a university.

In research terms, the question of credibility of digital resource building is still somewhat at issue: we still need to justify the fact that team-based, multi-authored research is as important as the monograph, so that digital humanities scholars may progress in their careers. This remains a problem for early career researchers. However, there are positive signs, as a result of MLA recommendations and the new rules for the UK REF. Thus, it is to be hoped that, in the future, it will be easier for those early in their careers to advance on the basis of digital resource creation and not simply scholarship produced as a result of it. If we are to do this, however, further advocacy on behalf of digital humanities will be needed, and this is why it is important for us to think about how we communicate both internally and with the wider world about the value of our subject.

Bibliography

Borgman, C. (2009) The Digital Future is Now: a call to action for the humanities, *Digital Humanities Quarterly*, **3** (4).

Burnard, L. (n.d.) *Humanities Computing in Oxford: a tetrospective*, http://users.ox.ac.uk/~lou/wip/hcu-obit.txt.

Clement, T. (2009) *Digital Humanities Inflected Undergraduate Programs*, *Tanyaclement.org*, http://Tanyaclement.org/2009/11/04/digital-humanities-inflected-undergraduate-programs-2/.

Clement, T., Jannidis, F. and McCarty, W. (2010) *Digital Literacy for the Dumbest Generation, Digital Humanities 2010, Kings College London, July 7–10*, 31–9, http://dh2010.cch.kcl.ac.uk/academic-programme/abstracts/papers/html/ab-815.html.

Fitzpatrick, K. (2011) Do 'the Risky Thing' in Digital Humanities, *The Chronicle of Higher Education*,
http://chronicle.com/article/Do-the-Risky-Thing-in/129132/.

Galina, I. and Priani, E. (2011) *Is There Anybody out There? Discovering New DH Practitioners in Other Countries, Digital Humanities 2011, University of Stanford, USA, June 19–22*, 135–7,
http://dh2011abstracts.stanford.edu/xtf/view?docId=tei/ab-124.xml;query=;
brand=default.

Higher Education Funding Council for England (2011) *Assessment Framework and Guidance on Submissions*, www.ref.ac.uk/pubs/2011-02/.

Madsen, C. (2010) *Communities, Innovation, and Critical Mass: understanding the impact of digitization on scholarship in the humanities through the case of Tibetan and Himalayan Studies*, http://ora.ox.ac.uk/objects/uuid%3A928053ea-e8d9-44ff-9c9a-aaae1f6dc695/datastreams/THESIS01.

McCarty, W. and Kirschenbaum, M. (2003) Institutional Models for Humanities Computing, *Literary and Linguistic Computing*, **18** (4), 465–89.

Moulin, C. Nyhan, J., Ciula, A., Kelleher, M., Mittler, E., Tajic, M., Agren, M., Bozzi, A. and Kuutma, K. (2011) *European Science Foundation Science Policy Briefing 43: research infrastructures in the digital humanities*,
http://www.esf.org/publications/science-policy-briefings.html.

Muller, C., Hachimura, K., Hara, S., Ogiso, T., Aida, M., Yasuoka, K., Okama, R., Shimoda, M., Tabata, T., Nagasaki, K. (2010) *The Origins and Current State of Digitization of Humanities in Japan, Digital Humanities 2010, Kings College London, July 7–10*, http://dh2010.cch.kcl.ac.uk/academic-programme/abstracts/papers/html/ab-630.html.

Nowviskie, B. (2011) *Where Credit is Due*, http://nowviskie.org/2011/where-credit-is-due.

Pannapacker, W. (2011) *'Big Tent Digital Humanities', a View From the Edge, Part 1*,
http://chronicle.com/article/Big-Tent-Digital-Humanities/128434/.

Siemens, L. (2009) 'It's a Team if you use "Reply All"': an exploration of research teams in digital humanities environments, *Literary and Linguistic Computing*, **24** (2), 225–33.

Sinclair, S. (2011) *Assessing Coauthored Contributions in DH*,
http://digitalhumanities.org/answers/topic/assessing-coauthored-contributions-in-dh.

Spiro, L. (2009) *Collaborative Authorship in the Humanities*, http://digitalscholarship.wordpress.com/2009/04/21/collaborative-authorship-in-the-humanities/.

Spiro, L. (2011) *Making Sense of 134 DH Syllabi: DH 2011 presentation*, http://digitalscholarship.wordpress.com/2011/06/20/making-sense-of-134-dh-syllabi-dh-2011-presentation/.

Svensson, P. (2010) The Landscape of Digital Humanities, *Digital Humanities Quarterly*, **4** (1), www.digitalhumanities.org/dhq/vol/4/1/000080/000080.html.

Terras, M. (2006) Disciplined: using educational studies to analyse 'humanities computing', *Literary and Linguistic Computing*, **21** (2), 229–46.

Terras, M. (2010) Digital Curiosities: resource creation via amateur digitization, *Literary and Linguistic Computing*, **25** (4), 425–38.

Unsworth, J. (2010) *Is There a List Anywhere of all the Graduate Programs that Study DH? (Answer)*, http://digitalhumanities.org/answers/topic/is-there-a-list-anywhere-of-all-the-graduate-programs-that-study-dh#post-539.

van den Huevel, C., Antonijevic, S., Blanke, T., Bodenhamer, D., Jannidis, F., Nowviskie, B., Rockwell, G. and van Zundert, J. (2010) *Building the Humanities Lab: scholarly practice in virtual research environments*, *Digital Humanities 2010*, *Kings College London, July 7–10*, http://dh2010.cch.kcl.ac.uk/academic-programme/abstracts/papers/html/ab-611.html.

Warwick, C. (2004) *No Such Thing as Humanities Computing? An Analytical History of Digital Resource Creation and Computing in the Humanities*, http://tapor.mcmaster.ca/html/Nosuchthing_1.pdf.

Warwick, C. (2011) *Archive 360: the Walt Whitman Archive*, http://archivejournal.net/three-sixty/.

Warwick, C., Terras, M., Huntington, P., Pappa, N. and Galina, I. (2007) *The LAIRAH Project: log analysis of digital resources in the arts and humanities. Final report to the Arts and Humanities Research Council*, www.ucl.ac.uk/infostudies/claire-warwick/publications/LAIRAHreport.pdf.

Warwick, C. et al. (2008) The Master Builders: LAIRAH research on good practice in the construction of digital humanities projects, *Literary and Linguistic Computing*, **23** (3), 383–96.

Notes

1 See, for example, www.samplereality.com/2010/11/09/digital-humanities-sessions-at-the-2011-mla/.

2 For example, Gold, Matthew (ed.) (2012) *Debates in the Digital Humanities*, University of Minnesota Press; Nowrotski, Kristin and Dougherty, Jack (eds)

(2012) *Writing History in the Digital Age*, University of Michigan Press. Both texts are forthcoming in 2012.

3 See the discussion below for details.

4 Dan Cohen has created a very comprehensive list of digital humanities scholars and centres on Twitter,
https://twitter.com/#!/dancohen/digitalhumanities/members.

Index